Designing Together

The collaboration and
conflict management handbook
for creative professionals

Dan M. Brown

New Riders | VOICES THAT MATTER™

DESIGNING TOGETHER:
THE COLLABORATION AND CONFLICT MANAGEMENT HANDBOOK FOR CREATIVE PROFESSIONALS
Dan M. Brown

New Riders
www.newriders.com

To report errors, please send a note to errata@peachpit.com

New Riders is an imprint of Peachpit, a division of Pearson Education.

Copyright © 2013 by Dan M. Brown

Project Editor: Michael J. Nolan
Production Editor: David Van Ness
Development Editor: Jennifer Lynn
Copyeditor: Jennifer Needham
Proofreader: Gretchen Dykstra
Indexer: Joy Dean Lee
Cover & Interior Designer: Mimi Heft
Compositor: David Van Ness

ISBN 13: 978-0-321-91863-5
ISBN 10: 0-321-91863-0

9 8 7 6 5 4 3 2 1

Printed and bound in the United States of America

Dedication

For Mom

Acknowledgments

I've wanted to write this book for a long time, and I'm grateful to the team at New Riders for helping me make it a reality. Nancy Davis and Michael Nolan were instrumental in helping me shape and articulate the vision, and I'm grateful for their vigilant leadership and shrewd understanding of what makes a great book.

Jennifer Lynn helped hone my voice and guided me out of some turbulent waters, some of my own making. I'm grateful for her even temper and occasional reminders about karma.

Liz Danzico's request that I expand my conflict management workshop to include collaboration skills was the catalyst that gave life to *Designing Together*. I'm grateful to her for working with me to develop that workshop, and for her ongoing trust in me to educate the next generation of designers.

Nathan Curtis is literally the best business partner a guy could have. He gave me the room I needed to scratch this itch. Nathan is the first person to tell you that he isn't a "people person," but he sells himself short. The truth is that much of the thinking in this book came from watching Nathan lead teams and from working with him to build a culture of collaboration at EightShapes. Nathan, now it's your turn.

The team at EightShapes was incredibly supportive as I "went dark" for long stretches to write the book. Jody Thomas, our director of visual design, provided some useful advice on the cover design. Veronica Erb and James Melzer provided some feedback on the format of the reference section of this book. Chuck Borowicz, Matt Dingee, Mary Specht, and Jason Wishard served as an occasional informal focus group as I bounced some ideas off them. I'm grateful to them for their candid feedback and for not asking, "So, is this billable?"

Some content started in the form of a card game, Surviving Design Projects. I presented this game for the first time at the IA Summit 2012 in New Orleans. Workshop participants were enthusiastic and generous with their feedback. Since then, I've run the workshop several times, and gotten feedback from a dozen people who played the game with their teams. Thank you to everyone who purchased the game and took the time to give me their thoughts. Thanks especially to EightShapers Veronica, James, Jason, and PJ, who play-tested the game.

The concept of mindset is based on the work of Carol Dweck. Her work over the last several decades to understand why smart people are afraid of failure has been instrumental to me as a mentor, as a manager, as a partner, as a parent, and as a designer. I've summarized her work in Chapter 2, extending it based on my experience. Any errors are mine alone.

Sometimes I think I write books so I have an excuse to talk to awesome people. In seeking contributors for *Designing Together*, I wanted to assemble a diverse group who could all speak to common themes of collaboration and team dynamics while offering different perspectives. Their thoughts far exceeded my expectations. Thanks to David Belman, Mandy Brown, Erika Hall, Denise Jacobs, Jonathan "Yoni" Knoll, Marc Rettig, and Jeanine Warisse Turner, PhD, for lending their voices.

I now get to cross "Scott Berkun writes Foreword for book" off my bucket list. I've long been a fan of Scott's writing and thinking, and I'm grateful he could lend a bit of both to this book. When I shared the manuscript with him, his enthusiasm for the content gave me the boost I needed to reach the bitter end of the project. Thanks, Scott, for your words and your encouragement.

My kids, Harry and Everett, were incredibly patient as I stepped away for a few hours each weekend to do some writing. It was really only in the last few weeks that Harry started to ask, "Daddy, when will you be done?" Boys, I'm looking forward to having some free time back so we can collaborate on our own projects.

Finally, my deepest gratitude and thanks go to Sarah, my constant companion and cherished partner in life, love, and child rearing. She took on more than her share of all three while I holed up to write in the evenings and on weekends. Thank you so much, sweetheart, for being a wonderful mother, a loving wife, and my best friend. Ours is the best project I've ever collaborated on.

Foreword

The cliché of Forewords for books is they have a seemingly famous person express how wonderful the book you're about to read is. But the secret we authors don't want you to know is often the Foreword is written by a friend who either lost a bar bet or is trading for the destruction of unsavory photos in the author's possession. This explains why most Forewords are dreadfully dull and unworthy of the book they're in. I can promise you I've only met Dan once and owe him nothing.

I'm writing this Foreword simply because this book is exceptional. It captures the central flaw in the talents of most designers: how to create with other people. And it achieves this without falling victim to the clichés and platitudes that render most books of this kind useless.

Back when I was a student, my vision was a lifetime of making world-changing designs. But in these dreams I always had a starring role, with minions scurrying about, taking every order and doing all the work I didn't (or couldn't) do. How naive the dreams of young designers are. No great thing in the history of design and engineering was, or ever will be, made this way. It always takes a team of craftsmen, working in harmony, to make something great. Working with others has always been ignored in design culture. And the result is that the student fantasy lives on far too long in the careers of creatives, squandering their talent and their happiness, too.

If you pick any great design from today, or in history, and dig into the details of how it was made, you'll find a team of talented people working well together. Each contributing and building on each other's work. They didn't always like each other, but they learned how to put the quality of the results ahead of petty differences. Their ability to do this isn't magic. Nor is it based on their creative talents. Instead it's a set of simple attitudes and skills this book clearly explains. While I've learned many of these practices along my career, I'd never seen them as clearly named, explained, and taught as they are here.

If you want to escape work that buries you in stress, disrespect from coworkers, or meetings that resemble Custer's Last Stand, you'll find solutions in the following pages. I'm jealous of the moments of clarity awaiting you in the chapters ahead.

—Scott Berkun

Contents at a Glance

Contents

CHAPTER 9
Situations: Circumstances and Scenarios Common to Design Projects 151

CHAPTER 12
Collaboration Behaviors: Embodying the Virtues 227

INTRODUCTION

Conflict, Collaboration, and Creativity

THE ASSIGNMENT SEEMED INSANE: Develop a new design for a Web site for a major consumer brand. By design, I mean an overall direction as embodied in a few key Web pages—the home page and some interior pages. Besides establishing a design direction, the project called for showing how the direction would be responsive—adaptable to a wide array of screen sizes, for Web browsers appearing on smartphones and tablets as well as laptops and big monitors.

The total timeline for the project was about a month, maybe six weeks. In that time, our team was responsible for devising the design direction and preparing a prototype to communicate how it would work in different browser sizes.

The odds were stacked against us, even more than already described. The client had insisted on a project framework that we didn't agree with. Though such a constraint would normally preclude us from taking the project, we chose to pursue it anyway. What we'd learn from the project would be worth the risk of failure.

Typically, plans for many of our projects include a week or two of intense prototyping. The team comes together and holes up in a room for four to five days to churn out the first draft of the prototype. During this week, the team establishes the underlying code framework, captures the behavior of key screens, begins to demonstrate the responsive behaviors, and embodies the broad strokes of visual styling. It's a massive collaborative effort that involves lots of moving parts, team members from various disciplines, and a lot of sketching on whiteboards and side-by-side programming.

As a part of this experience, I had to occasionally take a moment to step back and see the team through different eyes. It was like the advice I got before my wedding: you're going to be so caught up in the event, you should force yourself to pause and take it in. During those moments of pause, watching the team work, I could see the practice of Web design (maybe all design) changing. This spirit of collaboration, of finding satisfaction and efficacy in the well-oiled machine, became evident elsewhere. It showed up in the professional development objectives of my colleagues. It came up in conversations with candidates. It resonated with other clients and other projects.

We pulled it off, this by-all-accounts-insane design direction project. It was collaboration that brought us to the finish without killing each other and conflict that fueled the creativity.

What's in This Book

Designing Together is a book about collaboration and conflict, two equal but different forces that exert pressure on design teams. It is divided into three parts.

The first part, which focuses on the **fundamentals**, explains the role of the designer as a contributor on teams, and answers the basic question, "Why are conflict and collaboration important for creativity?"

1. "Designer as Contributor" describes the role and position of the designer who is part of a team.

2. "The Designer Mindset" draws on the work of Carol Dweck to explain how designers must have the right attitude.

3. "Listening: The Essential Skill" establishes some guidelines for the most basic skill to drive collaboration and put conflict to good use.

The next part, which focuses on the **theory**, establishes theoretical frameworks and language to help designers think about and talk about conflict and collaboration.

4. "The Role of Conflict in Design" explains how conflict is essential for the design process.

5. "Assessing Conflict: What's Really Wrong" provides advice on how to evaluate the difficult situations that arise in creative projects.

6. "The Model of Conflict: Patterns, Situations, and Traits" establishes a framework for showing how situations relate to designers' personality traits and patterns of behavior.

7. "How Collaboration Works" describes the dynamics of collaboration on creative teams and dismantles some myths about collaboration.

8. "The Four Virtues of Collaboration" establishes four guiding principles for collaborative environments.

The final part, which serves as a **reference**, summarizes practical tools for assessing designers and complicated situations, as well as tactical behaviors for dealing with conflict and cultivating collaboration.

9. "Situations: Circumstances and Scenarios Common to Design Projects" describes recurring difficult conversations or events.

10. "Traits: Evaluating Yourself and Your Colleagues" explores the aspects of a designer's working style or personality that affect how he or she interacts with the team.

11. "Conflict Patterns: Behaviors for Reaching Solutions" provides suggestions for behaviors to help unstick sticky situations.

12. "Collaboration Behaviors: Embodying the Virtues" examines habits that lead to more effective collaboration.

This Book Builds Stronger Teams

Designing Together is a book about team dynamics. It's about achieving the right chemistry so that design teams can do great things together. It considers

■ **Situations**: The obstacles that people run into on design projects

■ **Behaviors**: What people do on design projects to deal with situations

■ **Mindsets**: How participants consider and approach situations

■ **Virtues**: The principles that drive great creative teams

Where to Go First?

■ If you're just entering the field, start with Chapters 1 and 2, which frame the role of the designer in the modern creative team.

■ If you're working on a project that seems in trouble, you might skip directly to Chapters 4 and 5, to assess what's happening and what you can do to fix it.

■ If you're already working on a creative team that works well together, you might skip to Chapters 7 and 8, to see what you can be doing to improve the collaboration.

This book addresses a gap in the literature (or so my ego would like to think). Most books on team dynamics are directed to the leader of design teams. They

cover topics such as how to facilitate meetings, how to structure projects, and how to manage clients.

Designing Together instead focuses on the contributing designer, the person responsible for a portion of the project, but not necessarily the lead or the manager or the central stakeholder. It's for anyone working on a design project, because every person on the project team is ultimately responsible for its success or failure.

This Book Will Change Minds and Behaviors

Designing Together is ultimately a book about behaviors—behaviors that help designers untangle complicated situations, and behaviors that yield better outcomes on complicated projects. A slight shift in how people behave can change a hopeless argument into a productive conversation. Adopting some simple new behaviors can also change a tense, competitive landscape into a collaborative, mutually supportive environment. Adopting the right behaviors depends on having the right mindset.

Chapter 2 talks about mindset, the frame of mind that decides how someone perceives a situation, how they feel about it, and how they choose to react to it. Mindset and behaviors are linked. A person's mindset directly influences their reaction and behavior in a situation. But a mindset can be redirected, such that people can choose to react in a different way than their mindsets would dictate.

This is important: a person's mindset influences his or her behavior, but behavior also influences mindset. By adopting behaviors that go against his or her mindset, a person has an opportunity to influence how he or she perceives the world and reacts to it.

The Desired Goal: Great Design Teams

There are lots of ways to define a great design team. Greatness is, in part, measured by results. Great teams presumably produce great products, great buildings, great software, great whatever. But results alone can't measure a team's greatness. If a project yields miserable, burnt-out designers, can it really be called great? If a project focuses on a single visionary, a control freak who won't let other people make meaningful contributions, can it really be called successful?

Great design teams produce great products, but they also offer all members of the team difficult but attainable **challenges** and an opportunity to make meaningful **contributions**.

These aspects of designers yield unhealthy habits—behaviors that drive them to work too hard, to burn out, to compete with other designers, to rub clients the wrong way. This, then, is the essence of a great design team: It is one that channels designers' raw desire for challenge and meaningful contribution into healthy habits that yield great products. *Designing Together* is a guide for contributing designers to channel their desire into healthy habits.

Designers Like Challenge

Generalizations about designers may stereotype their arrogance, but spend a moment with a design team and you'll see there's really only one thing that unites them. Every designer wants to be challenged. Designers

- **Crave real-world problems**: They want to create products that make a difference in people's lives.

- **Relish reasonable constraints**: They understand that the best way to solve a problem is to do so within nonarbitrary boundaries.

- **Gravitate toward the novel**: They like to work on new things, but sometimes "new" means novel approaches to age-old problems.

- **Appreciate the esoteric**: They recognize that even the most obscure product will serve a need in someone's life.

- **Think of themselves as customers**: They acknowledge that they aren't perfect proxies for a product's users, but they love getting inside the heads of the people who will use it.

Designers Like to Contribute

Challenge is one draw for designers, but not the only one. Challenge alone is unsatisfying if designers can't make a meaningful contribution to the solution. Designers must feel that their effort has a positive impact on the design of the product. In this way, designers

- **Thrive on constructive feedback**: When designers get constructive feedback, it means someone is paying attention and believes that their ideas have some merit.

- **Seek to prove their value**: Designers have an almost constant insecurity that even their best efforts are not productive contributions to the project.

- **Overcommit themselves**: Designers struggle to say "no" to assignments because they are eager to make a contribution.

- **Struggle to relinquish control**: Designers struggle to let go of their work because they don't want to see their effort potentially wasted through compromise and iteration.

- **Accept short-term pain for long-term gain**: Designers recognize that meaningful contributions aren't easy, but understand that such challenges come with reward.

The desire for challenge and the desire to make a contribution, therefore, can be sources of positive behaviors, when channeled appropriately. The purpose of this book is to draw on these desires and cultivate the behaviors of healthy, happy, great teams.

This Book Is for Teams of All Shapes and Sizes

Creative teams come in all shapes and sizes. Some have just a few people, while others have dozens. Some include "non-design" roles like project coordination and product management, while others keep things focused on "creative." (Ugh, I hate those distinctions.)

The models and behaviors described in *Designing Together* make no presumptions about the configuration, size, or location of your team:

- **Small or large**: Teams both small and large have to find ways to work with each other efficiently and effectively, whether members of the team have overlapping roles or not.

- **Inside or outside**: Teams serving internal stakeholders or consulting in an agency model each deal with clients differently. That said, the issues of alignment and collaboration are relevant in either case.

- **Remote or colocated**: Increasingly, teams do not sit in the same location. Whether all or part of your team is remote, these behaviors are relevant and important to keep things running smoothly.

How This Book Will Help Designers

If you're a contributor on a team, you'll learn

■ How to be a better listener, the key skill for any designer on any team (Chapter 3)

■ How to recognize, diagnose, and deal with difficult situations (Chapters 5, 6, and 9)

■ How to reflect on your attitude and performance and cultivate habits to make you a better contributor (Chapters 2 and 10)

■ How to incorporate new behaviors and habits into your approach to make you a better participant on the team (Chapters 11 and 12)

■ How to talk to your manager or leader about what you need and how to be more effective (Chapter 7)

■ How to recognize potential problems on the team (Chapter 8)

How This Book Will Help Team Leaders

As someone who leads or manages teams, you'll learn

■ What habits to model and encourage among your team members for improved effectiveness (Chapter 12)

■ What values your team should strive for in their interactions with each other and their stakeholders (Chapter 8)

■ How to recognize a counterproductive attitude in your team members and things you can do to change it (Chapter 2)

■ How to evaluate team members to understand how they can be more effective contributors (Chapter 1 and 10)

What This Book Is Not

This book is not

- **A collection of brainstorming activities**: There are lots of great books out there that suggest how to structure brainstorming sessions. Check out *Gamestorming*, by Dave Gray, Sunni Brown, and James Macanufo.

- **A collection of team-building exercises**: There are even more great books on exercises for creative teams (or individuals) to flex their muscles. Check out *Creative Workshop* by David Sherwin.

- **A manual of facilitation**: Facilitation seems to go hand in hand with collaboration, and a lot of designers are interested in learning how to facilitate meetings. This book may provide some ideas, but consider the new book *Designing the Conversation* by Russ Unger, Brad Nunnally, and Dan Willis.

- **A manual of project management**: Great collaboration depends on well-structured projects, but this book is focused on the behavior of contributors, not the exact structures of projects. For that, consider Scott Berkun's classic *Making Things Happen*.

Brainstorming, team cohesion, facilitation, and project management are all crucial parts of collaboration, but they aren't the whole of it.

A Note on Language

Throughout the book, I make several concessions on language. Please bear with some of the language contortions, as I tried to

- **Avoid being prescriptive**: I've avoided using "you" because, though I hope you, the reader, find the ideas helpful, I don't want you to feel put on the spot.

- **Avoid being gender specific**: I've used the plural to avoid making gender-specific references. This occasionally yields sentences where nouns and pronouns disagree. ("The practicing designer appreciates their team.")

- **Avoid being industry specific**: I've used the term "product" to refer to anything a designer may be working on, because I believe these ideas to be useful to any creative team. My background is in Web design, however, so many examples are drawn from that experience.

Design Depends on Conflict and Collaboration

There is one central assumption of this book:

> Successful design projects require effective collaboration and healthy conflict.

Within the scope of design, healthy conflict isn't necessarily negative or turbulent. Instead, it's a process for arriving at a shared understanding. In the course of a design project, teams have to make decisions about the overall design direction, the details about the product, and how the project will proceed, among many others. Through the process of aligning on these decisions, designers experience conflict.

Through conflict, design teams work to become aligned in their understanding. Through conflict, design teams experience strife in the name of clarifying and refining decisions about the project. This process is worth the effort, because only through such discourse comes a shared understanding. Without shared understanding, team members will head off in different directions, work toward different goals, and not support each other's efforts. There are lots of ways to resolve conflict, and the single litmus test is understanding: Everyone is clear on the direction, the approach, and the desired outcome, and can work collaboratively toward those ends. And that brings us to collaboration.

Collaboration is working together to produce something that one person could not have produced on their own. Successful collaboration means each person doing his or her part to achieve the project goals. Positive collaborative relationships improve teams by enabling them to work efficiently and effectively. Through good collaboration, teams bring the best out in each other, pushing each other toward better design concepts while dovetailing each other's strengths and weaknesses to hit project goals.

Five Central Ideas

There are five ideas that permeate *Designing Together*. These concepts are fundamental: understanding them is a prerequisite for understanding how design teams can collaborate more effectively.

Behavior

This entire book is predicated on the notion that designers exhibit behaviors in the context of their project and their team. Whatever may underlie the intent of the designer, it's the behavior that impacts the efficiency and efficacy of the design team.

Behaviors can be

- **Specific**: A behavior may be a discrete action performed in the context of a particular situation. For example, repeating what someone says to you to make sure you've heard it correctly is a specific behavior.

- **General**: A behavior may be a habit in the way designers conduct themselves day to day on projects. For example, communicating progress updates every day is a general behavior.

Behaviors can also be

- **Healthy**: Healthy behaviors lead to activities that produce great design and move a project closer to its goals.

- **Unhealthy**: Unhealthy behaviors stall a project, embroiling participants in counterproductive situations. The healthy/unhealthy dichotomy is described in greater detail in Chapter 4.

Mindset

Behaviors are the embodiment of mindset (or a direct reaction to it). More than any other concept in this book, mindset permeates every word, every idea, and every recommendation.

> Mindset is a person's perception of, attitude toward, and desired reaction to the world around them.

With the wrong mindset, a designer's desire to pursue challenge and make meaningful contributions will yield counterproductive behaviors. The wrong

mindset causes designers to misinterpret situations and opportunities. It encourages them to feel negatively about themselves, their performance, and their colleagues' behaviors. The wrong mindset predisposes designers to be anticollaborative.

Self-Reflection

The book rests on the assumption that designers like reflecting on their work and their performance. They consider not just what they did, but how they did it, and what they could have done better.

This book asks designers to go a little deeper, asking themselves why they might have behaved in a certain way. It asks them to consider whether they have particular preferences or styles that influence their approaches. Learning to recognize these traits can help designers overcome unhealthy behaviors and confront the insecurities that prevent them from adopting healthy ones.

Empathy

Many of the behaviors, values, and attitudes described in *Designing Together* rely on the ability to relate to someone else. Empathy is crucial for untangling a difficult client meeting, or providing constructive feedback to a colleague, or establishing roles on a project. You won't find much on empathy in this book. I do not believe empathy is teachable. What you can learn, however, are behaviors and attitudes that reflect empathy.

Design Success

Every design project will be measured differently, because each has unique goals and constraints. That said, this book presumes that design projects are generally measured along two key dimensions:

- **Quality**: How good the design is relative to the goals of the project.
- **Completion**: How close the team is to meeting the project goals.

This definition of success drives many of the recommendations in this book. It helps designers separate healthy, constructive, productive behaviors and situations from those that don't improve the design or progress the project.

Surviving Design Projects, The Game

Some of the content in this book started out as a card game for creative teams to hone their conflict management skills. The game challenges players to apply a variety of conflict resolution behaviors to difficult situations. What ensues is a fun, team-building activity that encourages people to talk about their hardest projects without making things personal.

You can find an up-to-date version of the game through the book's companion Web site: http://www.designingtogetherbook.com.

Thank You

Finally, thank you for reading this book. The business of design, like other service industries, is undergoing a major change. Customer-focused services like healthcare, consulting, and education are experiencing similar shifts in mindsets and behaviors.

Your reading this book suggests to me that I'm not alone in sensing this change. I'm grateful to you for joining me in exploring what makes a great team and how to be a great contributor to a creative team. As you're reading about the model of conflict and the virtues of collaboration, the behaviors for better conflict resolution, and the habits of good collaborators, I hope you ask yourself questions like:

■ Is this something I do? Do I do it well or poorly?

■ Is this something we should be doing on my team?

■ Have I seen this happen on my project? Did we handle it well? What could we have done better?

If, as you're reading, you feel like I've left something out or have your own story to share, please contact me: author@designingtogetherbook.com.

1

Designer as Contributor

AS A GROUP, designers tend toward the ambitious. After all, success in design is having a product or concept widely used and admired. The designers celebrated by the community tend to be seen as sole visionaries—Steve Jobs, Dieter Rams, or Paul Rand. The stories behind their products, and so many other successful products, are far more complex than the single epiphanic flash of brilliance. Even if designers were to believe the apocrypha surrounding their favorite products, they eventually come to learn the truth: Designers don't work alone. This book will describe many reasons for this, for the fact that "designer in a garage" is—if it ever were true—no longer feasible. Regardless, it may be difficult for designers to come to terms with this conception of themselves.

This, perhaps ultimately, is the purpose of this book: to reassure designers that in their position as a contributor, they lose no opportunity to drive, to lead, and to influence. Being a contributor means rejecting the notion of a designer as one who churns out pretty visuals. It means embracing their role on the larger project team as one who shapes and fashions, as one who brings a unique perspective, and as one who is uniquely positioned to integrate multiple perspectives. Being a contributor means not relinquishing control, but finding it through the power of collaboration.

It's these three ideas, then, that drive the designer as a contributor:

1. Designers do not operate perfectly independently, even if they are the only designer participating in a project.

2. As participants, designers will play many different roles—leader, facilitator, expert, critic, director, author. Ultimately, they contribute a range of skills and responsibilities.

3. Being an effective designer means moving effortlessly between these roles to achieve the goals of the project. Effortless movement depends on understanding the team.

This chapter elaborates on these themes, first explaining the aspects that define a design team.

Elements of a Design Team

The design team is a group of people responsible for creating the design of a product. The team may also be referred to as the *project team* or the *product team*. Like any family, there are central members and then the "extended team," which comprises additional stakeholders or subject matter experts (**Figure 1.1**).

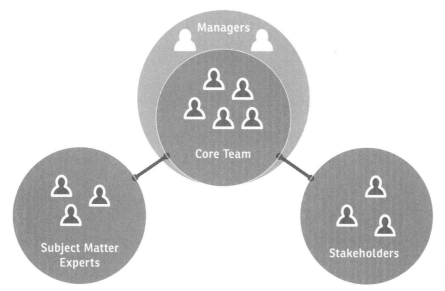

Figure 1.1.
A map of the typical design team.

But a team is more than just the people on it. A team includes the people, the roles they play, the team members' objectives, the tools and methods they use, and the framework or parameters in which they operate.

These are some of the primary elements of the team. For each of these elements, I offer a cursory definition: most experienced designers know what roles and goals and methods are. I provide some broad categories within each element to classify the variations of the element.

Most importantly, I offer principles to guide design teams as they assemble and evaluate the elements of a team. These principles establish parameters for success—the underlying factors that make some teams work better than others. They influence whether a team is well positioned to take advantage of the collaboration behaviors discussed later in the book and whether they're set up to make the most of conflict.

Roles and Responsibilities

Project teams almost always assign roles to team members. These roles come with responsibilities, the set of tasks and activities different people participate in. My experience indicates that most design teams normalize on four general categories of people on design teams:

- **Designers:** People responsible for generating and documenting ideas about how the product works, looks, or behaves. In many areas of design, there are designer specialties. A project may require more than one specialty. One of these people may be designated as the "lead," the person who owns the creative vision.

- **Managers:** People responsible for ensuring the project team delivers on its obligations, creates plans to do so, and successfully executes against those plans. Different projects assign the manager role differently: some consolidate it with the lead designer, and others separate it.

- **Subject Matter Experts:** People—sometimes designers, sometimes not— responsible for contributing information to the design process. These may be people who are the users of the product itself or who have some special insight into the users or the project constraints.

- **Stakeholders:** People ultimately accountable for the success of the project. They hold the purse strings and become the ultimate internal owners or champions of the product.

There indeed are others, but I can safely classify 90 percent of the people I encounter into one of these four buckets.

The roles themselves are interesting really only on the surface level and, at least in the world of Web design, have been examined ad nauseam. For me, the principles governing how people are assigned to a project are more interesting.

The Principle of Multiple Hats

> The people on a project may play multiple roles, but too much consolidation of roles can compromise the value of collaboration.

Roles and people do not have to be one-to-one. A single person may play as many as three roles: design lead, designer specialist, and research assistant.

That said, some roles don't mix well. Successful projects don't usually allow a project stakeholder to also be a designer. This isn't to say never in the history

of the world has a designer been a business stakeholder on a successful project. However, those projects are rare. For the most part, teams find value in keeping design activities separated from business activities. But on the flip side, designers can and should participate in project planning activities.

The Principle of Minimal Internal Risk

> The people on a project should not introduce any additional risk to the project based on their personality traits, working styles, or preferences.

Projects encounter so many risks from external factors that they should avoid further risk through the personnel assignments. External factors introducing risk include changes to requirements, goals, priorities, or parameters.

Personnel assignments can introduce risk when bringing on people who are incapable of doing their tasks or who struggle to deal with other project parameters. One common problem in small agencies is people who struggle to work on more than one or two projects at a time.

The Principle of Professional Growth

> The people on a project should find the project fulfilling because it introduces challenges that help them grow.

At minimum, designers expect every project to add an entry to their portfolios. Their participation in a project holds at least that appeal, if not more based on the project goals.

The Principle of Ownership

> Ownership—a contributor's feeling that he or she has a stake in the success of a project—helps team members understand their purpose on the project.

People like knowing their roles because they explain their purpose on the project. They like knowing what's carved out for them to own and drive, and where they can contribute. People like knowing whom to go to for other tasks and activities.

The Principle of Diverse Composition

> Project teams succeed when people who bring diverse perspectives and approaches can work toward a common goal.

The simple truth is that projects require a lot of people, and everyone is different. These differences can work to a project's advantage, but occasionally become the excuse when people can't work together effectively.

Goals and Priorities

A project team is defined as much by its goals and priorities as it is by the roles on the project. Like roles, goals and priorities are defined from the outside.

The project goals not only entail the end state for the project—a product definition, design specifications, a campaign plan, a building built—but also the change made in the world. Design projects tend to serve a business purpose—to sell more widgets, to attract more customers, to create new demand.

The Principle of Meaningful Mark

> People like working on projects that are going to make a difference in people's lives, no matter how small the consequence.

Most designers I've met prioritize making a difference in people's lives, even over working on "sexy" projects. The portfolio value of a recognizable consumer brand may be very tempting, but designers also like telling a good story about designing a volunteer management system for their favorite nonprofit.

The Principle of Personal/Professional Alignment

> People derive more professional satisfaction from working on projects that align with their own beliefs.

Design teams sometimes take on projects that, though meaningful, have the right impact on the wrong people. Or the wrong impact on the right people. Such political views may be personal, but they can influence the team's satisfaction or sense of reward from working on the project. Great design that serves the wrong purpose may not feel like great design at all.

The Principle of Discounted Novelty

> Designers don't like to work on "new stuff" as much as the world would think they do.

Though designers have a reputation for preferring to work on "sexy" consumer brands and radical product ideas, most designers just want to do interesting work. That means complex design challenges for the benefit of a specific target audience. Even working on an internal application for two dozen claims processors at a small dental insurance carrier is appealing when it makes a significant impact on their day-to-day job satisfaction.

Techniques and Methods

A team is defined by the methods it uses to solve design problems. Methods include

- **Methodologies:** Schools of thought or design philosophies that drive the approach teams take to meet project goals.

- **Processes:** Step-by-step flow of activities that define what the team produces and how team members reach their goals.

- **Techniques:** Activities to achieve specific project milestones, like user research or setting design direction. Techniques may be formal or informal. Teams choose techniques based on the overall methodology and the project goals.

The Principle of Appropriate Activities

Projects should use the right techniques for the right activities.

Every activity should clearly move the project closer to its goals. As self-evident as this principle is, many design teams structure their projects around activities they always do without considering the specific needs of the project.

The Principle of Novel Use

Projects should challenge the team to configure existing techniques for new situations.

Good techniques have levers you can adjust for various situations. Such levers on a technique vary depending on the type of activity, but could include

- **Scale:** How big you make the activity

- **Formality:** How formal the output is

- **Depth:** How detailed the team gets

- **Participation:** How much participation is expected from outside the core team

- **Dependencies:** How much the technique relies on other activities or outputs

For example, user interviews are a common technique in Web design to capture user needs. User interviews permit a wide range of novel applications. The basic activity remains the same—talking to the target audience—but there is flexibility in the number of users, the people who participate, and how the data is analyzed.

Project Parameters

Project parameters are the array of constraints that establish boundaries for the project. They generally fall into one of three categories:

■ **Scope:** Product-specific boundaries or requirements, like which parts of the product or campaign designers should focus on. In the case of Web designers, projects are typically scoped in terms of Web pages or aspects of an application, or features.

■ **Time, money, and geography:** The "physical" constraints of a project, like how much money can be spent, when it's due, and the temporal/spatial constraints of the team.

■ **Context:** The area in which the product will appear. This can be technical, like a particular network of servers; or physical, like a building site; or virtual, like the area of an organization that will get a new business process.

Great teams will ferret out definitions of these parameters in the earliest stages of a project.

The Principle of Full Definition

The project framework will be fully defined as early as possible in a project.

The better defined the project parameters are at the beginning of a project, the more effective the design team will be. Design teams forced to deal with shifting project parameters take energy away from solving the design problem. In such situations, teams find themselves retrofitting once-great solutions into spaces made for a different solution entirely. By changing the parameters, the project changes the design challenge.

The Principle of Reasonable Constraints

All parameters and boundaries make sense and don't seem arbitrary.

Nothing is more frustrating to a designer than seeing an obvious solution for the design challenge, but finding it's just out of reach because of some silly business rule or technical issue. A simple example is the final deadline—which is based on the scope of the project (reasonable), based on when it's been promised to customers (somewhat reasonable), or based on the end of the quarter (unreasonable).

The Principle of Parameter Flexibility

> Project teams will measure the flexibility of a project parameter on a scale, not as "yes" or "no."

Constraints should not be totally immobile. Successful projects depend on varying degrees of wiggle room on at least some constraints. For example, deadlines and milestones may have fixed dates (binary) or reasonable ranges (first week of April).

The Glue of a Design Team

The elements of a design team and the principles governing how projects are structured provide a framework for looking at the team as a whole—its composition, approach, and context. But it's the members that hold a team together.

Basic Values

There are some basic values that belong on every design team. Without them, design teams cannot function effectively. They set the tone for how members of the team treat each other. These basic values include, most importantly, respect, humility, and empathy.

Respect

Designers earn respect by doing great work, garnering acknowledgment from stakeholders or other team members. A well-known designer may have the respect of other designers simply because of success in the market, but that respect is easily lost if that person turns out to be difficult to work with or arrogant, or proves incompetent. With respect comes trust, the ability of members of a team to rely on each other.

Humility

Projects and teams succeed when people own their contributions but don't try to "own the team." I spent much of my early career as a superhero, capable of achieving successful design ideas with (apparently) little effort. When it came time to participate on a team with other "superheroes," this attitude had to go.

Empathy

Peel back the layers further, and it's clear that respect and humility depend on empathy. Some people argue that designers who incorporate empathy into their practices design better products. Whether that is true or not, empathy is important for successful team dynamics:

■ Collaboration behaviors require people to speak to each other directly and honestly, but a dose of sensitivity will make those messages stronger.

■ Successful collaboration also depends on being someone who brings out the best in one's colleagues. Providing this kind of support to each other depends on team members knowing what brings out their best.

■ Design depends on conflict, but not the kind that is dramatic, personal, and potentially toxic. Empathy can be the difference between healthy, productive conflict and unhealthy, counterproductive conflict.

Beyond the Basics

These virtues of design teams establish a nice foundation, but they aren't the whole story. Respect, humility, and empathy are necessary for effective and efficient teams, but they are not sufficient.

Just like designers learn to use tools (like software, pen and paper, or model making) as an extension of their imaginations so, too, must they internalize these behaviors. Incorporating them as second nature into their conduct, designers will have a range of techniques for keeping a project moving forward, supporting their teammates, and dealing with conflict.

Even with respect, humility, and empathy, teams run into problems. They disagree about the design direction, they become stuck in solving a design challenge, or they miscommunicate about expectations. Whatever the obstacles or opportunities, teams need to draw from a range of behaviors that allow teams to navigate through them and take advantage of the ever-shifting circumstances of a design project. This means learning the behaviors (Chapters 11 and 12), but also shifting one's mindset (Chapter 2).

The Contributing Designer

I have a theory. I call it the *Theory of Professional Reconciliation* because, if nothing else, the first chapter of this book reveals that I like naming things. The theory goes like this:

> When someone decides to become a designer, he has a vision of himself spending hours upon hours tinkering over drawings and prototypes to define and refine a product concept. In his imagination, this is how he spends the bulk of his time.

> The reality looks very different. Designers spend at best 50 percent of their time devising and refining their ideas. The remaining 50 percent or more is dedicated to collaborating with other people—managing expectations, defining project schedules, gathering requirements, validating design direction, negotiating design decisions.

> Practicing designers spend their entire careers trying to reconcile their visions with the reality. They believe that other designers do it better or differently. They believe that this "non-design" work is compromising their ability to be successful. They believe that if they just changed something about their practices, they'd be able to achieve their visions of design.

The sooner a designer can come to grips with the idea that the actual "designing" portion of his or her work is not a majority percentage, the sooner he or she will realize that design is more than working on concepts.

The truth is that products and audiences and production cycles and marketing and business are far too complex for one person to handle solo. Whether working on buildings or books or consumer electronics, the designer has to reconcile this notion that he or she is a contributor to a larger effort. Working designers, therefore, even when they're doing design, are making important contributions to a larger effort to bring a new product to reality.

At the beginning of this chapter, I laid out the factors that define a team. There are principles at work that make teams more or less effective. Part of what makes a team work is the underlying personality—humility, respect, and empathy. Ultimately, these basic traits get a team to stick together, but they don't automatically ensure success. For success, designers must have the right mindset. A large part of that mindset is recognizing that being a designer means being a contributor to a larger effort.

Erika Hall

Cofounder, Director of Strategy, Mule Design Studio

"Can you get that document to me today?"

"Totally."

So often, completely well-meaning colleagues have this exchange, both knowing in their hearts that the end of the day will come and go and no document will change hands. Too much communication between individuals in organizations is automatic, unintentional, and ritualized—that is to say, insincere. And without sincere speech (or email!) and sincere commitment, there is no trust and a whole lot of second-guessing. This wastes time and leads to bad work and bad blood.

Effective collaboration requires commitments—requesting, making, and following through on them. A collaborative team is a group of people who can rely on one another and have confidence in each other's words.

There are two sides to every commitment and two responsible parties:

■ One side requests the commitment and asks that something be done. In the design context, this is often a director or project manager, but it could easily be any other member of the team.

■ The other side makes the promise.

The enemies of successful commitments are fear and a desire to be liked. Requesters don't ask for what they need in clear terms because they are afraid of rejection, of getting "no" for an answer. Those who hear the request often agree too quickly or without clarifying because they want to be agreeable, to be liked, or just to be left alone. Each party might walk away from an exchange thinking they understand each other, but in actuality, the agreement is based on assumptions that don't match.

How to Ask for and Make Commitments

Whenever you make a request of a colleague (or client or vendor), keep the following things in mind:

■ Make the request specific.

■ Include a time frame.

■ Explain why you need a certain thing at a certain time.

For example, rather than asking:

> Can you review the client's feedback?

and then get annoyed the next day when you inquire and find out that your fellow designer hasn't looked at the feedback yet, say:

> Will you review the client's feedback by 6 p.m. today and email me to let me know that you've done it? I need to make sure everyone is prepared for our meeting tomorrow.

If you are on the other side of the request, don't just agree automatically—and definitely don't agree until you have all the information.

If you hear a vague request such as:

> Can you review the client's feedback?

ask for a deadline and a specific action before you say "yes":

> By when, and what should I do once I have done that?

Admitting Mistakes

Sometimes we just blow it. We make a promise we are unable to keep for reasons that may or may not be outside our control. In these situations, it is essential to recognize this is the case, own up, apologize, and renegotiate the promise. This can be very, very hard for some people. Defensiveness and blame shifting do major damage to teams.

While you should not agree to *anything* unless you fully intend to carry it out, accepting responsibility and renegotiating your commitment can preserve trust. Raising your hand as soon as you know there's a problem rather than pretending you didn't actually make a promise shows that your words have meaning and that you take your promises seriously.

Practice? Practice!

Like just about every other worthwhile human endeavor, making commitments gets easier and better with practice. Every time members of your team make and fulfill promises to each other, that team gets stronger and more collaborative. If this is a real trouble area and you deal with a lot of over-promising and under-delivering, start small. Request and fulfill a lot of little promises—replying to an email within the hour or calling a client before the end of the day. Make sure that every single request for a commitment has details and a deadline attached. And remember to celebrate each success. ■

Lest they think they've been reduced to cogs in the machine, designers must recognize that a single cog can fail without impact to the machine. By contrast, the designer as contributor must recognize that project success depends on **each person doing his or her part**. One person's failure is the team's failure. To that end, designers buoy the success of the project by being effective contributors, which means having self-awareness, playing well with others, and being comfortable with saying no.

Self-Awareness

Effective contributors recognize five attributes about themselves:

- **Their roles:** Each contributor must understand his or her realm of responsibility, not just in terms of assigned tasks, but also in terms of influence and control.

- **Their value:** Each contributor must understand his unique perspective and how it enhances the team's approach to solving the design problem.

- **Their weaknesses:** Contributors must recognize which kinds of tasks fall well outside their sweet spots.

- **Their preferences:** Contributors must acknowledge their preferences in terms of how they communicate and interact with other team members.

- **Personal goals:** Good contributors identify personal goals for their projects, establishing ways to use projects to help themselves grow.

Playing Well with Others

Besides self-awareness, contributors understand that they work on teams with a diverse set of people. As implied in the Principle of Diverse Composition earlier in this chapter, designers must anticipate a range of personalities, approaches, preferences, and styles. This can work to the advantage of the individual contributor. Being on a team means cultivating an interdependence that allows people to play to their strengths and fill gaps for each other.

Contributors, therefore, must set each other's expectations and encourage each other to reveal stylistic preferences and perspectives. Here are a few questions to ask colleagues:

- Can I interrupt you to ask for feedback?

- Do you keep your calendar up-to-date?

- Do you have time carved out to work on this project?

- Are you a details person or a big-picture person?

- Which tasks come easiest to you? Which require more time?

- How quickly do you respond to email?

Getting to No

Part of effective contributing is the ability of the designer to reject requests for additional commitments. In negotiation the intent seems to be to "get to yes," but in being a contributor the goal is to "get to no." No is far more valuable than yes because it tells project organizers that

- The contributor has a plate full of other obligations.

- Priorities must be shifted to accommodate the new request.

- The project or team may be at risk when stakeholders or organizers request things beyond current capacity.

While saying "no" may be disappointing to other members of the team, it preserves the integrity of the contributor. One's ability to say "no" is strongly dependent on the three basic elements that hold teams together:

- **Humility:** The contributor isn't trying to prove anything.

- **Respect:** The contributor knows that project organizers respect his or her judgment in determining capacity to work on additional tasks.

- **Empathy:** The contributor knows that project organizers understand him or her, and recognize that forcing additional work will be counterproductive.

Evaluating Designers as Contributors

As they come to terms with their role as a contributor, designers struggle to understand how to evaluate themselves. The practicing designer needs more than a portfolio to evaluate their quality and effectiveness. Constantly searching for validation and constructive feedback, designers need a way to help them answer the question, "What can I do to be a better contributor?"

Typical Evaluation Methods

When job candidates come to interview for a position, design teams generally ask them to show a portfolio. The evaluation criteria include

- **The output:** Was the quality of the work up to the standards of the design team?

- **The outcomes:** Did the design have the intended impact on the target audience?

- **The approach:** How did the designer attack the problem, and how did she work with other people?

What's missing from this picture is the designer's ability to deal with the inevitable obstacles on design projects. Sure, her narrative on how she solved the design problem may contain subtle clues:

- Does she present clients and stakeholders using antagonistic language?

- Does she disparage subject matter experts (like marketers or engineers)?

- Does she express project challenges in terms of wins and losses?

- Does she incorporate stories of how she grew during the course of a project?

Their language, in short, may reveal a mindset that isn't conducive to effective collaboration. By asking candidates questions about their outputs, the project outcomes, and their approaches, design teams can listen for key words that betray a non-collaborative mindset.

What, No Personas?

There are no personas in this book representing "designer types." Personas are a tool used in the design process to summarize and consolidate user requirements. Though tempting, their purpose isn't to classify actual individuals. Instead, they help design teams group and prioritize the behaviors and needs of the target audience.

Because a persona is a collection of related behaviors, it is necessarily abstract. To classify someone with a persona is to deny him all the nuance that makes him a person. It means jumping to conclusions about how he reacts and how he behaves. It provides an excuse for other people not to nip situations in the bud ("that's just how he is"). Classifying a colleague with a persona is disrespectful because it undermines his or her ability to grow.

This is the primary reason this book doesn't contain any classification models. The intent of the book is to give the practicing designer a set of tools for addressing difficult situations, not difficult people.

Why Mindset

Designers must be respectful, humble, and empathetic, yes, but their ability to succeed depends on their mindset, which includes

- Their ability to handle new challenges
- Their ability to handle changes at the project and organizational levels
- Their ability to adapt to new techniques and methods
- Their ability to manage difficult clients
- Their ability to collaborate effectively with defensive or confrontational people
- Their likely influence on the chemistry of a team

Great designers relish new challenges, see struggle as an opportunity for growth, and seek out opportunities to push their own boundaries. They take pride in learning something new on a project, keeping a project on track, and

designing something in collaboration with other people. Great designers don't sweat failure, so long as it comes with a valuable lesson learned. Great designers don't mind giving credit where it's due.

TL;DR

Before fully exploring collaboration and conflict, I lay out an understanding of the design team. There are four key aspects that define a project and the team behind it: roles and responsibilities, goals and priorities, techniques and methods, and project parameters.

There are principles behind each of these aspects that generally lead to more successful projects. Project success, however, depends on three factors that form the "glue" of a team: humility, respect, and empathy.

These together yield trust, but even these aren't enough to make sure the team is successful. In addition to these principles and factors, I describe the designer as a contributor, and what sets a contributor apart from a mere cog in the machine:

- Being aware of one's own strengths, weaknesses, style, and preferences
- Acknowledging the value of diversity
- Being able to say "no" to requests

Finally, I introduce the idea of mindset, the collection of attitudes and preferences that influence how a designer approaches design challenges, difficult situations, and collaborating with the team.

▪

2

The Designer Mindset

THE FIRST BOOK I WROTE (*Communicating Design*) is about design documentation—the collection of artifacts designers produce as create interfaces for Web sites or software. At the time I conceived the book, I thought the topic pretty harmless.

Since then, however, design documentation has experienced a backlash. Different attitudes have emerged, with some Web designers believing that any kind of formal documentation is harmful to the design process. Other Web designers find themselves in circumstances where they couldn't survive without formal artifacts.

As I watched this controversy unfold, I thought that the Web design community was missing the point. The vitriol directed at the artifacts (and the people who used them) seemed misguided. (I'm not exaggerating about the backlash. Web designers can be very opinionated.) It seemed irresponsible for people to eliminate tools from their toolbox just because someone else said they were obsolete. What's more, it seemed unhealthy for designers to judge each other based solely on the tools they use. There is much more to any designer's story.

As our design firm burgeoned, my partner, Nathan, and I came to appreciate the attitudes of different designers, which were far greater predictors of success than their expertise with different tools and methods. We were far more concerned about designers' willingness to share, to engage with each other, to sketch ideas, to validate ideas informally, to build reviews into their project plans. As we sought more complex projects, we recognized that successful designers need to work together better, but they also need to adapt to shifting and unpredictable circumstances. They need to embrace experimentation and a little flying by the seat of your pants, while at the same time bringing world-class professionalism and planning to their work. These attitudes don't come naturally to everyone. I started referring to this collection of attitudes as "mindset."

Note: *For more information about Dweck's work, check out http:// blogs.hbr.org/ ideacast/2012/01/ the-right-mindset -for-success.html.* ■

At this point, Nathan pointed me to an interview with Carol Dweck, a Stanford psychologist who explored the idea of mindset. Dweck defines two types of mindsets—fixed and growth. But I'm getting ahead of myself.

Mindset has become a crucial way of understanding how designers behave as part of a project team. Besides offering my interpretation of the concept, I'll provide some ideas on how mindset can be extended for designers.

Mindset Defined

The previous chapter introduced mindset. It explained that mindset influences how people behave when confronted with different circumstances and situations. Their behaviors largely reveal their mindsets because their behaviors are informed by their mindsets.

Attitude, Disposition, and Perception

In my definition, a person's mindset encompasses three things:

■ **Perception:** How he interprets the things happening around him

■ **Attitude:** How he reacts to the things happening around him

■ **Disposition:** How he decides his course of action

In the context of work, a designer's mindset might look something like this:

Sam receives a terse email from his manager, Barbara.

■ **Perception:** Because of the phrasing, Sam thinks Barbara is disappointed with him.

■ **Attitude:** Sam feels put on the spot by Barbara's feelings (or his perception of them).

■ **Disposition:** Sam decides to write a message back defending himself. He may or may not send the message, but that is his gut reaction.

Here's another example:

Barbara assigns Sam a project to design the search results screen for a major client's Web site.

■ **Perception:** Sam thinks Barbara is challenging him.

■ **Attitude:** Sam feels like he has something to prove.

■ **Disposition:** Sam decides to put a lot of effort into the assignment and in doing so invests a lot of emotional energy.

These mechanisms tend to work consistently, exerting pressure to see every challenging situation or every confrontation in the same way. For example, Sam will see every assignment as an opportunity to prove himself. And he'll read every terse email as expressing disappointment.

Mindset may be driven by deep psychological baggage and personal history. Frankly, it doesn't matter. The mechanisms may be automatic, but they are reactions that can be felt. Because they can be felt, they can be controlled. Sam may never be able to control his immediate perception, attitude, or disposition, but he can pause before he acts. He can take a moment to reflect on the situation and evaluate whether his perception, attitude, and disposition are productive. He can actively change his mindset to change the way he sees and reacts to the situation.

Dweck's Mindset Model

Carol Dweck studied mindset because she was interested in the phenomenon she observed in some students. Despite being labeled "intelligent," these people would often avoid difficult challenges. She found that such people would beat themselves up when they got a less than all-star grade. In her book *Mindset: The New Psychology of Success*, Dweck writes:

> Students with the fixed mindset stayed interested only when they did well right away. Those who found it difficult showed a big drop in their interest and enjoyment. If it wasn't a testimony to their intelligence, they couldn't enjoy it. (23)

She wanted to understand what drove this attitude, especially since for decades parents had been praising their kids for their accomplishments. Despite the persistent fawning over their intelligence, these kids consistently demonstrated an aversion to putting in effort.

Fixed Mindset vs. Growth Mindset

Dweck distinguishes between two mindsets: fixed and growth. At the root of these mindsets is the belief about a person's ability to change. As you might imagine, someone with the fixed mindset believes that people are born one way and no matter how hard they work, they can't change who they are.

So, when faced with challenges, they weigh whether they will succeed, avoiding those tasks they will likely fail. When faced with a failure, no matter how small, they believe they themselves are a failure. She refers to an average grade, a parking ticket, or a slight brush-off from a friend as examples of minor negative events that a fixed mindset person might blow up into a major catastrophe. They avoid participating in things that will measure their ability because they worry about confirming their worst fear: They're not as smart as everyone says they are.

On the other hand, people with the growth mindset believe that hard work will make them better. In Dweck's words, they hold "the belief that your basic qualities are things you can cultivate through your efforts" (7). They see setbacks as opportunities to learn more and get better.

Why Mindset Matters to Designers

Mindset is important to designers because the right mindset can mean the difference between successful collaboration and a train wreck. A fixed mindset can be devastating for a designer. Consider the following examples:

Example 1: Novelty

Designers are confronted with new challenges all the time. Whether asked to design for a new medium, or within a new industry, or just for a different set of stakeholders, designers never face the same challenge twice. Having a fixed mindset means that a designer would feel anxious about dealing with the new challenges, and likely feel that his or her skills were inadequate.

Example 2: Complexity

Designing a product today means dealing with lots of moving parts. Even seemingly simple start-up Web site applications entail issues around user interface, branding, support, engineering, and marketing. Besides new challenges, such complexity brings with it a need to interact with lots of people. Having a fixed mindset means that a designer would want to avoid exposing these colleagues to his or her failures.

Dweck indicates that people can change or influence their mindsets. When praised for their effort rather than their outcomes, children quickly relish harder and harder challenges. By contrast, those praised for their outcomes stick with easy challenges to avoid contradicting that perception of them.

In the professional world, designers are not always surrounded by people who praise their effort rather than their outcomes. Indeed, designers are typically measured on their outcomes—their portfolios—which can make it difficult to cultivate a growth mindset. This is the important point: designers, confronted constantly by their successes and failures in their outputs, must still cultivate a growth mindset to be successful collaborators.

Designers, therefore, must take responsibility for cultivating this mindset in themselves. Fortunately, they are well on their way to embracing a growth mindset given the need to respond constructively to feedback and critique.

But taking criticism is only a part of the successful designer's mindset.

The Best Mindset for Designers

Dweck's model is useful for designers. It's the kind of model where, once you understand it, you see the whole world through its lens. Colleagues become labeled "fixed" or "growth," and praise becomes self-consciously about effort rather than outcome.

Dweck shows how the model applies to a range of types, from business leaders to professional athletes. She provides practical advice to parents, teachers, coaches, and others who are in a position to give feedback. Though she explores the fixed/growth dichotomy in depth, and offers detailed advice for a broad range of people, she doesn't focus specifically on creative work.

The growth mindset is a solid foundation for designers, but they must cultivate other ways of seeing and reacting to their world to be successful collaborators and contributors. Unfortunately, this mindset may yield uncomfortable (but not unhealthy) behaviors. That is, by forcing themselves to regard circumstances differently, designers may try behaviors that feel "against the grain." Introverts may need to pick up the phone to call someone. Extraverts may need to sit quietly and let other people do the talking. Detail people may need to participate in big-picture conversations, and big-picture people may need to force themselves to sit and absorb the details.

While Dweck's view of human psychology resonated with my experience, and this need to alter behaviors for the good of the project seemed right, it remained incomplete. There are other aspects of a designer's attitude that are crucial for success on a team.

These mindsets make two assumptions about design projects:

- **They are hard.** Design projects are not just difficult to solve, but they also entail lots of moving parts. The complexity alone implies that assignments are always novel and have lots of detail.

- **They require a team.** The complexity of design projects demands a team, but it isn't just the complexity of the assignment. The environments in which we design impose demands that are better addressed with a team of people.

These assumptions aren't especially confining. Most people working on design projects today would agree with them. These assumptions have a direct impact on how designers can be successful contributors, which brings me to three design-specific mindsets:

■ Adaptive versus Rigid

■ Collective versus Solitary

■ Assertive versus Passive

Adaptive (Not Rigid)

Dweck distinguishes between fixed and growth mindsets, and perhaps the adaptive/rigid mindset is a simple extension of her original model. For designers, the salient point is:

> Adaptive-mindset designers acknowledge the need to modify their approaches to accommodate novel and unique circumstances.

With an adaptive mindset, designers release the need to follow their processes strictly or remain adhered to their favorite tools and techniques. An adaptive mindset might look like this:

> Barbara asks Sam to conduct informal user research before diving into design, though Sam is used to conducting user research with a partner and a formal plan.

■ **Perception:** Sam sees an opportunity to test some of his assumptions about formal user research.

■ **Attitude:** Sam understands that he can accomplish many of the same goals with informal user research as he does with formal research.

■ **Disposition:** Sam decides to craft two plans—one showing how he would do this research formally and one showing an informal approach—allowing him to compare and contrast.

One crucial point is that adaptation begins and ends with process, not principles. In approaching a design project, designers employ a set of principles to structure the process. The exact principles for effective design processes are a topic for another book. The point here is that Sam's principles offer him some flexibility in how he structures his process. Sam can still adapt even within the framework of these principles.

Table 2.1 compares the designer's adaptive mindset to the rigid.

Table 2.1 The Adaptive Mindset in Practice

	Adaptive	Rigid
Perception	Sees different ways to apply common design principles across different challenges and situations	Sees design process as immobile.
Attitude	Interested in testing assumptions and the strength of principles.	Feels defensive about process.
Disposition	Decides to pursue new approaches.	Insists on avoiding novel circumstances or applying the process in the same old way.

Having an adaptive mindset doesn't mean changing direction whenever the wind blows. It doesn't mean simply going with the flow. The challenge with being adaptive is understanding that adaptive doesn't imply change for change's sake. Instead, good designers recognize when their abilities and capacities do not align with circumstances, and when circumstances present opportunities to introduce meaningful changes in approach.

Collective (Not Solitary)

The collective mindset is

> The belief that contrasting opinions, alternative perspectives, and additional feedback make for stronger design work.

There is substantial literature these days promoting the lone designer, what I might call "ivory tower design." The design world is experiencing yet another backlash, this one against "brainstorming." They insist that some of the world's greatest ideas were the product of solitary thinking. As Dweck puts it:

> There are many myths about ability and achievement, especially about the lone, brilliant person suddenly producing amazing things. (56)

Dweck goes on to relate how Charles Darwin's *The Origin of Species* took decades of effort, research, and teamwork. To be clear, the collective mindset here isn't that people look at every situation, challenge, and project activity as an opportunity to gather a group of people for discussion. Instead, designers with this mindset recognize that their colleagues are enthusiastic resources: they can provide quick feedback, offer ideas, validate assumptions, clarify challenges, and suggest new perspectives.

For example, when I'm working on a design concept, I frequently ask members of my team or my colleagues for feedback by showing them sketches throughout the day. "Sharing sketches" may not be a novel idea, but consider the contrast: the designer who doesn't want to show anything until the idea is fully baked. In complex, team-driven environments, this approach is fraught with risk.

A collective mindset might look like this:

> New designer on the team, Prithi, is sitting in front of a blank canvas in her design software. As she reviews the assignment Sam gave her, she realizes that there remain a few unknowns about the assignment.

- **Perception:** Prithi sees these unknowns as a need to clarify a few things.

- **Attitude:** Prithi understands that the best way to prove herself to her new colleagues is to be engaged and collaborative.

- **Disposition:** Prithi decides to sketch a few ideas on paper quickly to share with Sam to validate direction.

Of the fixed mindset, Dweck says that people with this outlook see other people as "judges instead of allies" (67). This is the crux of the collective mindset: the people on the team are collaborators and supporters, not competitors and judges.

Designers, therefore, must approach design with the idea that two heads are better than one. The collective mindset isn't prescriptive about how people work together. Instead, it implies that when faced with a choice, someone is inclined to engage another person for input. This is the crucial point, and the distinction that naysayers don't understand. Having a collective mindset means relying on trusted colleagues to provide useful feedback and alternative perspectives.

Table 2.2 compares the collective and solitary mindsets.

Table 2.2 The Collective Mindset in Practice

	Collective	Solitary
Perception	Sees how input from others will help her progress.	Sees other people as competitors or invaders.
Attitude	Feels more confident when teammates have provided input or feedback.	Feels defensive about feedback before the work is "done."
Disposition	Decides to engage teammates in constructive ways.	Avoids contacting teammates unless dictated by the process.

With a collective mindset, designers may err on the side of too much collective thinking. Group brainstorming can be a useful tool, but taking it to the extreme yields consensus-building and the dreaded "design by committee." Designers with the collective mindset don't rely on others to save them from their insecurities (like making a tough decision) but instead identify meaningful opportunities to bring in other brains.

Assertive (Not Passive)

Finally, designers need to see themselves as empowered to make clear statements to the team about their opinions, their needs, and their ideas. The assertive mindset is

> The belief that confidently expressing opinions, clarifying expectations, and closing gaps in understanding is essential for successful design work.

In other words, designers should be able to assert an opinion about a design decision, a need relative to their work or the project, a point in need of clarification or elaboration, and an idea for a solution.

The truth is that people are just as likely to keep their thoughts and opinions to themselves as they are to express them. Even more likely, they will remain quietly uninformed about an essential input or requirement, rather than admit their ignorance. Ultimately, more information is better.

An example of an assertive mindset might be:

> Prithi, the new designer, realizes she has some gaps in her understanding of the assignment from Sam.

- **Perception:** Prithi sees this as an opportunity to assert and validate her opinions on the assignment's assumptions.

- **Attitude:** Prithi believes that quickly clarifying her assumptions now could save hours of rework later.

- **Disposition:** Prithi decides to make a list of her assumptions to email Sam to get validation.

There are countless opportunities for designers to assert themselves on a project. Experience shows that even though they may have strong opinions about design, or even process, there are ways in which designers can be better contributors to a project. They can assert their

- Additional availability to provide help to other team members

- Need to reduce their workload if overbooked

- Need for specific kinds of feedback

- Anxiety about using certain techniques

- Confusion about a particular process or approach

- Need for help dealing with a difficult situation

Having an assertive mindset means feeling comfortable admitting anxiety, ignorance, and shortcomings, and seeking help for addressing those issues.

Table 2.3 compares the assertive and passive mindsets.

Table 2.3 The Assertive Mindset in Practice

	Assertive	Passive
Perception	Sees it as his role to express opinions and seek clarification.	Sees differences in understanding as not his problem or unimportant.
Attitude	Feels that gaps in understanding or expectations must be closed quickly.	Assumes that lingering questions or issues will be addressed later.
Disposition	Decides to asset opinions or ask open questions in a way appropriate to context.	Avoids raising issues.

The challenge for the design team member is knowing when to keep one's mouth shut. Situations and circumstances exist where voicing an opinion at the wrong time can undermine a project direction, usurp authority from the project leads, or distract the team. The assertive mindset means that designers feel empowered to speak up when appropriate. Recall the tone of the other mindsets:

- **Adaptive:** Inclined to see opportunities to explore new approaches and adopt new techniques (but not acquiescing to every demand)

- **Collective:** Inclined to see opportunities to invite other perspectives (but not make everything about a group of people brainstorming)

And finally:

- **Assertive:** Inclined to see opportunities to express an opinion and perspective on the matter at hand

One parting thought on mindset in the workplace: Carol Dweck refers to millenials entering the workforce as "the praised generation." These are people whose parents lavished them with outcome-based praise to boost their self-esteem. Writes Dweck:

> We now have a workforce full of people who need constant reassurance and can't take criticism. Not a recipe for success in business, where taking on challenges, showing persistence, and admitting and correcting mistakes are essential. (137)

Reading this, I was struck by how true this is—especially in design. While I believe designers are better equipped than most to deal with criticism, design work is fraught with challenges. The impetus for this book is that many of these challenges stem from the conflict and collaboration that drive the design process.

Changing One's Mindset

Not everyone is wired to be adaptive, collective, and assertive. I can safely say that I am a person who tends toward solitude and passivity, for example. For many people, at least one of these mindsets feels "against the grain" of their personalities. Circling back to Dweck's model and conception of mindset, recall the growth mindset—the belief that people can change the way they perceive and deal with the world around them. Dweck has shown that the growth mindset can be taught. In teaching growth mindset attitudes and behaviors, Dweck's team helped low achievers turn their outcomes around. Of one, she writes

> He now believed that working hard was not something that made you vulnerable, but something that made you smarter. (59)

Designer prima donnas think they don't need to change their mindsets. They think that everyone is entitled to his or her own attitude, that a change would affect their processes or creativity.

Yes, great teams deal with the foibles and shortcomings of their members. But adopting the right mindset isn't just a matter of dealing with one's own shortcomings. It's about being an effective contributor, and doing what's right for the project.

THE NEW JOB REQUIREMENTS

Jonathan "Yoni" Knoll — @yoni
Principal, Designer+Architect, InfinityPlusOne

Having talent is awesome, but it doesn't mean you are good. It just means you are talented. I have always felt that before being good, you must first understand the problem space in which you are working, you must be able to properly communicate your ideas across relevant media, and, finally, you must always deliver on expectations.

As you get better, you learn to ask more questions early, you establish reasonable expectations for yourself (often by saying "no" to unreasonable demands), and you exceed those expectations through clear communication and by improving your abilities. You must always deliver on agreed-upon expectations, whether those expectations are reasonable or not. If people are unable to make decisions based on expectations of your work (or your word), you are, quite simply, not good. Talented, maybe, but definitely not good.

I wrote this "job requirements" piece after a particularly harrowing experience with a talented designer I was expected to manage. It's a little harsh, but at least it doesn't leave much room for interpretation.

Skills Required

1. **Ability to write.** You must be able to piece together more than two sentences at a time. Specifically, you must understand how to communicate without bullet points.

2. **Ability to ask questions.** If you don't understand something—whether it is the material at hand or simply what is expected of you—ASK!

3. **Ability to say "no."** We're all human, and we all make unreasonable demands. Sometimes, you'll be asked to deliver more than is reasonable. Let us know.

4. **Ability to set expectations and meet them.** If you say you can get something done, we'll believe you, until you don't. Then we won't worry about it again.

 And as a corollary to both #3 and #4:

5. **Willingness to work yourself to death when you were either too stupid to say "no" or you set unreasonable expectations for yourself.** Your problems are not our problems, and they shouldn't become our problems. If it gets to this point, not only will we not care, but, short of a hospitalized injury or an immediate family member's death, we won't even sympathize. ■

Note: *As you read the book, make note of behaviors that make you uncomfortable or challenge your assumptions. Pick one or two of these to try next time you face a difficult situation.* ▪

Sometimes this means adopting behaviors that seem to run counter to one's personality. Throughout this book, I'll be talking about a variety of behaviors that may feel unnatural or uncomfortable. Some of these behaviors are ones I'm still trying to incorporate into my own interactions with project teams. Using them and forcing myself to confront my own insecurities, however, is the most effective way to change mindsets.

TL;DR

Mindset is at once a person's perception, attitude, and disposition toward circumstances:

- **Perception:** How one interprets circumstances
- **Attitude:** How one reacts to one's perception of the circumstances
- **Disposition:** How one intends to behave based on one's attitude

The disposition may not come to pass. People can effect change in their mindsets and look at situations differently, modifying their gut reactions.

My notion of mindset is drawn from the work of Carol Dweck, who defined two mindsets:

- **Fixed:** The belief that people are born a certain way, and no amount of effort can change them
- **Growth:** The belief that hard work can change someone's capabilities and skills

These mindsets are useful for thinking about designers, but I've added some depth:

- **Adaptive:** The belief that people do not have to compromise their principles to adapt to new situations
- **Collective:** The belief that perspectives and contributions from other people improve design work
- **Assertive:** The belief that people should confidently state their opinions or close gaps in their understanding

3

Listening:
The Essential Skill

LISTENING IS NOT PASSIVE. Every good book on listening says the same thing. Listening is actively engaging people in conversation: internalizing what they say, acknowledging it, encouraging them to elaborate, making them feel confident so they do elaborate.

Design, however, is run by an agenda, an objective with a plan for attaining it. The "innovationists" will say that good ideas come from letting people explore. I say good ideas come from following a plan—establishing a framework for people to collaborate effectively and contributing ideas that support the goals. Nothing is more inspiring to me than hearing (and seeing) other people's ideas. But those ideas must be relevant and appropriate to the assignment at hand. Listening isn't just letting someone sermonize on and on about one thing or another: it's about corralling ideas and details and requirements into a cohesive picture.

(Yes, the innovationists are a made-up group of people. And, yes, I just copped to using a straw man argument.)

By the way, this chapter focuses exclusively on listening. It would be easy to extrapolate advice for speakers, but that's not the purpose. There are dozens of books on public speaking and facilitation and leading, but not as many on just listening.

There are things designers can do to become better listeners, habits to cultivate and behaviors to incorporate. This chapter describes good listening manners and classifies them into four types of behaviors:

- **Prepare:** Get everything ready to hear what other people have to say.
- **Pause:** Provide space to let people say what they need to say.
- **Probe:** Encourage people to elaborate.
- **Paraphrase:** Summarize and repeat to validate what was said.

But there are bad habits, too—behaviors that shut down conversations and make it difficult to hear what others are saying.

The Good Listener's Checklist

Think how easy it is to stop listening. The speaker drones on about mostly irrelevant project details. There will always be a next meeting where the details will be there again. The Internet with its cat videos and social networks and *The Onion* is RIGHT THERE. The distractions are bound to overpower the speaker. No contest.

Yes, sometimes it just requires putting down the mouse, closing your eyes, and following along in the conversation. But even as distractions are eliminated, there's a right way to listen and a wrong way.

The checklist (**Figure 3.1**) covers behaviors to use before a conversation starts, while someone is speaking, while someone is wrapping up a thought, and immediately following a thought. Listening encompasses the techniques used to acquire and understand what someone is saying.

Figure 3.1.
Becoming a good listener.

The Listening Behaviors Checklist

PREPARE
- ☐ Establish a capture tool.
- ☐ Eliminate distractions.
- ☐ Think ahead to your next question.
- ☐ Establish a framework for discussion.
- ☐ Ask for visuals.

PAUSE
- ☐ Ask for the whole story.
- ☐ Visually demonstrate that you heard.
- ☐ Let the speaker finish thoughts.

PROBE
- ☐ Ask clarifying questions without judgment.
- ☐ Use cues to encourage elaboration.
- ☐ Redirect when speaker gets off topic.

PARAPHRASE
- ☐ Repeat what you heard.
- ☐ Validate your interpretations.

Listening is a set of behaviors and habits for meetings formal and informal; for conversations in-person, electronic, or remote; for conversations happening in real time or asynchronously via email. It won't always be possible to listen in the ways implied by this checklist, but every designer must strive to build these habits so they become automatic, regardless of the situation.

Prepare

Good listeners come to conversations prepared. Whether they're responsible for leading the conversation or not, they already have a set of questions they want to ask. They've done the background research. "Prepare," however, happens throughout the conversation. With each statement or idea from the speaker, the listener revises his or her list of questions and prepares the next.

Preparation involves doing the research, having sufficient background and context to understand what's being said and to ask meaningful questions. But there are other things designers can do to prepare for a conversation:

■ Eliminate distractions.

■ Establish a capture tool.

■ Establish a framework for discussion.

■ Ask for visuals.

■ Think ahead to the next question.

Establish a Capture Tool

Create a structured way to capture the things you hear. The structure can be loose, but keep the end in mind. A text file generally works fine if the intent is to distribute (machine-) scannable notes to the team and beyond. Insert topic headings into the text file to establish some structure for the conversation.

Note-taking serves multiple purposes:

■ It creates a record of the conversation to ensure that everyone agrees on what's said.

■ It shows the speaker that you were listening.

■ It helps the note-taker recall the content of the meeting, even without the notes in front of him or her.

- It provides a way for listeners to capture spontaneous questions.
- It provides a way for speakers to respond to the things they said or react to the way something was captured.

Eliminate Distractions

Distractions abound. They are the scourge of the modern workplace. Here are just a few of the things that threaten my attention when I'm in an in-person meeting or participating in a conference call:

- Email notifications
- Instant messenger notifications
- Reminders embedded in my calendar
- Phone calls
- Multitasking other project work while listening in on a call
- Sudden thoughts that prompt some unplanned research
- Smartphone buzzing with anything happening on any social network anywhere

For meetings that take place as conference calls in front of the computer, such as webinars, keep open only the conferencing software, the inputs to the conversation, and your capture tool.

Think Ahead to Your Next Question

It can be hard to focus on capturing information while thinking ahead to the next question. It's like forcing one's brain to be in both the present and the future. If you are targeting a question derived from a past statement, your brain is in the past, present, and future.

One way to do this successfully is to capture several key words or phrases as the speaker is talking. Prioritize one of those concepts and ask him to elaborate:

> "You said, 'The call center struggles with the current process.' Can you tell me more about the current process?"

Keep an ear out for words that imply comparison (like "current") or conflict (like "struggles"), as these can be hooks for follow-on questions.

Establish a Framework for Discussion

Determine the list of topics to cover in the conversation. Meeting agendas can vary from highly structured affairs to a handful of keywords. Either way, such a structure can keep the meeting focused and give the listener an easy way to ask the next question.

Listeners may not feel responsible for establishing the structure, but in reality they are the ones who are seeking the information. Defining a list of topics to cover, and an order in which to cover them, helps listeners anticipate the scope and depth of the conversation. It gives them a chance to generate probing questions.

At the beginning of the conversation, I provide participants with an overview of the expected topics and allow them to add more topics. This way the "owners" of the information can make sure the range of topics adequately covers the purpose of the meeting. That said, listeners shouldn't adhere to their framework if it isn't working or if the speakers just run with their stories.

At the end of every conversation, I ask the question, "Is there anything we should have talked about but didn't?" This way, I give the speaker an opportunity to insert any topics we may have missed.

Assembling this list of topics will keep the conversation on track, but also provide some context for the conversation. As people speak to each of the topics, they can do so within the context of the larger conversation.

Ask for Visuals

If you are invited to a discussion, ask the speaker to bring things to look at. In a design context, this is hopefully not too much of a challenge. Even if they're not looking at design concepts, team members can look at research reports, project plans, or competitive or comparative products. Visuals engage listeners with two senses—sound and sight—and preempt distractions.

Pause

Good listeners pause, avoiding interruptions and subtly encouraging the speaker to continue. By pausing, listeners give speakers room to assemble their thoughts and give themselves time to prepare their next question. Pauses aren't so much the absence of action as they are the encouragement of elaboration by avoiding behaviors that might shut down a thought. Listeners that jump too quickly to the next topic risk losing the essential parts of the speaker's ideas.

Listeners can pause using these behaviors:

- Ask for the whole story.

- Visually demonstrate that you heard.

- Let the speaker finish thoughts.

Ask for the Whole Story

Good listeners encourage speakers to provide the entire story—the beginning, middle, and end—of an idea. Reassure them that there will be no interruptions so they can lay out the entire concept, be that a design idea, a project plan, the results from research, the outcome of analysis, or whatever.

There are multiple opportunities to press for a full story. Listeners can use phrases like these throughout the conversation:

- "Take me back to the beginning…"

- "Let's take it back even further. Where does this all start?"

- "And then what happens?"

- "Can you connect the dots for me? How does what you just said relate to the earlier part?"

- "How does it end?"

- "Let's start with the conclusion, or big idea, and then you can walk me through how we get there."

By asking speakers to structure their thoughts in terms of a story, listeners get the ideas in the context of a narrative. Such a structure makes ideas easier to follow and allows the listener to go back to different points in the story to ask

for elaboration. The conversation, in a sense, iterates over the structure to flesh out the details. This approach would be difficult without first knowing how the story ends.

Visually Demonstrate That You Heard

Good listeners expose the capture tool for all conversation participants to see. Pausing is more than just leaving gaps of space for the speaker to fill. It is positive encouragement for continuing. The exposed notes visually demonstrate that the speaker is being heard, building the speaker's confidence and potentially highlighting opportunities for him to correct any misconceptions, to reprioritize, or to elaborate.

Let the Speaker Finish Thoughts

If the speaker is in the middle of a statement, allow him to finish before asking the next question. Even subtle interruptions can have a negative impact on the speaker's approach and demeanor.

With interruption comes implied hegemony. When people interrupt each other, it's generally not just about enthusiasm. It's about enforcing dominance or hierarchy.

Some situations, however, require the listener to come to the speaker's aid. The speaker might lose his train of thought, or find himself painted into a conceptual corner. As his speech becomes hesitant or stumbling, the listener can gently course-correct with

- "You were talking about…"
- "Can you go back to …?"
- "I think I get the idea, but is there anything else you want to say about…?"

Probe

While pausing can yield complete ideas, speakers may be unwilling or unable to provide a complete story. They may focus on the wrong things. Probing behaviors get people to elaborate and focus.

Probing behaviors can be challenging. They often conflict with pausing behaviors, because they require listeners to be assertive in getting the speaker to talk. They fill spaces when speakers have trouble elaborating. Good listeners

understand that they have to strike a balance in these behaviors, getting the full story without alienating the speaker. Probing behaviors include

- Asking clarifying questions without judgment
- Using cues to encourage elaboration
- Redirecting when the speaker gets off topic

Ask Clarifying Questions Without Judgment

There will be time enough to critique, to judge, and to invalidate. In listening mode, team members should be positioned to help their colleagues elaborate and clarify without dismissing. Clarifying questions start with phrases such as

- "Tell me more about…"
- "Can you explain…"
- "Help me understand what you meant by…"

Use Cues to Encourage Elaboration

Besides the visual cues of nodding in agreement or taking notes so that everyone in the meeting can see, listeners can use audible cues, too. Over the phone, people could "Uh-huh" or "OK" or "Mmm," and that would be enough to signal "I'm listening, keep going."

Audible cues can be challenging on anything but phone or in-person conversations. Many meetings today take place with Voice over Internet Protocol (VoIP)—through software like Skype, WebEx, or GotoMeeting—which has enough of a lag that it makes short verbal cues inaudible at best and disruptive and confusing at worst. ("Were you trying to say something?") Most experienced people drop those from conversation when using these technologies.

Instead, during longer pauses, I'll say things like

- "You're doing great."
- "Keep going. I like where you're going."
- "Are you ready to move on to the next topic?"

Redirect When the Speaker Gets Off Topic

Even the best speakers find themselves down rabbit holes and off on tangents. Good listeners take the speaker back on track by referencing an earlier, relevant point through a clarifying question.

Paraphrase

Good listeners confirm that what they heard is correct. Paraphrasing helps ensure that the listener understood the speaker, and that the speaker said what he or she meant to say. Part of listening is demonstrating that what was said was heard. Of course, part of listening is not interrupting.

In paraphrasing, good listeners rely on these behaviors at reasonable moments in the conversation:

■ Before transitioning to a new topic

■ After a particularly complex idea has been shared

■ After an important idea has been shared (important because it addresses a meeting objective, or will have a major impact on the project)

Paraphrasing behaviors include

■ Repeating what you heard

■ Validating your interpretations

Repeat What You Heard

Reflecting statements approximately word for word allows listeners to confirm that they heard correctly. And it builds the speaker's confidence.

Use phrases like these to reflect back the statements made by the speaker:

■ "Let me make sure I understood you correctly. You said…"

■ "Did I get this right? You said…"

■ "Can you say that last part again?"

Validate Your Interpretations

Many listening guides encourage listeners to avoid conflating hearing the statements with analyzing and validating them. While I think there's value to this distinction, this is advice for people involved in a negative or dramatic conflict. This generally is not the case for a design conversation.

In the context of design conversations, listeners must hear the messages and immediately understand and internalize the implications. They need to apply this information to their work. So, even when the meaning seems obvious, it's helpful to ask speakers to confirm that their statements have been interpreted correctly, using phrases like

- "OK, you said… I take that to mean…"

- "Here's my interpretation of what you said…"

- "If I understood you correctly, we should…"

- "Right, so based on what you said, the impact to [the project, the design, the team] is…"

When to Break the Rules

OK, so even the best listeners occasionally break these rules. Speakers don't always say the most helpful, valuable, or relevant things. Whether they come to a conversation unprepared, talk about things over which they have no authority, or dominate with their own irrelevant agendas, some speakers aren't worth listening to.

When I'm invited to a meeting, I always ask myself, "Is this a listening exercise or a facilitating exercise?" The distinction is perhaps utterly semantic or philosophical. With listening, I know that the speaker knows the information I need and that I need to provide gentle nudges. With facilitating, I know I'll need to play a more active role in engaging participants. Breaking the rules of listening means transitioning the mindset from gentle nudges to active engagement.

FOR BETTER LISTENING, SPEAK THE SAME LANGUAGE

David Belman
Threespot

If you're reading this book, we likely share a language. I don't know what it's called. Maybe "Design Language?" Even though I don't know its name, I do know the vocabulary: UX, wireframes, taxonomies, modules, templates, experience design, brand, IA, responsive, adaptive.

It's a language we worked hard to learn, and that hard-earned mastery is an achievement that makes us proud and creates a sense of self and identity. It's not a degree or a badge, but it absolutely reflects a level of commitment, experience, and knowledge. And like a credential, it places you in a community that you value and that values you. With your agency, in your shop, and on your teams, it provides a shorthand and efficiency. It's a bridge and a secret handshake—the key to working together.

And that language we share, that vocabulary we've collaboratively built over the past decade, those terms that are the tools of our trade, producers of our identities, and the key to cocreation—they are the enemy of the most important collaboration: collaborating with our clients.

For the first five or six years of our agency's life, we would start projects with a kickoff meeting. The meeting was truly the starting line. Sure, we did some research and substantive work in the proposal and pre-project conversations. But the kickoff meeting was where we really brought in the team and started investing hours.

And while the meetings worked well enough—people met face to face, we talked about goals, we touched on audiences—they weren't great. We brought our words to the meeting. They brought theirs. And sometimes we managed to bridge the abyss.

Then we moved the starting line back; we started working on the project before ever meeting the client. Not days early. But weeks early. Months early. We read their books. We downloaded their white papers and streamed their speeches. We learned their

business. But more importantly, we learned their vocabulary. And something interesting happened. We walked into the "kickoff meetings" with their words. And instead of mostly listening, they were mostly talking. Heads started nodding earlier in the meetings. Ideas and information started flowing. And more work started happening—sooner and better.

Learning your client's language does many things:

- It shows respect. You respect their work and their world, and it shows that you've made the effort. Respect is a critical component to any collaboration. Bank some up front. You'll need it as the project progresses.

- It begins to build trust. It's all too easy for clients to immediately discount, distrust, and dislike the consultant who walks into the room armed with alien processes and language. But walk into the room knowledgeable about their work and comfortable with their language, and you'll start to see the trust build. You are of their world, not a foreign intruder.

- It allows you to understand not just their communications problems and their design challenges, but also to engage with their business challenges. And that's when you'll begin to deliver true value.

- It provides our clients with an environment to gently begin to learn our terms, and for the team to being building a shared vocabulary.

Respect. Trust. Engagement. Learning. They're cornerstones of collaboration. And you can begin to cement those cornerstones immediately in your relationships and your work by building a common language with your client—a language that borrows terms from the agency and the client, and that allows you to truly partner in designing solutions to critical problems. ■

Obstacles to Listening

Despite the value of listening, people find it hard. I find it hard. Even the best listeners have some bad habits. These bad habits generally erect obstacles that prevent speakers from fully elaborating their thoughts, from clarifying their meaning, or from contributing meaningfully. Obstacles to listening include:

■ **Short circuits:** Behaviors that prevent speakers from elaborating

■ **Closed doors:** Behaviors that discourage speakers from contributing

■ **Embattled egos:** Behaviors that redirect attention to the listener

Short Circuits

With short-circuiting behaviors, listeners (or the people who are supposed to be listening) prevent speakers from getting to their conclusions. When exhibiting these behaviors, the so-called listeners make assumptions about things said.

Listeners can try to eliminate short-circuiting in their behaviors by

■ Highlighting potentially loaded phrases: "I think I know what you mean by 'user requirements,' but let's make sure we're on the same page." This prevents the listener from assuming that he or she shares the same definition with the speaker.

■ Repeating the high points of a conversation at the end of the meeting and translating them into an "action item." This gives the speakers an opportunity to elaborate.

■ Asking, "Is there anything I didn't ask about that you think I should have?" This gives the speaker an opportunity to flesh out incomplete ideas or identify topics that were missing altogether.

Jumping to Conclusions

Instead of asking speakers to clarify ambiguous ideas, listeners may gloss over them, assuming erroneously that they understand the concept or implications. They make assumptions about the speaker's intent or underlying meaning. Most often this happens without listeners realizing it. They assume they understand the conclusions and implications, but they really don't.

Interpreting Without Validating

Another short circuit is to interpret a statement without validating the interpretation with the speaker. By "interpret," I mean rendering the idea in a way that's more meaningful to the listener's context.

For example, imagine a Web designer describing a screen layout for a complex application. One thing she says is

> "We ordered the form fields from most important to least important. If users don't want to fill everything out, they can just focus on the stuff at the top."

The project manager, to interpret the statement, says,

> "Since the fields are laid out in priority order, we would need to confirm the priority of these input fields. Did I get that right?"

Giving the designer an opportunity to understand the implication of her statement, the project manager puts it into a context meaningful to her own next steps.

Closed Doors

Closed-door behaviors discourage speakers from elaborating. Listeners, through what they say or through body language, imply that they're not interested in what the speaker has to say.

Listeners can circumvent closed-door behaviors by using the "prepare" behaviors described earlier in this chapter. They can also

■ Set the stage at the beginning of the conversation by reminding the speaker of the topics of interest.

■ Be aware of interruptions and catch those the moment they happen: "You know what, I interrupted you. Start from the beginning and let's make sure I get the whole story before I jump in."

Note: *Unspoken behaviors can trump what listeners say, such that words of encouragement— "Tell me more"—are overshadowed by glances at cell phones.* ■

Forcing the Speaker into a Defensive Position

One way to close the door on someone is to make him defensive. This turns a good discussion, rigorously validating an idea, into a crucifixion. That is, good ideas should be examined, validated, and defended, but speakers should never be put on the defensive. Defensiveness shuts down a conversation by making the speaker retreat, focusing on the personal aspects and not the important topics.

Preventing Complete Thoughts

Listeners with the best intentions may prevent speakers from completing their thoughts. They might

- Ask several questions at the same time, not giving the speaker a chance to address each one individually.

- Prioritize the clock over the content, moving to the next topic before the speaker is done

Embattled Egos

When being competitive, listeners aren't really listening at all. They are trying to find a way to direct attention to themselves or avoid invalidating their own ideas. Listeners competing with the speaker prioritize their work, their egos, or their "territory" over the value of collaboration.

Listeners can try to stave off competitiveness by

- **Being honest about their agendas and objectives.** Writing out their objectives in advance of the discussion can make them aware of their biases.

- **Saving time for the listeners to be speakers.** Knowing that they will have a chance to get their issues off their chests later in the conversation, listeners can focus just on listening.

Injecting One's Own Agenda

Turning good listening behaviors into tools of evil (I may be overstating this), some listeners direct speakers to topics or ideas that support their own objectives. Such "leading the witness" can appear like good listening (**Table 3.1**), but it really undermines conversations and collaboration by preventing other people from contributing ideas or perspectives.

Table 3.1 Examples of Good Behaviors Gone Bad

Behavior	Good Version	Bad Version
Establish a framework for discussion. (Prepare)	Agenda includes a range of topics appropriate to the project. You've solicited all participants for other agenda items.	Agenda doesn't set expectations for the range of topics to be covered. Other people aren't consulted.
Let the speaker finish thoughts. (Pause)	Using gentle reminders to encourage speakers to flesh out their ideas.	Letting opaque ideas hang without further clarification.
Redirect when the speaker gets off topic. (Probe)	Asking speaker to return to core topic to explore further.	Using being off topic as an excuse to move on.
Validate your interpretations. (Paraphrase)	Offering an interpretation and then inviting the speaker to correct misapprehensions.	Offering an interpretation, then changing the subject.

Closing One's Mind to New Ideas

No less evil than directing the conversation for their own nefarious purposes, some listeners aren't really listening at all. They dutifully "hear" new ideas and perspectives, but have decided before going into the meeting that they aren't interested. (This is kind of like walking into a movie already deciding to hate it. The actual quality of the movie aside, you will hate that movie.)

Closed-mindedness can come from different places:

- **Competition:** Fresh perspectives and ideas can crush egos, making people feel inadequate or incompetent. They brood over why they didn't think of these things themselves.

- **Fear:** Some people are afraid of considering new ideas, mostly because it forces them to defend the status quo. In the case of a design project, the status quo means existing design decisions. People may be afraid of having to revisit design decisions with which they've grown comfortable.

- **Laziness:** Knowing that new perspectives or new ideas mean more work will lead people to shoot down every one that comes their way. That work could entail action items outside the meeting, or even just spending more time to reconcile the new ideas with the existing ones.

TL;DR

The Good Listener's Checklist at the beginning of this chapter says it all. There are 13 behaviors for effective listening. These behaviors are divided into four categories. I've conveniently labeled them with words starting with the letter P (the mnemonic ends there):

- **Prepare:** Walk into meetings prepared with topics, questions, and a means for capturing answers.

- **Pause:** Take a moment to let the speaker finish her thoughts.

- **Probe:** Encourage the speaker to elaborate on her ideas through direct questions.

- **Paraphrase:** Restate key ideas and confirm that you hear them correctly.

There are also some common obstacles to listening. These obstacles are behaviors, intended or unintended, that prevent you, the listener, from getting the complete story. There are only three categories of obstacles, with no mnemonic:

- **Short circuits:** Making assumptions about the speaker's conclusions or implications, without taking the time to validate your understanding.

- **Closed doors:** Preventing the speaker from elaborating on ideas.

- **Embattled egos:** Not hearing what's said because you feel competitive toward the speaker (or defensive about your own ideas).

4

The Role of Conflict in Design

THIS IS MY definition of conflict:

> Conflict is the way design teams come to a shared understanding of each decision made in the design process.

Over the course of this chapter, I'll unpack this statement in more detail, focusing specifically on the phrases "shared understanding" and "decision made."

Conflict is the engine of design. When designers come up with the initial idea, turning it over and over to make sure it solves the design problem, it is conflict that spurs that process. When designers take that idea and draw it out—fleshing out details, establishing a design's basic concept—and then take it all the way through to a specification, it is conflict that drives that growth.

These are tough conversations, but they make all the difference in the final product.

I've sweated through countless design reviews—and the best ones are also the most challenging ones. Presenting design concepts to a room full of stakeholders and getting blank stares or empty nods is the bane of my professional existence. On the contrary, put me in a room where colleagues call me out on every design decision, demand a rationale for every typographic or layout choice, and throw out lots of new ideas. These are tough conversations, but they make all the difference in the final product.

Conflict is the process through which ideas are validated and elaborated. Through conflict, ideas grow from a spark to a concept to a full-fledged design because

- **Conflict validates ideas:** Designers working together seek to understand an idea fully, so they confront each other, forcing themselves to justify every decision. They challenge each other to ground their ideas.

- **Conflict elaborates ideas:** By talking over an idea and disagreeing with it, designers force each other to fill in missing details.

When ideas are tested and expanded to the satisfaction of all involved, this is when conflict works right. Design teams, however, sometimes find themselves in conflict that doesn't move a project forward. Before explaining where conflict goes wrong, I'll describe the important role conflict plays in design.

The Value of Conflict

To demonstrate the value of conflict clearly, I'm going to oversimplify the design process. Design is, in this oversimplification, merely a series of decisions (**Figure 4.1**).

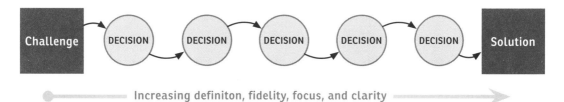

Figure 4.1. Oversimplifying the design process, design is really just a series of decisions.

Decisions may be broad, such as decisions about scope:

"We're going to focus on how users navigate product categories."

Or, decisions can be small, such as decisions about specific aspects of the product:

"This button should say 'Start.'"

Making one decision allows the design team to make the next decision. That is, they can tackle the next level of detail, the next element in the product, the next challenge facing the project. One decision leads to the next.

But as most designers have come to understand, one bad decision can have devastating consequences later in the project. A simple example is a decision that implies a convention in the design of the product, like "All buttons will be orange with a white label." Make this decision when there's only one visible button, and the team might think all is right with the world. Realizing later they have to design an interface with a dozen buttons, the team might regret that decision. They're now faced with another challenge: Change the convention? Or establish a new convention for this circumstance?

The design process ends when the team has made sufficient decisions to define the product. That definition addresses all the established goals (decisions early in the project) and respects all the technical constraints (perhaps later in the project). That definition is sufficiently documented for a production team to

implement the product. Design is therefore measured along two dimensions: quality and moving the project forward, which I'll call *movement* (**Figure 4.2**).

Figure 4.2. Two dimensions define success: quality and movement.

Decisions made by the design team must do two things, then. A design decision must

- **Be good.** It meets the goals of the project, for example.
- **Move the project forward.** The decision brings the conclusion of the project into greater focus, further clarifying the product definition.

OK, so the design process is a series of decisions that increasingly defines the product and yields a good product. These decisions are made collectively by the design team. And the team cooperates to make decisions. Right?

Actually, that's not true.

Not every member of the team contributes to every decision. Nor does every member of the team agree with every decision. But to move a project forward, all members of the design team must understand the decision. That is, they know

- Why the decision was made
- How the decision impacts their contribution
- How they can incorporate the decision into their work

Enter conflict. By working toward a shared understanding of design decisions, team members enter into conflict. It is through building a shared understanding around decisions that conflict manifests. That is, team members must understand how a design decision makes a better product and moves the project forward.

For example, a design team who has resolved their conflict can answer all these questions the same way (**Table 4.1**).

Table 4.1 Questions about Quality and Movement

Questions about Quality	Questions about Movement
Do you know how this decision addresses project goals?	Do you know how this moves the project forward?
Do you know how this decision can help improve the design?	Do you know what to do next?
Can you explain how the decision is appropriate to the project?	Do you know how this decision will enable (or impede) your next task?
Does this decision take the design outside the project's boundaries or constraints?	Do you know how this decision moves the project closer to success?

A shared understanding is crucial for both design quality and moving the design process forward. To get aligned on these answers, team members conflict. It's that conflict that allows them to acknowledge their lack of alignment and to work together to achieve a shared understanding.

When team members are not aligned, when they do not have a shared understanding, they can't move the project forward or make the project successful. Teams can (and often do) gloss over the conflict, but the lack of shared understanding of these decisions will negatively impact them later. On the other hand, teams that take the time to align their understanding on design decisions will ultimately bring projects to conclusion successfully.

Design Decisions and Shared Understanding

There are two parts to any design decision: the content of the decision and the method used to make the decision. The content is what was decided, generally about the design of the product itself. The method may be a technique or a rationale. It answers the question, "How did we make this decision?"

In each of the following sample decisions, the content is italicized and the method is underlined:

- We *won't use tab-based navigation* for this Web-based application because we anticipate growth, and tabs won't scale well.

- We *will incorporate context-sensitive help* in the kiosk because most users won't be experts on this process.

- We *will prioritize information about travel conditions* because usability testing indicated that this information was the most important.

In the last example, there could be any number of reasons to prioritize travel conditions, but the method chosen by this design team involved conducting usability testing.

This structure for decisions is an oversimplification. Digging into the underlying structure of a decision, between these two things, the content and the method, there's a chicken-and-egg relationship. On the one hand, the content may not yet be defined, but the designer knows what he or she needs. That is, the designer knows to ask the question, "What information do I need to prioritize in this kiosk?" The designer then decides upon a method for answering that question: the content comes before the method. Once the designer determines the answer, that's the content of the decision, and the method is what produced it (**Figure 4.3**).

Figure 4.3.
The chicken-and-egg
structure of decisions.

A team's shared understanding rests on everyone understanding both the content of the decision and the method used to reach that decision. They need to be clear on the decision and aligned in their activities for getting there (**Table 4.2**).

Table 4.2 A Shared Understanding in Making Decisions

Aspect of Decision	Required Understanding	Implication
Content	Clarity	Not everyone is going to agree with every decision ("creative differences") but team members need to be clear on the content of the decision.
Method	Alignment	Not everyone needs to agree on how the decision will be made, but they do need to understand the method being used and how they contribute to it.

Note that clarity and alignment don't necessarily mean agreement. People working on a project team may not agree with the direction set by their leads or managers. They may not agree with how those decisions are made. Designers bristle at arbitrary decisions (like unreasonable constraints in production or bizarre institutionalized business rules) but can generally get behind a decision if it's clear and they know how it impacts them.

And this brings me back to the definition of conflict. Conflict is the way design teams come to a shared understanding of each decision made in the design process. Conflict in design isn't always accompanied by negative emotions, hostility, or drama. It isn't always about disagreement. Conflict is about two (or more) people trying to understand each other, paving the way for future decisions and ultimately the project conclusion.

What Happens Without a Shared Understanding

When teams work from a disparate understanding, they risk becoming further separated as the project progresses. They make decisions individually that seem misinformed or misaligned with the rest of the team. If the team doesn't understand the boundaries of the design project, they will create concepts that are unrealistic or don't solve the problem.

Good designers may purposefully break boundaries, seeking to challenge conventions or expose new ideas. But this boundary breaking is counterproductive if they do it in ignorance, naively thrashing about without first ensuring that they have a shared understanding of the assignment. Without being able to position it as boundary breaking, they are unable to tell the story of the design concept to their team or their stakeholders. A design decision that cannot be justified is not one that will move the project closer to its conclusion.

Misunderstanding happens most often with respect to design direction and design scope.

Lack of Design Direction

When designers do not understand direction, they lack clarity on the underlying principles that are driving the design. While not every design process will articulate these principles concretely, the lead on the project is responsible for ensuring that the designers understand them. Good leads help their design

DESIGNING TOGETHER REQUIRES SHARED UNDERSTANDING AND SHARED PURPOSE

Marc Rettig
Fit Associates

In my experience the key to successfully designing together lies in paying attention, together, to the heart of the work. Design begins with understanding, and at its heart lies intention. Before you attend to the idea and expression or form of the work, attend to shared understanding and intention.

Design is a meeting of understanding and creation.

Unfortunately, "understanding" is too often confused with "explaining." In corporate design, a tremendous proportion of the time and money spent on research and testing goes toward generating elaborate explanations. These explanations are used to make everybody feel like they are doing principled, rigorous work, with clear argument and justification for their design decisions. There's nothing wrong with this, and in fact it is very useful for the kind of complexity we face in corporate design.

But this can be shallow and seldom provides anyone with creative fire. Explanations can bring a team together intellectually, but they rarely provide passion.

If you know that humans perceive different frequencies of light as different colors, you have an explanation. If you personally look at the world through a prism, visit places where color sets different moods, and then listen to people talk about color in their lives and the way color touches their memories and is mixed up with deep, identity-level notions like "home," you begin to develop an understanding. And I promise you'll begin to get excited. You might not be able to explain everything about the way your attention to color has shifted, the new ways you see and engage with the world, but you'll know that something really important has developed inside you: a new understanding of color.

Now, give that to your team. And give it to the extended network of people who make up the larger ecosystem in which "designing together" takes place and on which it depends for the work to get out into the world. You give it to people by giving them personal experiences. Don't outsource "research." Get out there together! Do what it takes to provide yourselves with a shared understanding of the people, contexts, activities—the lives you are about to affect with your decisions. The degree to which your team is mingled with the lives it will affect is a predictor of the degree of its collective understanding, which is also a predictor of its passion and sense of purpose, which is a key to the quality of the work.

John Bielenberg of Future Partners suggests this activity: "This is 10 by 10 by 10: By the end of the day, everybody will visit 10 places, talk to 10 people, and bring back 10 stories." As someone who has participated in dozens of ethnographic design research projects, I believe more than half of them would have been better served by involving the team and its extended network in a round of 10 by 10 by 10.

Designing together begins with understanding together, and at its heart lies shared intention. The second key to successfully designing together is to work from a shared purpose.

An intention is different from a goal, a mission, a design brief, or a business mandate. It is a statement about how the world will be improved by the work you are doing together. I recommend writing them in the form of a question: "How can we…?" But you don't have to write it down. You just need to arrive at it together, and it needs to emerge from your shared understanding.

Once you've been out there, once you've collectively acquired the sort of excitement and altered vision I described in the color example, get in a circle and talk about what really matters. This may be different from the charter or question that brought the team together, but it's going to feel like something worth fighting for. Be bold. Shed your sense of limitation, of being "small" relative to the organization you're work-ing in or the complexity of the situation you're addressing. If you feel excitement in your solar plexus, if you find yourselves in a frontier mood, a fighting mood, a lover's mood, you're finding an intention that can sustain a team through a project. Once you have found the calling you all want to say "yes" to, all that's left is "how."

Now you've got something. You have people who share a connected understanding of a slice of the world, a slice of life. People who have agreed to work together for a pur-pose that lights them up. You have the beginning of design, and you have the heart of design. And you've begun to do the work together. ■

teams internalize them, such that they can make decisions relying on those principles. For example, a designer potentially wastes time (i.e., money) laying out screens for a Web site that don't follow an implicit set of principles determined at the beginning of the project. The lack of shared understanding here might be from

- **Misunderstanding the design direction:** The creative director did not provide a clear set of principles to drive the design.

- **Misunderstanding the constraints:** The team didn't clarify the project's or the design problem's boundaries, so the designer produced things that were hopelessly unrealistic.

Lack of Design Scope

A designer could waste time creating designs for the wrong thing. The design team can easily understand that the assignment entails designing a marketing site for a large high-tech product company. But perhaps they aren't fully aware of which pages to focus on, or that they shouldn't touch the site's primary navigation, or that they can't rely on certain product information being available.

Conflict can be uncomfortable for some people, but recall that conflict is good for design—it's the engine that makes design productive. As the understanding of a project's goals or direction diverges, that discomfort becomes more pronounced. Good teams detect and resolve conflicts as they arise. Yes, they understand the risk of not addressing conflict, but more importantly they know that the product is better for it.

Obstacles to a Shared Understanding

Some design teams hardly think of this as conflict; they are used to the dance necessary to achieve a shared understanding. Experienced teams with a good rapport can sense this shared understanding, or lack thereof, and know, almost at an intimate level, what it takes to resolve it.

Rarely do designers have the opportunity to work consistently in such an environment. Instead, new people and new challenges are injected into design jobs all the time. The conflict becomes front and center in these situations. Experienced designers understand they need to go through a learning process: they need to learn how to work with this new set of people.

But cultivating this rapport and empathy takes time. Until then, you may encounter obstacles that prevent you from engaging in productive conflict:

- **Misconception:** People may think they understand, but they really don't. That is, they believe they have a shared understanding. Unless you can confront them—test their knowledge, so to speak—you won't know for sure.

- **Ego:** People refuse to admit they don't understand. Call it stubbornness, pride, or just plain old naive optimism; some people's personalities prevent them from copping to their misunderstanding.

- **Disinterest:** People don't care enough to figure it out. We've all encountered the colleague who stinks of that classic fragrance, "I'd rather be somewhere else." Whether they are aware of their own lack of understanding, they choose not to clarify.

Reaching a shared understanding usually means overcoming these obstacles first, and then engaging in meaningful conflict—that is, conflict that produces useful decisions. But these obstacles produce a form of conflict in and of themselves—what I call "unhealthy conflict."

Healthy vs. Unhealthy Conflict

Conflict is a loaded word, and when I ask groups whether they can do design successfully without conflict, they are, well, conflicted. Beyond the mere "lack of alignment and clarity," conflict also has a negative connotation. It is often associated with violent emotion, drama, and a lack of desire to agree.

In this meaning of conflict, the word embodies an obstacle to overcome, something for our hero (you, of course) to defeat. In this meaning of conflict there are winners and losers. People who see conflict only in this way seek to push their design through and piss off everyone around them.

So, this isn't the kind of conflict that is the engine of design. It's the engine of sociopathy.

Unfortunately, these two versions of conflict can look, on the outside, very similar. Arguments and even emotion can play a role in both kinds of conflict. The

key difference is their intent. Are the participants trying to further the design? Are they arguing in service of the project? Or are they just trying to win?

I distinguish these two kinds of conflict as healthy and unhealthy. Healthy conflict moves projects forward by building momentum or contributing to quality—or, hopefully, both. Unhealthy conflict yields no progress on the project, no better design solution.

Distinguishing Between Healthy and Unhealthy Conflict

Unhealthy conflict can create an obstacle that prevents teams from talking about disagreements that matter. In other words, one person's personal or stylistic issues can prevent the team from successfully engaging in meaningful discourse. Therefore, designers must recognize the differences between these things and do what they can to avoid being the source of unhealthy conflict.

Perhaps this is the designer's greatest challenge: conflict is good for design, but pointless arguing is counterproductive. Arguing wherever and whenever possible, therefore, is not a safe gamble. The occasional productive conversation isn't worth it if no one wants to work with you.

Unhealthy conflict is easy to recognize because it's personal. I had a client say to me, "This is all wrong. You got this all wrong." Throwing failure in someone's face, deserved or not, is the fastest way to divert a conversation. My immediate reaction was to get defensive. In this case, the defense mechanism manifested itself as redirecting blame: I insisted that she was constantly changing the project objectives. Her only response was to deny that. We got, no surprise, nowhere.

You can recognize unhealthy conflict when people

■ Lash out at designs without a rationale for their critique: "This sucks."

■ Attempt to undermine a team member's creative skills without constructive criticism: "This is clearly above you."

■ Attack other aspects of the designer's style or approach: "You're so disorganized."

■ Defend their own actions: "I told you how to prioritize the requirements."

These phrases represent real situations, and their messages are important, but the phrasing is purposefully antagonistic. People who have the good of the project in mind (not their own self-interest) will position these messages differently **(Table 4.3)**.

Table 4.3 Recognizing Unhealthy Conflict

The statement...	...tries to...	It could...	...by saying...
"This sucks."	Undermine the designer's self-confidence.	Help the team zero in on a design direction.	"Help me understand some of the decisions you made."
"This is clearly above you."	Elevate the speaker over other members of the team.	Simplify the scope of the task or assignment.	"Seems like you're spinning. Which parts can I help with?"
"You're so disorganized."	Deflect attention from the design challenge.	Help the team prioritize tasks.	"Are you having trouble prioritizing?"
"I told you how to prioritize the requirements."	Deflect attention away from the speaker's shortcomings.	Align the team's understanding of the design problem.	"How did you interpret the priorities I gave you? Let's make sure we're on the same page."

Unhealthy Conflict as a Mask

If healthy conflict is all about achieving a shared understanding, then surely unhealthy conflict has nothing to do with understanding. Right?

In reality, unhealthy conflict is a smokescreen for potentially healthy conflict. That is, the misalignment and lack of clarity surrounding design decisions that feed healthy conflict are the same as those that feed unhealthy conflict. The difference is how participants choose to react. There are two ways this can happen, but both yield the same result—defensiveness.

■ They have anxiety about not understanding the decision. They realize they do not understand the decision, so they lash out to protect themselves, to prevent others from realizing they do not understand.

■ They have anxiety about the decision itself. For one reason or another, they don't like the decision made (whether they understand it or not), and they lash out to protect themselves.

Anxiety from Not Understanding

Admitting ignorance is one of the central tenets of resolving conflict. By admitting you don't know, you create an opportunity for someone else to help you understand. People still struggle with this. People believe themselves to be judged on what they know, and on proving that they know it. Combine this with an "unhealthy" view of conflict—that every conflict has winners and losers—and people are bound to behave counterproductively.

Anxiety from the Decision Itself

Decisions come with implications: tasks to complete, milestones to hit, activities to perform. As people come to understand how a decision impacts their responsibilities or expectations, they may activate defense mechanisms if the implication exposes perceived weakness.

Converting Unhealthy Conflict to Healthy Conflict

Designers may not see it as their responsibility to deal with every jerk that walks into their professional life. Indeed, not everyone can have a "no asshole rule." Designers, however, are not always at liberty to choose with whom they work.

All the jerks I've encountered thrive on reactions. Emotion sets their anxiety at ease. They've shifted focus away from their inadequacy or ignorance, setting it squarely on their opponent's shoulders. By picturing the jerk as someone without the means for expressing himself in a productive way—literally missing that mechanism from his brain—the situation looks different.

Once you've depersonalized this person's attack, it becomes a starting point for a real conversation. To ease the transition to a productive conversation, try redirecting the topic at hand (**Table 4.4**).

Table 4.4 Snappy Answers to Stupid Statements

Unhealthy Statement	Constructive Response
"This sucks."	"Let's start at the top. What isn't working about the header? Too much information crammed in there?"
"This is clearly above you."	"Let me walk you through the design to help you understand the decisions I made."
"You're so disorganized."	"Let me walk you through the process, and I can give you some insight into where I'm at and where I'm going."
"I told you how to prioritize the requirements."	"My takeaway from that conversation was that requirements 2, 5, and 9 were most important. I used those to drive the design. I'll explain how. If there are different priorities now, let's talk about them."

The Nature of Resolution

The next two chapters discuss techniques for assessing difficult situations and coming to a shared understanding. The conclusion of those two things—figuring out what to do and then doing it—yields resolution.

Within the context of a "shared understanding" definition, resolving conflict means achieving a shared understanding. In creative conflicts, there are five kinds of resolution. That is, after a conflict there are five ways people come to a shared understanding:

- Persuasion
- Iteration
- Perspective shift
- Deferred decision
- Common ground

No one type of resolution is better than the other. It's not like persuasion will always lead to the best design or a deferred decision is always bad. The value of a resolution is determined by the situation and the ultimate outcome.

These types are inventoried here to help teams carve a path toward resolution. By understanding the situation and prioritizing the conflict, members of the team can behave to achieve a particular resolution.

To explain these different kinds of resolutions, I'll use a sample scenario throughout, showing how different decisions might be resolved:

> Dan and Nathan are collaborating on a web design project for a large publication. The publication has thousands of articles already published online across three different Web sites. Ostensibly, these sites are geared toward different audiences. The scope of the assignment is huge: the publication has asked them to redesign the user experience from the ground up, integrating these sites.

Persuasion: One Adopts the Other

Persuasion is when one person convinces another person to adopt his or her position.

Example: Dan and Nathan have two different ideas on how the publication should be organized moving forward. Dan believes the publication should eliminate the three separate properties. Nathan believes that the publication should preserve the distinctions. After discussing it, Nathan convinces Dan that preserving the separate properties makes the most sense given project constraints.

Iteration: They Reach a Compromise

Iteration happens when participants discuss their ideas, revising and refining them to the point where a new idea emerges.

Example: Dan and Nathan feel pretty strongly about how to organize the new site. After trying to persuade each other, they spend half a day sketching different ideas. (They invite Jody and Veronica, too.) After several rounds of sketching, a new concept emerges. There are aspects of Dan's original idea and Nathan's original idea, but this is a new one altogether.

Perspective Shift: One Looks at It Differently

When one person shifts his perspective, he chooses to look at the situation differently. By doing so, he is more willing to adopt another person's position. This isn't so much persuasion (as the first person isn't convinced that the position necessarily makes sense) so much as letting the process take its course.

Example: Nathan has sketched some ideas very early in the project and wants to show them to the client. Dan worries that showing too much too soon will

compromise the design process. He believes they need to iron out more of the underlying architecture before exposing the client to screen design ideas. Nathan worries that showing the client abstract drawings of Web site architecture will cause them to "spin" needlessly. Nathan decides that though he doesn't believe the process works better this way, giving Dan a chance to share architecture drawings will help him learn more about the client.

Deferred Decision: They Decide to Hold Off

When participants opt not to make a decision at all, they are deferring the decision. This may seem like the easy way out, but responsible teams understand that decisions deferred now turn into challenges later. Responsible teams also understand when they don't have enough information to make a decision. Deferring decisions makes sense when the team recognizes that they need more inputs.

A deferred decision is toxic when the team is simply incapable of making a decision. Deferred decisions are productive when everyone willingly decides to "sleep on it," and they have a rationale for doing so.

Example: Having zeroed in on the overall structure of the site, the design team needs to make a decision about the underlying navigation. While users will have several ways to filter articles, the team recognizes that they need to prioritize one mechanism as primary. They're torn between a content type approach (long form versus short form, for example) and a topic approach (environmental news versus medical news, for example). Dan and Nathan weigh different approaches, realizing that they don't have good criteria for making a final decision. They defer it, giving Dan the action item to comb through user research to identify potential inputs into the conversation.

Common Ground: They Agree on Something

Coming to common ground means going back to fundamentals that everyone agrees on. By reeling back to those items everyone has in common, the design team sets the stage for exploring the decisions again.

This is, in a way, a form of deferred decision. Instead of acknowledging the need for further inputs, though, the team acknowledges that they are at an impasse because they can't agree on anything. Finding some mutually agreeable starting point gives the team the right mindset for seeking out some

solution. At best, it creates a platform for building together, and at worst, it helps them identify where their paths may diverge.

Example: Dan and Nathan decide they can't resolve their conflict, acknowledging that the problem may be more fundamental. As they're talking, they open a document that describes the project charter. They review each of the project's goals, design principles, and high-level requirements. They reaffirm their agreement on these and their respective prioritization.

Evaluating Resolutions

Describing the nature of the resolution is helpful for planning your response to conflict. But none of these descriptors offers a value judgment. How do you know if a resolution is good?

At the beginning of this chapter, I defined the criteria for design decisions. A good design decision must be good and move the project forward.

Resolving conflict is one way of making a decision. Therefore, a resolution can also be evaluated by these criteria. Mapping possible resolutions to these two criteria, there are four possible outcomes (**Table 4.5**).

Table 4.5 Two-by-Two of Resolution Outcomes

	Movement	
Quality	**Good design, poor movement** Some resolutions lead to good design ideas, but don't actually move the project forward. Think: sketching over and over again, burning away budget and schedule, while crafting the perfect experience.	**Good design, good movement** These resolutions produce good design ideas (meeting the goals of the project) and get the project closer to completion. Think: project team that knows what they need to do to solve the design problem and move forward.
	Poor design, poor movement These resolutions do not solve the design problem, nor do they represent meaningful steps toward the project conclusion. Think: generating lots of crap, and having no clue about how to move things forward.	**Poor design, good movement** Some resolutions yield poor design decisions, yet successfully move a project forward because they hit the "gates" of the project plan. Think: producing a comprehensive set of specifications that describe an utterly unusable design.

These are the criteria by which you should be judging the outcome of your decisions. To revisit some of the examples, let me elaborate on how they might be good decisions (**Table 4.6**).

Table 4.6 Example Resolutions

Resolution	Is It Good?
Nathan **persuades** Dan to separate the publication into three separate properties.	Quality? The decision adhered to the project goals and requirements.
	Move forward? The decision allowed the team to elaborate on the design further.
Nathan **changes his perspective** and agrees to let Dan share architecture artifacts with the client.	Quality? This is a resolution about process. In this case it is good because it will adhere to client expectations. It avoids potentially confusing them.
	Move forward? While it doesn't move the project as quickly (Nathan's objection), getting feedback from the client will help the design team understand the client's disposition toward certain kinds of design conversations.
Dan and Nathan decide to **defer the decision** about the underlying navigation.	Quality? It's too soon to judge, but they opted to gather more information before making a commitment. More information will help them determine what is good.
	Move forward? By deferring the decision, they arguably kept the project stagnant. They understood the risk, however, and chose that path rather than making a hasty decision that was difficult to undo.

So specific kinds of resolutions do not necessarily lend themselves to bad outcomes. Ultimately, the circumstances (not the type of resolution) determine whether a decision is good or not.

TL;DR

This chapter provided a foundation for understanding conflict. It started with two assumptions:

■ Design is, when oversimplified, a series of interconnected decisions.

■ A decision comprises two parts: the method used to make the decision and the content of the decision itself.

With that understanding, the chapter elaborated on conflict:

1. When people on the design team do not have a shared understanding of a design decision, they experience conflict.

2. There are three things that can prevent a shared understanding: misconception, ego, and disinterest.

3. Conflict is healthy when it moves people closer to achieving a shared understanding.

4. Unhealthy conflict is conflict for its own sake, and is usually caused by someone acting defensively.

5. There are five types of resolution—persuasion, iteration, perspective shift, deferred decision, and common ground—but none of these is better than another.

6. The real criteria of a resolution are the same as those for a design decision: Does it yield good design? Does it move the project forward?

■

5

Assessing Conflict:
What's Really Wrong

"WE REALLY JUST needed ideas on the home page." It came as a bit of a shock, showing up to a design review having spent hours on design concepts for several different screens. This was the client, sounding somewhat incredulous and annoyed: Just how much money had we wasted on screens way out of scope? Things hadn't felt right on this project from the start, and while it was a relief to understand finally the disconnect, it was also disappointing to have gotten it so wrong.

Here's the thing about conflict, healthy or unhealthy: in your first encounter with a situation, you may not really understand what's going on. You may not have the right perspective to understand the factors at play leading to a situation.

Unfortunately, there is no perfect algorithm for assessing what's really wrong in a situation—what's preventing the project from moving forward—and what it takes to fix it. So many factors contribute to the conflict:

- Where you stand in the design process
- The project parameters (timeline, budget, and other constraints)
- The personalities of the people involved
- The roles of the people involved
- The individual circumstances of each person on the team
- The organizational circumstances surrounding the project
- The baggage brought both by individuals and the parts of the team that worked together previously
- The assumptions made by everyone having worked on similar projects

I could go on, but you get the idea—there is no simple mechanism for diagnosing the underlying cause of a difficult situation. Ultimately, the design team needs to recognize the obstacle preventing them from achieving a shared understanding.

What Causes Conflict?

You may be tempted to look deep below the surface, to identify the central "causes" of the situation. Experience shows, however, that addressing the obstacles, not the causes of conflict, makes for more productive resolutions (see **Table 5.1**). A friend helps someone deal with the underlying cause of their behaviors; colleagues, however, just need to focus on overcoming the obstacle.

Make no mistake, obstacles come from underlying causes. Those causes include issues from childhood and previous difficult professional or personal experiences. Regardless of the cause, however, the impact on the project is the obstacle erected by those underlying issues.

Table 5.1 Causes vs. Obstacles

Underlying Cause of Conflict	Apparent Obstacle to Design
"Because I felt a lot of pressure to perform as a kid, I have trouble dealing with direct feedback on my design concepts."	"I take your direct feedback personally, even if you don't mean it that way. Can you reassure me that my performance is OK?"
"These design exercises are a total waste of time because the last design team I worked with wasted a lot of money on 'strategy.'"	"I don't want to participate because these activities seem like a waste of time."
"I have trouble finishing things because I'm afraid of failure."	"Sorry, I didn't finish the assignment."

A Deck of Situations

You'll read about situations versus patterns versus traits in the next chapter. One reason I created the game Surviving Design Projects was to have a set of cards to represent common situations (**Figure 5.1**). Sometimes, when I'm dealing with a tough circumstance, I flip through the cards to help me zero in on what might be going on. Merely eliminating some of the less relevant situations can be enough to help me assess the real situation better.

Figure 5.1.
The situation cards from Surviving Design Projects help me to narrow down the possible root of the situation.

In the previous chapter, I explained why conflict is important in the design process. In this chapter, I'll dig into the structure of conflict, establishing a vocabulary for talking about its causes. The structure of a conflict revolves around the decisions people make during the design process and the disposition of those people participating (**Figure 5.2**). The structure encompasses the obstacle preventing people from coming to a shared understanding, how that obstacle manifests itself.

It focuses on these concepts:

- **Situation:** A set of circumstances that typically arises in design projects
- **Conflict:** The need to come to a shared understanding
- **Decision:** A choice made during the design process to advance the design solution closer to its objectives
- **Method:** The "how" component of a decision, usually a technique or justification for arriving at a situation
- **Outcome:** The "what" component of a decision, the content of the decision
- **Tensions:** The ways people feel prevented from resolving conflict

Both decisions and tensions can be the source of conflict. That is, a situation can arise from

- People realizing they disagree about a decision
- Someone feeling prevented from contributing to the design process.

Imagine that Jason and Dan are Web designers sketching some ideas for a dashboard interface. They sketch independently, then hold a meeting to review their ideas. The intent of the meeting is to zero in on a final approach to share with their stakeholders.

In one version of this scenario, Jason and Dan come to the meeting and have a conversation about each of their concepts. While they have meaningful differences, both can be justified by the project parameters and requirements. Both would serve the needs of the target audience, but in different ways. They decide to show their stakeholders both approaches and structure the conversation around how each concept represents a different set of priorities. They'll use this conversation not to force stakeholders to pick one, but instead to clarify the project's priorities.

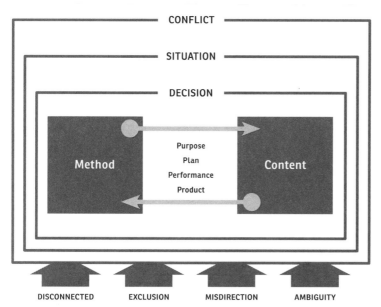

Figure 5.2.
A decision lies at the heart of a conflict. The conflict may come from inside the decision, when people disagree about the decision itself. The conflict may come from how people react to the decision, called tensions.

In another version of this scenario, Jason believes that Dan's concept focuses too much on the use of touch gestures to manipulate the data. While it solves many of the design problems, it leaves out several essential functions. Jason thinks that Dan might be "distracted by shiny objects" (yes, there's a card for that). This version of the scenario maps to the elements of conflict:

- **Situation/Conflict:** Jason doesn't share Dan's understanding of the priority of certain requirements, and believes him to be distracted by shiny objects.

- **Decision:** Dan chose to incorporate touch gestures that compromise the desktop experience.

- **Method:** Dan sacrificed key requirements to incorporate new ideas.

- **Outcome:** Dan made a decision that limited the functionality of the product.

- **Tension:** Dan is experiencing misdirection, where he feels focused on the wrong things.

Disagreement about a decision is an internal cause—it comes from the design process itself. Someone's perception of obstacles is what I call an external cause, coming from a person's perceptions or sensitivities. I discuss the internal causes next.

Internal Sources of Conflict

There's no one simple way to classify conflict. Even if there were, conflicts of a certain type may have countless ways to be reconciled: there's no silver bullet for resolving conflict. Therefore, designers should strive to understand the range of obstacles they might encounter. By understanding the obstacles themselves, designers can consider how to redirect the conflict in a positive, productive way.

In this section I'll look at typical obstacles from the inside out—understanding the obstacles based on the structure of design decisions. In the next section, I'll take an outside-in approach, explaining the different ways in which conflict gets expressed.

Recall that a design decision consists of two parts. In making a design decision, I've got the content of the decision itself and the method used to make that decision. The content is *what* was decided, the method is *how* it was decided.

Method Conflict

"We should use tabs in this interface because there's precedent on the Web site, they're typically used for this, and we know the content won't scale beyond four categories." By providing a rationale, the designer has established a method for how he or she has made the decision.

Another designer may disagree: "No, we really need to be focused on the results of the usability test, which implied that the tabs may not be clear to users. I'm also worried about the situation where there isn't enough content to justify having tabs. What happens to the interface in that case?"

Recall that a decision's method may not just be a technique. More typically, the way designers make a decision is based on a series of assertions that provide a logical argument supporting the content of the decision.

Conflict stemming from method therefore comes from a disagreement about which criteria are the most important to drive the decision. In the preceding story, the first designer emphasizes *precedent* and the *risk of scale*:

- **Precedent:** The decision is justified by the fact that the same design idea has been used elsewhere within the same product or on other similar products.

- **Risk of scale:** The decision is justified because it doesn't introduce any risk to the future growth of the product.

The second designer instead prioritizes *empirical data* and the *worst-case scenario*:

- **Empirical data:** The decision is justified by data gathered by the design team about the target audience.

- **Worst-case scenario:** The decision is justified because it is still valid in an extreme test case.

Sometimes designers don't have a rationale. Some people believe that as a creative endeavor, design must not always rest on a concrete justification. You might interpret this as "aesthetic" justification: the designer believes the inherent elegance of the decision is what makes it work. For examples of justification, see **Table 5.2**.

Table 5.2 Different Ways to Justify a Design Decision

Justification	Description	Example
Precedent	The decision is justified because we made the same decision in previous, similar situations.	"We use the primary button style for all transactional interactions and the secondary button style for other interactions."
Risk of scale	The decision is justified because it won't break under increased usage or content.	"We put the navigation in the left column so it could grow. We know you'll be adding more categories in the future."
Empirical data	The decision is justified because we have research data to back it up.	"We started with a design for small screens because we know the target audience mostly accesses the Web through their smartphones."
Worst case	The decision is justified because it remains valid even in the most extreme cases.	"Since much of your content is privileged based on subscription level, we prioritized the content components this way so that even anonymous users would see something interesting."
Extension	The decision is justified because it extends previous design decisions.	"We rounded the corners of some elements because of the desire to be 'friendly and approachable.'"
Constraint	The decision is justified because it accommodates some technical, operational, or organizational constraint.	"We limited the number of items to three to simplify the maintenance by the editorial team."

(continues on next page)

Table 5.2 Different Ways to Justify a Design Decision (continued)

Justification	Description	Example
Compromise	The decision is justified because it makes everyone (important) on the project team happy (or unhappy) equally.	"We chose to be inconsistent in the navigation labels because the business made it clear they expected to see certain words there."
Meaningful	The decision is justified because it appeals to some universal truth, or because it is derived from some common understanding.	"We used the classic red because that color is so identified with your brand."

When conflict deals with the method, the participants are really trying to figure out how to prioritize the criteria for making the decision. They disagree about which justifications matter more, even if the outcome is the same. "Violent agreement" generally comes from people who agree on the outcome, but still find themselves arguing because they came to that conclusion through different paths.

The Value of Method Conflict

Whether the participants agree on the outcome or not, having a shared understanding of the decision method is valuable. By coming to a shared understanding, participants can

- **Understand what's important to each other:** Never underestimate the value of getting to know your team better. Unpacking a design decision to see what drove it can help you see things from your colleagues' perspectives, shedding light on their priorities and blind spots.

- **Decide what's central to the project:** Surfacing method conflicts early in a project can encourage the team to establish common criteria for the duration of the project. That is, they can agree that certain justifications— empirical data, for example—are stronger for this project.

- **Strengthen later decisions:** Knowing what your colleagues consider important will help you rationalize decisions made down the road.

- **Anticipate arguments against decisions:** Other members of the team may try to undermine the content of team decisions. By exposing different kinds of decision criteria, the team can anticipate these attacks to strengthen their argument.

Useful Patterns for Identifying Method Conflict

Method conflict may be hidden by outcome conflict. That is, the design team may be so preoccupied with the fact that they disagree on the content of the decision that they don't take a moment to reflect on their individual justifications.

These patterns (**Table 5.3**) can help the participants take a step back and examine the methods they used to make design decisions. For the examples in Table 5.3, imagine three or four designers sitting around a table presenting different design concepts for a well-understood project. They've each taken a different approach, but they're struggling to zero in on why the concepts aren't resonating with each other.

Table 5.3 Patterns to Help Identify Method Conflict

Pattern	Example
Enumerate issues	Each participant makes a list of the design decisions essential to his concept, and then identifies the core rationale for making the decision. By starting with the content of the decision, participants can reverse engineer the methods.
List assumptions	Each participant lists all the assumptions made about the target audience, the business priorities, and the constraints.
Reflection	As each participant presents his concept, the others listen for rationale. They restate the justification to the presenter to ensure they described it correctly.
Tell me a story	The designers present their concepts by positioning it as a story in the context of the business or target audience. Positioning it as a story with the product in use can surface the justifications.
Frame critiques	The participants agree to present their concepts, highlighting three or four key design decisions and the rationale for those decisions.

Method conflict is healthy. It is designers trying to get under the hood, trying to understand each other's process and relate to the decision in a deeper way.

Outcome Conflict

The result of the method is the outcome, or what I sometimes call the **content of the decision**. Disagreements about a decision's content probably feel more common to you: people generally disagree with what people decide, but not how they decide it. This may be true, but design is as much about how we make our decisions as it is about the decisions themselves.

Most decisions that we think of as design decisions are what I call **product decisions**. Product decisions include choices about how the product looks, feels, behaves, interacts, responds, or engages. Ultimately, it is what people think about when they think about the product.

But there are other kinds of decisions that are part of the design process—performance, plan, and purpose, as described in **Table 5.4**.

Table 5.4 Different Types of Decisions, All Starting Conveniently with the Letter P

Type	Is a decision about...	Like...
Product	The look, feel, behavior, and interaction of the thing you're designing.	The color of the finish.
Performance	The designer's contribution.	How they've developed a specification or created a design artifact.
Plan	The way the team chooses to structure the project.	Putting usability testing after a prototype is finished instead of throughout the design process.
Purpose	The way the team expresses the design problem and ultimate project goal.	Setting "user happiness" as the primary goal of the project.

These decision types are increasingly abstract—less about the product itself and more about the process. They are interdependent, such that decisions made about the purpose have an impact on decisions about the plan, the performance, and the product. The content of one type of decision is frequently the method of the next decision.

Figure 5.3 shows the interconnectedness of each kind of decision. One decision's content is another decision's method.

The interconnectedness can obscure the real conflict. Our disagreement about a product decision may be obscuring an underlying disagreement about the purpose.

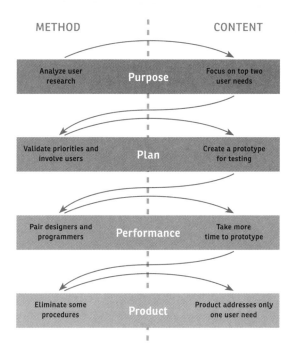

Figure 5.3.
The interconnectedness of the different types of decisions.

Recognizing Product Conflict

Product Conflict: When people disagree about how the product should look or work

Product conflict is perhaps the easiest conflict to recognize because it is so concrete. Designers disagree about what's right for the product. Decisions about the aesthetic, functionality, feel, tone, and experience of the product are all in play here.

The healthy version of this conflict quickly reverts to method conflict, with designers discussing how to make the right decision for the product.

Recognizing Performance Conflict

Performance Conflict: When people disagree about how to execute the plan

Performance conflict may be easy to recognize too, because it's about one person's contributions to the project. On the other hand, it can be the most difficult to resolve because it can be highly individualized.

The process of design entails many activities and decisions that don't manifest themselves in the final product. Performance decisions can be independent of product decisions, but practicing designers know that there is often a straight

line between decisions we make as part of the process and those that end up in the product.

Healthy versions of this conflict entail level setting, where team members come to an understanding about their expected contributions.

Recognizing Plan Conflict

Plan Conflict: When people disagree about the right structure for the project

Plan conflicts manifest themselves in two ways: ambiguous plans or disagreement about the approach. With ambiguous plans, people may make assumptions about how the project will go. Without discussing it, teams may rely on previous experience to set their expectations about the project's structure.

Healthy versions of this kind of conflict entail designers reconciling an approach based on their understanding of the need. Conflict about plan can quickly escalate to conflict about purpose if people realize they don't understand project objectives.

Recognizing Purpose Conflict

Purpose Conflict: When people disagree about why the project is important and what's driving it

Purpose is a catchall term for any external force that bounds or constrains the project. Purpose conflict may be the "why" of the project, but it could also be how much and how many. Conflict about purpose may come from

- **Disagreement about the project's goals:** The team doesn't see eye-to-eye on what the project is about.

- **Lack of definition or clarity around project goals:** The team never took the time to articulate the goals of the project.

- **Disagreement about project parameters:** The team doesn't agree on "how much" or "how many" for key constraints that would define the scope or effort of the project.

Conflicts about other things may ultimately appeal to the project purpose for resolution. Well-articulated goals and parameters put to rest all other conflicts. A healthy project purpose can

- Clarify product conflicts by providing a rationale for design decisions.

- Set expectations around performance by establishing project parameters.

- Guide the creation of a plan by clearly stating final objectives and boundaries.

External Sources of Conflict

Conflict may not come from the decisions per se, but from the ways team members interact with each other. As such, these sources of conflict are considered external rather than internal. As these interactions grow from slightly annoying to increasingly toxic, team members may be blocked from achieving a shared understanding. Ultimately, the team member is prevented from contributing because he or she can't get past this tension.

I've encountered four types of tension (**Figure 5.4**), and while they prevent a shared understanding, they also are symptomatic of some underlying disagreement. In other words, someone may feel misunderstood or excluded (for example), and this must be addressed, but the healthy conflict comes from the decision itself, not how people feel.

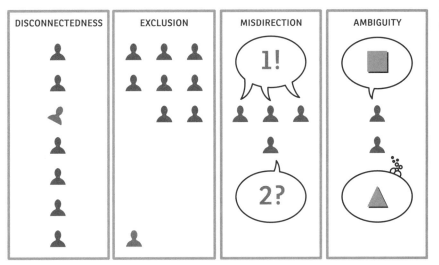

Figure 5.4. The four expressions of tension.

That said, the tension can sometimes dominate the conversation. Resolving conflict means coming to a shared understanding. If someone is coming from a position of alienation or defensiveness, then he or she is not of a mindset that would allow a shared understanding. People like to feel understood and included, and when they do, they're inclined toward a shared understanding.

By understanding these tensions, you can treat them—addressing the superficial problem and exposing the real issue underneath.

FEAR: THE KRYPTONITE OF CREATIVITY

Denise Jacobs
Speaker, Author, Evangelist

Deep inside, I believe we'd all like to express some level of design superpower. We'd like to be known to be awesome at wielding our creativity, even if it is within a small group. While no one expects to be able to fly, have superhuman strength, x-ray vision, or leap over a building in a single bound, I do believe that there's some part of ourselves that desires to a superhero professionally in some way, shape, or form.

As designers, we are immensely powerful. We have the capacity to solve problems by transforming the imagined or envisioned into the tangible and usable. Even further, we can use ours powers to provide betterment and positive change in the world through our work.

However, while we may have moments of brilliance, our consistent success can be thwarted by our own form of Kryptonite: fear.

If you are periodically debilitated and paralyzed by fear, take heart: you're not alone. In the book *Idea Revolution* by Clare Warmke, designer Mikey Richardson of the AmoebaCorp in Toronto shares some of his own: "Fear that the idea isn't my best, that others may not like it, that I may not like it. Fear that it isn't the 'right' idea. Fear that the idea will ruin everything and that I will be exposed as a hack. Giving birth to an idea can be a very stressful, heavy, scary process." Most—if not all—of us can relate to Mikey's fears, and probably have several additional ones including fear of critique, fear of letting down the team, and the fear of not being able to generate anything "new," "original," or "fresh."

The majority of us know that fear is not helpful in general, but here's why it's particularly is bad for a creative from a neuroscience perspective: Fear actually suppresses generative impulses in your brain. Fear disables your ability to think, rendering you incapable of coming up with new ideas. Generating ideas depends on the brain's creating new neurological pathways when disparate concepts come together to spark new ideas. Plainly put, fear makes you dumb and uncreative.

Your inner critic shows up as that incessant, persistent voice that constantly nags at you, second guesses your choices, and questions your abilities. This critic is your brain's allegedly protective voice: a conglomeration of every piece of criticism, bad advice, and misguided information about you and your abilities you've ever received. Some inner critics are vociferous, while others keep their grating voices at a constant, low hum of nagging judgments.

If you're in the habit of just taking a little more time and work and little bit more on the idea so that it will be perfect when you show it to the team or client, you may be suffering from perfectionism. You know: just a little more time…just a little more tweaking…just a little more—and then they will have to love it, then they won't be able to poke any holes in it, then they won't be able to say anything negative about it. Right? Perfectionism has been said to be "the highest form of self-abuse" because whatever you're creating will never be perfect, as perfection doesn't truly exist.

Naturally, your professional success is just dumb luck, but you'll just keep pressing on until someone finds you out to be to be the fraud that you are, right? My friend, you are suffering from impostor syndrome, the inability to see your talents for what they are and being driven by the fear that you'll be found to actually be a talentless incompetent.

No matter what form your fears may take, here's my guess: despite your best efforts, your hidden insecurities and fears are blocking you from being as creative as you could be. You want to be a superhero: you want to give your best to the project itself, the spirit of the ideas that come to you, and your team, but sometimes that feels akin to walking through quicksand.

To be able to really kick-ass at what we do as creatives, we need to remove blocks and filters to be able to do great work on your own and as part of a team. And you can't do that if you're letting fear put the breaks on the natural expression of your brilliance.

Here's the good news: your fear response was learned, and has become a habit. Therefore, as a habit, it can be broken, and replaced with practices that are far more beneficial for your mental and professional well-being.

Here's a little three-step process to start ousting your fears so that you can begin to truly let your creativity flow. The first step is to boost your awareness of when these voices pop up in your head and start putting the brakes on your creative mojo. Have a notebook on hand to make a mark every time a fear-based thought pops up. The second step is to acknowledge the thought as the F.E.A.R. ("false evidence appearing real") that it is. The third step is to replace the thought with a different one. Use your strong powers of visualization to imagine deleting the thought like an unwanted file, then think something true about your ability to create instead. It helps to have reminders of great things you have made in the past around you for these moments.

In stark contrast to Superman did not a have a choice about his reaction to Kryptonite, we do have the capacity to look our fears straight in the eye and transform them into productive creativity. Getting to the point of really expressing your creativity super-powers is well worth it, considering the good that can come of it. It just starts with the first step. ■

Disconnectedness

Conflict sometimes expresses itself as two or more people not in sync. They can't reach a shared understanding because they're just not on the same page. As much as I dislike that metaphor—being "on the same page"—it is accurate. The issue here isn't so much that someone is left out of the process (that's exclusion, as discussed in the next section) or that they're misunderstood (that's ambiguity, a little further down). It's that the team isn't working in concert to execute their plan.

At its most concrete, members of disconnected teams operate in their own bubble, unaware of others' activities and outputs. They perceive themselves on independent tracks, all working toward the same goal but not necessarily working together to make it happen. A subtler expression of conflict is when team members work together, but don't have one another's best interests in mind—they don't care about each other.

Disconnectedness manifests itself through obvious project risks:

■ Duplicative work: "I already did that!"

■ Missing pieces: "But wait, who's working on…?"

■ Unplanned dependencies: "I'm just waiting for you to finish your task."

If your project team has become hopelessly disconnected, see the patterns designed to establish connection, as shown in **Table 5.5**.

Table 5.5 Patterns for Reconnecting the Project Team

Try using...	In which you...	For example...
Back to basics	Rely on basic project management techniques to get the team organized.	"Let's make a list of all the tasks that everyone is working on and schedule some milestones for each person."
Meeting as workshop	Use meeting times as inter-active sessions rather than one-way presentations.	"Please come to the brainstorming workshop on Thursday, where everyone will have a chance to contribute ideas."
Good cop, bad cop	Blame a colleague for specific needs or demands.	"Look, the creative director wants to make sure that everyone has a chance to share ideas. Let's write our ideas down on stickies and then post them on the wall to discuss."

Exclusion

Another way in which people feel conflict is by feeling excluded from the activity. This is different from being disconnected: active participants in the project can be disconnected from one another. People feeling excluded are absent from participation.

Consider two team members. I'll call them William and Laura. The team has been working together on a design project for their intranet for a couple months. The team completed a prototype and conducted usability testing. They are in a meeting to review the results of the test. Laura and William arrive at the meeting and before things get going, Laura announces that she feels really removed from the project. Laura has been invited to every meeting, but shows up only about 10 percent of the time. Because she hasn't been able to follow the thread of the project—and the project team hasn't pursued it particularly aggressively—she's utterly lost, and feeling excluded.

Meanwhile, William has come to every meeting, participated in every conversation, and contributed wherever he can. But when Laura mentions feeling disconnected, William says he's also feeling this way. His comments are frequently ignored or dismissed. No one responds to his emails. None of this is personal, just the nature of busy teams working on big projects.

The rest of the team is puzzled. One refuses to come to the meetings when invited and one shows up, but both feel separated from the project. The truth is that feeling connected to a project is more than just showing up and seeing your name on meeting invitations. It really means two things:

- Following the thread of a project even if you're not coming to every meeting
- Making meaningful contributions that are heard, understood, considered, and discussed

Dealing with both of these things may seem like putting an enormous burden on the people who are showing up and making meaningful contributions. Should they be responsible for their colleagues? Well, yes, which is kind of the point of this whole book.

Consider the following patterns for inclusion, as shown in the following tables. **Table 5.6** provides examples of what to try if you're the one who's feeling excluded. **Table 5.7** provides examples of what you can try if you notice a team member who's feeling excluded.

Note: *To be clear, project teams should not babysit every participant or bend over backwards to accommodate people who won't also help themselves.* ▪

Table 5.6 Patterns for Inclusion When You Feel Excluded

Try using...	In which you...	For example...
Set expectations	Describe what you can and cannot do within the allotted time.	"Hi. I'm dedicated halftime to this project, and the tasks I have don't take that long. I'd like some more on my plate."
Help me help you	Identify opportunities to pitch in.	"Hey, I'd like to help out more on this project. You mentioned a few things in the last meeting, and I thought I might be able to..."
Help me prioritize	Ask for help prioritizing tasks.	"I feel like I'm focused on the wrong things and not making a meaningful contribution to the project. Can we review my tasks?"

Table 5.7 Patterns for Inclusion When Others Feel Excluded

Try using...	In which you...	For example...
Summarize positions	Outline someone's perspective to make sure you got it right.	"Let me take a moment to outline what everyone should be working on, and what the expectations are."
Write what you hear	Visually capture things someone is saying to demonstrate that you heard her.	"Keep talking, I'm going to take notes on the white board. Let me know if I get anything wrong."
Reflection	Repeat things back to the person talking to make sure you understood them.	"OK. Let me make sure I got this right. You said..."

Misdirection

"Not seeing the forest for the trees" is one way of telling someone that they're too focused on the details, and missing the big picture. "Too much in the weeds" is another way of saying pretty much the same thing. (Apparently, plant life is an effective metaphor for being focused on the wrong thing.)

The truth is that "wrong focus of attention" happens all the time, and not just with the details of something. I commonly miss the trees for the forest. That is, in spending too much time trying to articulate the big picture, I miss the

essential details. I've worked with people who focus so much on the use of their methodology that they miss the design problem. Other people focus too much on the design problem so they don't see the practical or business problem. Some people have a skewed view of the way in which their product will be used. Other people emphasize the needs of one target audience over another.

All these issues, taken together, I call "misdirection," a term I'm borrowing from stage magic. It refers to techniques magicians use to get the audience to focus their attention away from the sleight of hand. In design processes, misdirection is generally not encouraged so explicitly. It can refer to situations where one part of the context or design problem or design solution overshadows every other part. It can be subtler, where lack of knowledge or insight creates a biased perspective. In either case, this symptom exposes a disparity of understanding.

If the team is focusing on the wrong things, or can't agree what to focus on, consider the patterns in **Table 5.8**.

Table 5.8 Patterns for Focus

Try using...	In which you...	For example...
List assumptions	Make a list of the underlying assumptions driving each person's position.	"Let's make sure we agree on the things driving our design decisions. That way we can make sure we align on where we should focus."
Reduce the assignment	Narrow the scope of the assigned tasks.	"You know what, I think we're trying to do too much. Let's just focus on..."
Help me prioritize	Ask for tasks or assignments to be prioritized so you know where to focus first.	"Let's make a list of all the pending design decisions in front of us and prioritize which ones we should tackle first."

Ambiguity

In some conflicts, people feel like they can't make themselves understood. Try as they might, they can't express their ideas—with words or pictures or both. Sometimes this misunderstanding is fleeting, in the moment of a conversation, like the person who can't follow the narration of a hastily sketched design concept. Sometimes it is unresolved and has follow-on effects, like the designer who presents ideas that seem to ignore all feedback from the creative director.

In the first case, the designer sketches a quick idea, then walks the team through the concept. He may face countless questions as colleagues attempt to clarify the concept. He'll feel misunderstood when they ask questions about things he's already covered. As he tries to explain further, the concept becomes increasingly unclear to the rest of the team. Rather than find another way to explain the idea, the designer may give up altogether.

In the second case, the creative director may fume at the ignored direction. She may feel misunderstood, but lay the blame at the designer's feet, and attempt to exclude the designer from the project. She may decide that she can't work with the designer, who appears to be insubordinate or obstinate or incapable of taking basic direction.

If you feel like you're not being clear, try the patterns for clarity described in **Table 5.9**.

Table 5.9 Patterns for Clarity

Try using...	In which you...	For example...
Take responsibility	Blame yourself, and avoid putting your colleagues on the defensive; cue them to help you find the right way to express your ideas.	"I'm not sure I'm expressing myself well. Let me start at the beginning, and let me know if I'm missing anything in my description."
Paint a picture	Use visuals to explain yourself.	"Let me try drawing what I'm talking about to see if that helps me express it clearly."
Pick one thing	Unpack a situation by choosing one aspect and focusing on that.	"Let me just focus on X. Let's make sure I can clearly articulate that before we focus on everything else. Cool?"

Examples of Conflict

The elements of a conflict described at the beginning of the chapter offer a reasonable vocabulary for dissecting difficult situations, but they can't explain every nuance. The intent of the vocabulary, however, is for designers to estimate the true obstacle producing the conflict. Is it about the decision itself? Or is it better explained by a tension? Identifying the obstacle producing the conflict

is the first step in addressing the situation, and attempting to turn that conflict into something productive is the next step.

Breaking down conflict into its component parts is helpful for analysis, but that isn't how reality works. To help bridge the gap between reality and understanding, I offer a couple scenarios to show how the vocabulary might apply.

Scenario 1: Confronting Insufficient Progress

Lee and Kara are working together on a concept for a dashboard with a readout of key business indicators. This is a dashboard geared toward executives. Kara is the design lead, and she has assigned Lee to sketch some ideas for the set of screens representing deals, which are any pending contracts with a vendor or partner. The dashboard covers much more, but deals comprise a key element. The project is now four weeks in, and the team has been immersed in the design problem. By now, they're familiar with the terminology, the range of content, and the expected functionality.

Lee arrives at their review meeting with sketches of rectangles and squiggly lines, drawn hastily and lacking detail. The concepts reflect limited thought and imply, among other things, that Lee doesn't really get what the project is about.

Kara confronts Lee, wondering why he hasn't made more progress on the design concepts. At this point, she could assume that the issue is one of **performance** (performance conflict): Lee didn't complete the assignment because he was lazy.

Before she goes there, however, she attempts to eliminate and examine other possible issues:

- This isn't really a conflict about the **product** (product conflict): It's not that Kara disagrees with Lee's suggestions about the design.

- This may be a conflict about **plan** (plan conflict): Kara may not have allotted enough time for Lee to flesh out the necessary ideas.

- This may be a conflict about **purpose** (purpose conflict): Even after weeks of immersion in the project, Lee may still not understand the nature of the project.

Kara decides that the issue may lie with plan or purpose, but she's going to work it from the performance angle.

Note: *Before reading on and seeing how Kara addresses this conflict, consider how you would deal with this situation.* ■

Kara: You know, Lee, I had expected these ideas to be fleshed out more than they are here. By this point in the project, we should be using real content in our sketches. Also, since these sketches weren't part of a rapid-fire assignment, you should have had time to increase the level of detail.

Lee: I know they're a little lacking. Frankly, I didn't dedicate enough time to them. I gave myself an hour, but should have used two or three.

Kara: To be honest, even within an hour I would have expected more detail—

Lee: I got stuck iterating on this idea for a collapsible panel to expose details about the deal. See?

Kara: Ah. You got bogged down in one aspect of the interface and spent all your time there?

Lee: Exactly.

Kara: Got it. Well, why don't we take the rest of this hour to get these sketches further along. Is that cool with you?

Lee: That would be awesome. Actually, I could use some help in making my sketching more efficient.

Scenario 2: Clarifying Design Principles

Sharon and Galen are working together on a Web site for a high tech company that sells a variety of security products. The catalog is broad and deep, making the information architecture and design challenges especially difficult. The company is launching a line of online and home networking security products aimed at the consumer market. While the company is preserving their name and most of their identity for the new line of products, they do want to introduce a more casual visual design. Sharon and Galen's project entails establishing a separate Web site to showcase these products.

Sharon and Galen conduct a peer review of each other's work before showing it to the creative director. As each designer presents his or her work, they realize they've taken two very different approaches. Sharon's design echoes many of the same visual design elements from the primary Web site. She's softened the color palette and introduced some texture, but otherwise relies on the same typographic system. In contrast, Galen's concept takes a radical departure, using an entirely new palette, changing the typeface, and minimizing references to the parent company.

Both designs follow the sketches established by the team earlier in the project. Both designs prioritize the right information and employ the same

navigation system. Both designs accomplish the same thing—establishing a Web site for a new line of products—but each takes a different approach.

Neither designer can understand why their designs look so different. After some discussion, they realize that their disagreement isn't about the outcome as much as it is about the **method** (method conflict):

Sharon: Your design looks nothing like the company's identity.

Galen: I know, I was trying to get away from relying too much on their visual system.

Sharon: But they specifically told us to extend their brand principles.

Galen: Right, and I did. I created a design that implied reliability, confidence, and accessibility. All of those things are central to their brand system.

Sharon: But you didn't use any of their colors. Even their logo is wrong.

Galen: Wrong? I minimized it because of the user research results. Remember, most of the consumer users said they either didn't recognize the company's name or they didn't trust it because of that scandal in the financial industry a few years ago.

Sharon: Sure, but the client said they still needed to maintain a connection to the corporate brand. Ultimately, they want to be transparent about who they are. I backed off the saturated colors a bit and introduced some playful elements, but mostly tried to stay within the standards of their brand system.

Galen: But you basically ignored the user research!

Sharon: I had to prioritize, and the client direction seemed pretty clear to me.

Galen: This would be a good thing to hash out with the client, no?

Sharon: Totally, though I think we should get the creative director in here to validate that the client hasn't already clearly stated their priorities.

TL;DR

Sometimes, solving conflict is the easy part. What's harder is identifying the real problem: Do you and I just disagree about design direction, or is there something more going on? If you and I disagree about design direction, is it because we have a different understanding of the design problem? Of the project parameters? Of the project's priorities?

This chapter established a vocabulary for analyzing situations, explaining that the conflict can be internal or external.

Internal sources of conflict come from the design decisions themselves:

■ **Method conflict:** The source of conflict has to do with how a decision was reached.

■ **Outcome conflict:** The source of conflict has to do with the content of the decision.

Design decisions yield one of four types of outcomes, and designers may lack a shared understanding of

■ **Product:** A decision about the design of the product

■ **Performance:** A decision about what the designer did or how the designer behaved

■ **Plan:** A decision about the structure of the project

■ **Purpose:** A decision about the goals of the project or product

External sources of conflict come from tensions—how people interact or react to a situation:

■ **Disconnectedness:** Despite active participation, the person feels like he or she isn't successfully contributing to the project.

■ **Exclusion:** The person is not participating in the project.

■ **Misdirection:** The person is focused on the wrong aspect of the design challenge.

■ **Ambiguity:** The person cannot express himself or herself clearly.

Analyzing and understanding situations is more art than science, and rarely do designers have the luxury of time to dissect a situation fully. When taking a moment to reflect on their difficulties, however, designers can ask themselves simple questions about whether the conflict is inside the design decisions or outside. From there, they can proceed to identify resolution strategies.

■

6

The Model of Conflict: Patterns, Situations, and Traits

DIFFICULT CONVERSATIONS on creative projects come in all shapes and sizes. Precipitating events for those conversations are likewise diverse. Here are a few of mine from the last couple of months:

- Valuable but poorly timed feedback from the client undermines much of the underlying structure of the team's design concept. The team has to revisit some key interface elements. The prototyper on the project, under pressure to finish a first draft of the prototype, calls into question many of the lingering design decisions.

- A team member neglects to complete the assignment and is transitioning to a new project, so is unavailable to help the team fill the gaps.

- A client wants to pile more work onto the team's plate, but the team doesn't have the capacity to take on the additional work. The client is unable to prioritize tasks to accommodate the limited availability.

As described in Chapter 4, all of these scenarios involve a lack of a shared understanding. For example, in the last scenario, the client and the team have different understandings of the nature of the relationship between them.

Chapter 5 provided some ideas for helping designers identify what's really going on in each of these scenarios. For example, in the second scenario above, the team lead clearly has a performance issue on her hands, but she might also look to external sources of conflict. In this case, the designer may feel disconnected from the project.

To have productive conversations about conflict, designers need a model that can address these and many other types of scenarios. That's what this chapter is all about.

The Model of Conflict

Of all the ways to talk about conflict, the most effective model for me involves three aspects (**Figure 6.1**):

- **Situations:** The different ways conflict manifests itself
- **Patterns:** The behaviors team members can use to deal with conflict
- **Traits:** The inherent characteristics that shape our behaviors and perceptions

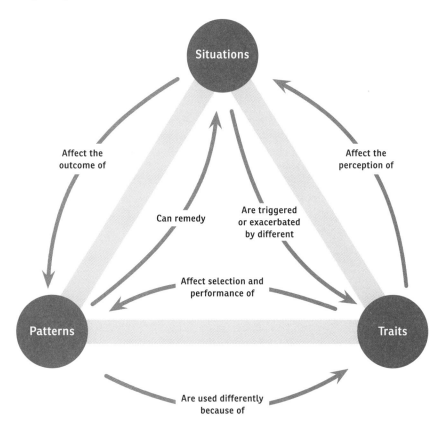

Figure 6.1. The model of conflict: patterns, situations, and traits.

This is the model in a nutshell, but it isn't the whole thing. Over the course of my career, I've been collecting examples of situations, patterns, and traits.

These are inventoried in Chapters 9, 10, and 11, respectively. They're short, and they're practical.

The remainder of this chapter elaborates on the model and provides some ways to think more deeply about each piece.

Situations

Chapter 5 deals with situations—the different ways conflict manifests itself—extensively. As a reminder, a situation is a scenario precipitated by conflict faced by a design team. The source of that conflict can be internal or external.

Internal Sources of Conflict

Internal refers to a design decision. There are two aspects to a design decision—the method and the outcome. Either one of these can precipitate conflict, since someone can disagree with what I decided or how I made the decision.

There is a range of "methods" that drive design decisions. Conflict between two designers usually comes from a disagreement about which method was used.

External Sources of Conflict

Note: *Conflict sometimes arises because a team member is a jerk. Keep in mind that some conflict is unhealthy because the participants aren't motivated by product quality or project completion. They're motivated by something from within, something separate from the project or the team.* ■

External refers to some interpersonal factor outside the design decision itself. This is conflict stemming from the way people interact with each other. Within a project, there are four ways conflict may arise outside the context of a design decision:

- **Disconnectedness:** Participation is ignored or minimized.
- **Exclusion:** Inability to participate.
- **Misdirection:** Focusing on the wrong things.
- **Ambiguity:** Inability to articulate ideas.

While these external sources of conflict are useful for deconstructing complex situations and zeroing in on underlying insecurities that motivate conflict, they are hardly exhaustive.

Patterns

"Pattern" is a term already used in design to refer to "effective starting points" for specific design challenges. A pattern, for example, might help a Web designer devise a solution for navigating a long list of content or a building architect establish an entryway. These starting points are not fully fleshed solutions, but neither are they devoid of concrete applications. In Web design, pattern libraries sprung up all over the Web in the 2000s, the most prominent being perhaps the Yahoo! Design Pattern Library.

Like design patterns, the patterns in this model of conflict are specific solutions for generalized problems. In codifying these conflict-solving behaviors, I intend to give designers simple techniques to try in complicated situations. These techniques aren't silver bullets, but they aren't so grandiose as to be impractical.

Therefore, these patterns are simple statements or ways of framing conversations. They're meant to open designers' eyes to different ways of approaching a discussion. They may challenge designers who have one and only one approach for dealing with difficulty. They may provide a crutch to those who know they need to do something differently, but don't know where to start.

Some principles about these behavior patterns:

- **No right answer:** There isn't one right answer for a given situation. That is, the pattern that works for a particular situation is the right answer, but it may not work in similar circumstances next time.

- **Diversity corollary:** Because there's no one right answer, any of the patterns may introduce a new approach for dealing with a particular situation.

- **No perfect fit:** On the flip side, not every pattern works in every situation. It can be a valuable exercise to imagine applying a nonobvious pattern to a situation, but that could be disastrous in practice.

- **Convergence:** Several patterns for a given situation may yield the same outcome or even the same approach. This doesn't make the diversity of patterns useless. Instead, it just means that there may not be a lot of different ways to think about that particular situation.

- **Comfort zone:** Designers will find that some patterns are more comfortable for them, and may retreat to these patterns frequently. Sometimes the best way to untangle a situation is to try something new, especially since it might surprise the participants.

I've categorized the patterns into four groups, depending on their overall approach to dealing with a situation.

Each type of pattern corresponds with one of the four external causes of conflict (**Table 6.1**). This isn't to say that there are no patterns for internal causes: just as conflict expresses itself through the behaviors of the participants, so too is it turned productive through behaviors.

Table 6.1 Causes of Conflict and Patterns for Dealing with Them

External Cause	Related Pattern Type
Disconnectedness	Empathize
Exclusion	Involve
Misdirection	Redirect
Ambiguity	Reframe

Empathize

Some patterns build empathy between team members. That is, their purpose is to break down misunderstanding. They encourage shared understanding by helping participants see each other's perspective.

Write what you hear is a pattern where one person visibly takes notes about what someone else is saying. Doing this makes the speaker feel heard, providing an opportunity to correct any misconstrued statements.

Involve

Some patterns establish a way for getting people more involved in the design process.

Tell me a story is a pattern where one person asks someone else to express his or her ideas in the form of a story. By using this framework, the speaker feels more engaged in the conversation.

Redirect

Some patterns help collaborators focus on the right things. There are many ways to find focus. Some patterns help narrow the scope of things to pay attention to while others ask participants to look at the situation differently.

Baby steps is a pattern for introducing large changes in a team or organization by first introducing small changes. This approach gets people to focus on more realistic, and less scary, changes.

Reframe

Some patterns help collaborators express themselves differently, to overcome semantic misunderstandings. If two people use a different "language" to talk about the same things they may not achieve a shared understanding. These patterns should align the language designers use to express themselves.

Good cop, bad cop is a pattern for defusing difficult situations by blaming a scapegoat (generally a manager) for increased pressure or challenge. It reframes the situation by putting it into a language of mutual self-preservation.

Traits

The third part of the model of conflict covers the baggage brought by each person on the team. Traits are preferences, styles, and characteristics. They're intrinsic, but two people with the same trait may express it differently.

Traits are an important part of the model. While it's useful to deal with situations independently of the participants—many design projects experience similar situations—designers must be aware of their own contribution to the situation.

Most traits are described as a scale. Some of the traits (like transparency) are purely positive or negative, so designers either have none, a little, or a lot of that trait. Some traits (like level of abstraction) have two extremes, where neither extreme is especially good or bad. In short, however, a designer may not always sit at one point on the scale. Though everyone has natural tendencies, they also vary their characteristics in different situations.

Self-Awareness

Traits help designers understand their colleagues. They provide a language for talking about perspectives and preferences. They take the guesswork out of what helps a designer thrive and what makes him or her stumble. But traits are important for designers to help them reflect on themselves. That is, designers must understand their own boundaries, their own limitations, their own strengths, and their own preferences. Through this self-awareness, designers can become more effective team members. Self-awareness allows

- Managers to assign projects, based on the workload, cadence, and other factors that impact a designer's success

- Team leads to anticipate risks, based on what they know about the designer's ability to deal with different challenges

- Colleagues to confront potential conflicts before they start, based on what they know about the designer's situational weaknesses

- Colleagues to provide support for key gaps, based on what they know about the designer's skill set

- Designers to plan their professional development, based on what they know about their own ability to perform

Traits encourage a granular view of individuals' personalities, whether reflecting on themselves or their colleagues. When first getting to know someone, however, designers can ask themselves broader questions about the four primary characteristics of a creative professional.

Four Characteristics

The traits listed in Chapter 10 offer pragmatic criteria for understanding designers' strengths and weaknesses. They're tactical and specific, dealing with preferences in project parameters, soft skills, and capacity to see different perspectives.

When sizing up new colleagues, however, there are really four questions to ask.

Style: What's Their Approach?

When talking about creative people, "style" often refers to a signature look. In the context of building better teams, though, style refers to a working style—the collection of characteristics that describes what it's like to work with someone.

Working styles come in all shapes and sizes. Some people are aggressive, some are passive. Some are steamrollers, others are conciliatory. Some people prefer to show work in its early stages and get lots of feedback. Others want to show a polished product. Some people thrive on feedback, while others cringe at criticism.

Great collaborators can recognize different styles and adjust their own approach to work with them, without sacrificing the elements of their style that make them great. To that end, great collaborators have a self-awareness of their own style, which makes them both good to work with and difficult to work with.

Agenda: What Do They want?

A person's agenda is his or her central objective. It's the answer to the question, "What's in it for them?"

Everyone on a design team assumes that everyone else has the same agenda—to create a great product. But there are as many motivations as there are people:

- Leave a legacy.
- Win more business.
- Get a promotion.
- Prove oneself.
- Get better at one's job.
- Pay the bills.
- Keep the client happy.
- Keep the boss happy.
- Keep everyone on the team happy.
- Focus on other things.

Dig deep enough, and you may find motivations that have nothing to do with design. Many of these objectives have the same outcome—a great product— but the behavior and approach for getting there will vary. People will do things that don't seem focused on that end.

Good collaborators make their agenda transparent. Even if my objectives are self-serving, by admitting them to my colleagues, I can be a more effective

contributor, setting expectations about my behaviors. It also gives my team constructive ways to communicate with me.

Imagine I was on the hook to provide some sketched design concepts and my effort shows little thought. **Table 6.2** shows some different ways my team lead can position her feedback, knowing my objective.

Table 6.2 Motivating People by Understanding Their Agenda

If my agenda is...	My team lead encourages me by saying...
Keep the client happy	"Our client really wants to see a wide range of ideas."
Focus on other things	"I know you have a lot going on, but if we show these ideas to our client, we'll end up doubling the amount of work we need to do later. Let's get these polished up so we can get clear answers on direction."
Prove myself	"It seems like you were somewhat tentative in your explorations, perhaps because you were afraid of failure. Frankly, now's the time to explore as many ideas as possible. That will help us establish boundaries and requirements. With a clear understanding of those parameters, we can mitigate failure later."

Circumstances: How Do They React?

If "style" captures a person's general approach with all things being equal, "circumstances" describes how they deal with the extremes. Design projects face countless pressures, both from within and from without. Substantive and irreconcilable disagreements in design direction, rapidly changing priorities, and sudden fluctuations in deadlines or budget make for difficult circumstances.

No one expects everyone to react heroically to dramatic changes in circumstance. Still, it can be disconcerting to see a trusted colleague crumble under the pressure of too many projects or unpredictable stakeholders. Depending on the working relationship between team members, colleagues may find a person's reaction to circumstances bewildering, frustrating, or perfectly normal.

Good collaborators recognize circumstances that cause anxiety, even anticipating the possibility of those scenarios when they see early warning signs. They explain what makes the situation difficult and what they need to do in order to continue being productive. Team members anticipating difficult circumstances might say

- "When I've had to juggle more than two projects in the past, I've really struggled to manage my time. Can you help me structure my schedule to be more effective?"

- "Indecisive stakeholders set me on edge. Can I come to you to vent?"

- "I'm going to need an escalation plan if I feel overwhelmed."

- "The last time I worked with this designer, we really butted heads. Can you give me some suggestions for working with him?"

Knowledge: What Do They Know?

The final characteristic is knowledge—the facts and skills and experience someone brings to a team. They may have extensive history with obscure technical arcana, or they may have worked on a project from a similar industry, or they may find the operating environment familiar. Knowledge encompasses the kinds of things people put on a resume, but experienced designers understand that for every skill and data point that someone brings to the table, there is nuance and range.

More importantly, understanding a person's knowledge means understanding where and how that person fits on a team. In structuring projects, team leads learn that designers aren't swappable one-for-one. Applying Designer X gets you stronger experience in a relevant industry but leaves the team with some holes in technical skills. Designer Y gives the team those technical skills but will require more oversight. Such conversations are crucial to successful collaboration, but impossible without understanding where someone's knowledge begins and ends.

Assessing Your Traits

The earlier section "Self-Awareness" explained why it's useful for designers to have a picture of their own strengths, weaknesses, boundaries, and capabilities. In short, a clear definition of oneself allows people working on projects to anticipate risks, fill gaps, and know how to rely on each other.

Flipping through Chapter 10 will provide some ideas on how to self-assess for different traits. Consider spending 30 minutes answering these questions to gain a better understanding of yourself as a designer in these four aspects

(**Table 6.3**). My intent isn't to give you a Myers-Briggs–style personality assessment, but instead some tools to reflect on who you are. From this exercise, you should learn a little something about yourself, but you should also become comfortable asking yourself these kinds of questions and answering them honestly.

Table 6.3 Questions for Self-Assessment

Style	Agenda
1. The last time you faced a difficult situation, did you capitulate or argue to get your way?	1. On what recent project did you do your best work? What brought that out of you?
2. Do you generally try to avoid confrontation?	2. When was the last time you felt dissatisfied with your work? What about the situation made it dissatisfying?
3. Does showing unfinished work cause you anxiety?	3. What are your goals as a designer or creative professional for the next one, three, and five years?

Circumstances	Knowledge
1. What is the best setting for you to do design work?	1. How would you characterize your comfort zone in your field of design? What is your level of confidence in these areas?
2. How many hours a day would you spend working alone at your desk, informally chatting with colleagues, informally chatting with stakeholders, or conducting formal design reviews?	2. In which area of your field do you have the least expertise or authority?
3. When was the last time you felt truly anxious on a project? What were the circumstances?	3. Where do you add the most value to a project?

Mutual Impact

Understanding the model of conflict includes understanding the relationships between situations, patterns, and traits. That is, in addition to looking at the individual components of conflict, the model acknowledges that they have a mutual impact on each other.

Situations < > Patterns

The relationship between patterns and situations is the essence of the model–the idea that designers can use patterns (specific behaviors) to untangle situations. The situation captures the discrepancy between two people—the thing they disagree about or how the misalignment is manifesting itself between them. By using patterns, designers try to achieve a shared understanding.

The relationship between patterns and situations is bidirectional, however. Just as a designer using a pattern intends to affect the situation positively, so too do situations have an impact on patterns.

Keep the following in mind:

■ **The right pattern:** Not every pattern will work in every situation. Different situations call for different patterns.

■ **How it's applied:** The same pattern may be used differently in different situations, such that the actual behavior appears different, even if inspired by the same pattern.

■ **The resolution:** Patterns employed in the same way in different situations, or even in the same situation in two different circumstances, likely lead to different outcomes.

Patterns < > Traits

The inherent characteristics, or traits, of a designer have several possible impacts on behavior patterns:

■ **Choice of pattern:** A designer's traits include how she perceives situations, circumstances, scenarios, and the world in general. That perception influences which pattern she chooses for a particular situation.

■ **Application of pattern:** A designer's traits include characteristics that influence her behaviors, in turn influencing how she interprets and uses a behavior.

■ **Pattern preferences:** A designer's traits include strengths and preferences, and she might gravitate toward particular patterns to play to her strengths.

■ **Trait reinforcement:** By using a particular pattern successfully, a designer may take that to reinforce part of her personality, or one of her characteristics.

Traits < > Situations

The characteristics of a designer impact the situations by

- **Precipitating specific situations:** Attributes lead to behaviors that lead to certain situations.

- **Exacerbating situations:** Besides causing situations, traits can make certain situations worse by reinforcing the misunderstanding between people.

- **Exacerbating traits:** On the flip side, certain situations bring out the worst in people. In this case, some situations may amplify a designer's trait.

- **Avoiding situations:** Designers may avoid certain situations because they recognize that their personalities aren't suited to dealing with them. Of course, avoiding a situation can exacerbate or precipitate other situations.

The Model in Action

Now let's look at an example of the model of conflict in action. Imagine a designer isn't delivering promised work within specified deadlines. The design lead on the project must confront the designer to identify and resolve the performance problem. The model of conflict can frame this scenario this way:

Situation

- **Insufficient progress:** Assigned tasks are incomplete.

Designer's Traits

- **Transparency: Closed book.** The designer is not great at communicating status updates.

Design Lead's Traits

- **Desired cadence: Daily.** The design lead likes to make incremental progress each day, and share it—even if incomplete—to solicit feedback.

Design Lead's Patterns

The design lead chooses a couple of patterns to help assess the situation:

- **Acknowledge achievements:** The design lead points out that the designer did deal with a particularly difficult design problem, but that he didn't complete the entire assignment.

- **Ask questions:** The design lead asks a lot of questions about the tasks to find out what prevented the designer from completing the assignment.

Upon learning that the designer struggled to make progress because he didn't have a complete set of inputs, the design lead uses these patterns:

- **What's your first step?** Having clarified the assignment and established follow-on tasks, the lead asks the designer to spell out the first steps he would take toward achieving those objectives.

- **Provide starting points:** The design lead also sketches out some initial ideas to help the designer get over the hump of missing inputs.

Next, of course, the design lead must have a difficult conversation with project stakeholders to explain the delay.

TL;DR

This chapter described the model for conflict resolution. The model defines three aspects of conflict resolution:

- **Situations:** The different kinds of conflict (misunderstanding) that happen on creative projects

- **Patterns:** The behaviors designers can use to achieve shared understanding

- **Traits:** The characteristics and attributes inherent to designers that affect their perception of situations and their behaviors

Each aspect of the model mutually influences the other aspects. In any given circumstance, the situation will bear upon which patterns are selected or how people react to it. The pattern used to deal with the situation is influenced by the person using it and the circumstances in which it is used. Personality traits affect how people perceive and react to situations.

For more on each of these, see Chapters 9, 10, and 11, which provide an encyclopedia of different situations, patterns, and traits.

■

7

How Collaboration Works

AFTER THE LAST several chapters, you might think that great design teams do nothing but fight all day. (If so, I'd suggest you go back and read those chapters again, as they made clear that conflict in design is not fighting.)

Beyond conflict, though, what makes design teams effective? If conflict is the engine, then collaboration is the oil. (And I think that's a good time to stop using that metaphor.) Many books on collaboration stitch together lots of techniques for encouraging employees to work together. There is perhaps no better example of this than David Coleman's *42 Rules for Successful Collaboration*. In the section on "Collaboration Tools," rule 31 is

> Collaboration tools should be easy.

The truth is that all tools should be easy, and collaboration is no exception. It's "rules" like these that conceal the real impetus of collaboration, because collaboration is much more than a set of techniques. Collaboration is a system of beliefs embedded into the culture, the minds, and the tools of a design team to yield better work more effectively. At the heart of collaboration is the single belief that working together produces far better design than working alone.

This chapter will unpack this simplified definition of collaboration:

> Working together to produce something better that you could not have produced on your own

It will look at the thin line between collaboration and groupthink, squash some of the myths of collaboration, and finally lay some groundwork for my model of collaboration.

A Definition of Collaboration

The dictionary definition of collaboration ends at "working together," but for design teams, that isn't enough. Working together merely for the sake of working together offers little value to people who pride themselves on their individual ingenuity.

More Than Working Together

"Producing something" is an important component of my definition. One trap of any creative endeavor is "spinning"—going round and round on ideas without getting to a tipping point where you can take those ideas to the next

step. Spinning feels productive because the team seems to evolve the ideas. In reality, however, the team hasn't gotten to a design definition that lets them elaborate the details or begin building the product. The sad truth is that spinning is magnified for each additional member of the team: the design effort is even more counterproductive. Members of the team act as enablers, creating a twisted codependency of revising decisions and revisiting requirements. (And, yes, I have worked for the federal government, why do you ask?)

Collaboration, therefore, must yield product, not simply ideas. The second component of the definition insists that the product is better than what any one person can make individually. This implies two fundamental corollaries to the definition of collaboration (**Figure 7.1**):

- **The Corollary of Perspective:** The design benefits from the contributions of multiple perspectives.

- **The Corollary of Production:** The product is so complex that the knowledge and resources required to make it a reality are not within the power of a single person.

COROLLARY OF PERSPECTIVE

COROLLARY OF PRODUCTION

Figure 7.1. Two corollaries of collaboration: perspective and production.

Incorporating Multiple Perspectives

One reason why collaboration entails creating a product that you couldn't do alone is that design benefits from multiple perspectives. There are lots of ways for different people to contribute to the design process. One common view of the design process, known as the *diamond model*, is that it starts by generating lots of ideas, then ends by winnowing down those ideas into a single concept (**Figure 7.2**).

Figure 7.2.
The diamond model of design.

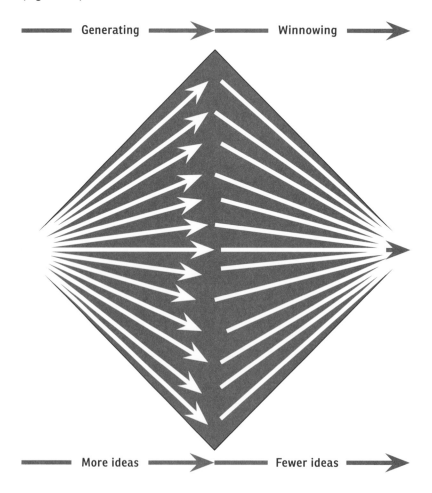

Multiple perspectives offer several possibilities to enhance this process. Here are a few ways that can happen:

- **Ideas:** A team can generate lots of ideas.

- **Questions:** Different people will ask a broader range of questions to help stimulate and validate ideas.

- **Constraints:** Different people will perceive the constraints of the design challenge differently, yielding different design concepts and different critiques of design.

Teams of more than one person offer countless opportunities to improve on design ideas—more brains to evaluate, question, elaborate, and contribute.

Distributing Production

In many design fields, the products and outcomes are so complex that no single person can maintain enough knowledge to do it all. The architect may be able to design an extension for her home and do the renovation herself, but designing and building a skyscraper is of a different scale.

So, even if the design team consists of only one designer, that person still must collaborate with other disciplines to bring the design to reality. Building the product these days stretches across many different kinds of industries and disciplines. There are endeavors like designing buildings and Web sites, but there are also endeavors like designing a call center process or designing hospital patient intake procedures. In this case, the outcome (the product) is the people. In short, the realization of a design concept—physical, virtual, or service-based—depends on other people.

Despite the advantages of perspective and production, more people does not automatically equate to better products. Collaboration does not ensure quality. Indeed, it's possible that teams of greater than one person can do more harm than good. One thing to look out for, for example, is groupthink.

Collaboration vs. Groupthink

Groupthink is a concept from social psychology capturing the idea that the desire for harmony undermines the desire for quality. People would rather agree with each other than come up with something better. One of the charges leveled at collaboration is that it leads to groupthink. But unqualified

conformity isn't inherent to collaboration. On the contrary, collaboration done wrong can lead to groupthink.

Carol Dweck, the psychologist who elaborated on the idea of mindset, uses groupthink to illustrate how a fixed mindset can poison a group. Recall that a fixed mindset is one in which the person believes that people's intelligence and talents are innate—that no amount of work can help them improve. The fixed mindset, especially among leaders, can undermine a group's ability to perform. In her book *Mindset: The New Psychology of Success*, Dweck offers three explanations for groupthink:

- "Groupthink can occur when people put unlimited faith in a talented leader, a genius" (134).

- "Groupthink can happen when a group gets carried away with its brilliance and superiority" (135).

- "Groupthink can also happen when a fixed-mindset leader punishes dissent" (135).

Its critics sometimes make these arguments against collaboration as well. Indeed, collaboration gone wrong exhibits these same symptoms of groupthink. But collaboration must be organized to prevent these risks:

- Collaboration requires strong leadership and facilitation, someone to make decisions, but not in a dictatorial fashion.

- Collaboration requires established success criteria to allow participants to validate their ideas.

- Collaboration must be conducted in a safe space where all participants are allowed to disagree, but where established rules prevent consensus from beating out quality.

But even collaboration done wrong doesn't reflect the same risks as groupthink. Whereas groupthink can produce answers, they may be no better than ones vetted and elaborated through collaboration. Collaboration gone wrong, however, can be the opposite—lots of effort with little to show. This experience of collaboration is what leads to common misconceptions about it.

Misconceptions about Collaboration

There are three ways in which people misunderstand collaboration:

They **oversimplify** what it is.

They believe it to be **ineffective and inefficient**.

They focus on the **wrong aspect** of it.

Collaboration is far more complex than they realize, far more productive than they imagine, and much more about behavior and culture than tools and activities.

Oversimplification

Sometimes, people think of collaboration in very simple terms, ignoring the planning, structure, and organization it requires. There are three common misconceptions that oversimplify collaboration, as discussed next:

- **Throw smart people together.** Suffice it to say that working with smart people is satisfying and challenging. But collaboration isn't just about smarts. It's about providing a framework for working together. Just as important as intelligence is a willingness to work within the framework.

- **Put people in the same room.** Collaboration doesn't just happen when people are face-to-face. Collaboration must be embedded in the culture of a team, such that the team thinks about working together—depending on each other, seeking out contributions and critiques—even when they're not in the same room.

- **Do what we did before.** There isn't some one-size-fits-all technique that teams can use to collaborate. While good collaboration comes from the same set of values, each team must establish its own rhythm, behaviors, and habits.

Ineffective and Inefficient

Collaboration has a reputation for producing little value for lots of time invested. Besides mistaking collaboration for "putting a lot of people in a room," this view also discounts the opportunity costs of distributing work. This leads to three additional misconceptions:

■ **The best ideas are from independent thinkers.** Collaboration naysayers sometimes imply that independent thinkers are more successful. This emerges as a celebration of the introvert. This view is shortsighted in many ways, but especially in how it positions collaboration as simply a mechanism to generate good ideas.

■ **Brainstorming doesn't work.** Positioning collaboration as ineffective brainstorming is a twofer. On the one hand, collaboration is much more than brainstorming. On the other hand, brainstorming can be effective if framed correctly.

■ **Design by committee doesn't work.** Designers learn to fear "design by committee," the practice of having every design decision vetted and discussed by every member of the team. Part of collaboration is establishing a framework for making decisions, which isn't necessarily building consensus. Good collaboration entails each person doing the work for which he or she is best suited.

Wrong Focus

Good collaboration is built into the culture of a team, manifesting itself in the process and the people. Some misunderstandings of collaboration pick on only one aspect, without appreciating the greater whole.

■ **Collaboration is about tools.** Some people focus on the tools of collaboration—file-sharing services, conference call systems, screen-sharing software, to name a few—and not on how those tools support a culture of collaboration.

■ **Collaboration is in the project plan.** On the flip side, some people focus on the activities of collaboration, inserting them into their project plan without first considering the intent. They ask teams to participate in these

collaboration activities without also providing the right tools or encouraging the right behaviors in the culture.

- **I'm not good at collaboration.** Finally, people think that collaboration is a skill that you can be good or bad at. (This is directly related to the fixed mindset, which generally insists that skills and talents are innate.) The truth is that collaboration is less skill and more habitual behaviors. It can be challenging for people to adopt these habits because they feel contrary to their personalities. But since collaboration is a range of habits, dispositions, and techniques, there is something for everyone in a collaborative culture.

When Collaboration Isn't Working

Team leaders may try to encourage collaboration but base their approach on one of these misconceptions. For example, they might deploy a new file-sharing system or drop in a new brainstorming technique without first laying the groundwork for a collaborative culture. When you encounter these attempts, and they fail, don't let the organization throw the baby out with the bathwater. Use the failed attempt as a way to introduce these values, at least in part, and encourage the team to review the tool or activity or what have you. Use the review to surface what worked and what didn't work about the tool, and what about the current culture prevented the team from adopting it effectively.

The Aspects of Collaboration

If collaboration is "working together," then it is a philosophy that is embodied and manifested in three things: tools, mindset, and culture.

- **Tools:** The systems used to collaborate—not just the physical and virtual tools, like document cameras and file-sharing software, but also techniques and activities.

- **Mindset:** The attitudes and preferences of the individual members of the team, setting the tone for their perceptions and behaviors.

- **Culture:** The collection of policies, procedures, and corporate attitudes that provide a setting for design.

ARE YOUR COMMUNICATION TOOLS PROVIDING THE RICH
ENVIRONMENT YOU NEED FOR COLLABORATION?

Jeanine Warisse Turner, PhD
Georgetown University

Collaboration can be problematic in the best of circumstances, when we are working
with people we like, who like our ideas, in a common physical space with access to
all the body language, tone, and other nonverbal cues to support and reinforce our
messages. When we start removing some or all of these variables, the collaboration
environment can become much more intense, complicated, and challenging.

While communication technology innovations have created many opportunities for
new forms of collaboration with an ever-expanding possibility of partners, it also
brings challenges. Researchers have explored how the "presence" created by the
communication technologies involved impacts communication. In the '80s, research-
ers Robert Lengel and Richard Daft (Lengel & Daft, 1988) suggested that media could
be characterized by how rich they were in providing cues. Face-to-face was the "rich-
est" in that it provided the opportunity to use nonverbal cues, tone, personal focus,
and feedback to convey a message. Leaner media like a fax or computer report pro-
vided fewer opportunities to convey the same message. These researchers suggested
that complicated discussions required richer media. When we receive limited infor-
mation through a channel (for example, email), we don't often stop ourselves to say,
"I better be careful how I interpret that email because maybe they didn't mean it that
way." Instead, we make assumptions about the content based on limited information
and hit reply.

While complicated discussions and misunderstandings can happen at many stages of
a collaborative process, early stages of the process are critical. When a team is devel-
oping a vision for a project and making decisions about responsibilities and action
steps for future work, a rich environment for information is important. Not only does
a richer environment convey more information, but it also provides the opportunity
to provide relational cues that support the development of trust and rapport. These
elements are critical as the project progresses and the misunderstandings can spiral
without a sense of relationship established first.

For example, when I first met Dan (this book's author) we talked for about an hour and a half over lunch about his ideas about collaboration and its impact on design. I was able to get a sense of Dan, his excitement about conflict and its contribution to design, and his collaboration ideas in a full and rich way. We had a stimulating discussion as we compared our ideas and thoughts based on our different backgrounds. Later, when he called and asked me to contribute to his book project, I reflected back on that conversation to better understand what he needed. Then, once we decided on a course of action, email was helpful to facilitate our exchanges. The more certain we both were with our understanding of the project and each other, the less richness we needed in our communication environment.

Today, we have many more technological options for communication, and these tools are becoming more and more integrated into our daily practices. We can video chat with multiple groups while simultaneously collaborating and contributing to a project in real time. In fact, technology designers have worked hard to replicate many of the mechanics of a face-to-face collaboration in a virtual environment. However, it is important to continue to think about the "richness" provided by the tools you are using. And when collaboration becomes difficult, emotional, or complicated, it is important to question the tools you are using and whether the lack of communication cues available to you or your conversation partner might be contributing to those challenges.

Lengel, R., & Daft, R. (1988). "The Selection of Communication Media as an Executive Skill." *The Academy of Management Executive*, 2(3), 225–32. ■

Tools

Without knowing anything about a design team, you can tell a lot from the tools they use to collaborate. For example, most creative teams use simple digital communications channels like email. Some may use instant messenger, video chat, or screen sharing. These tools may indicate some degree of collaborative virtues. Tools that help team members coordinate their activities, communicate availability, and provide continuous status updates on projects may indicate a higher degree of collaboration. A team's tools are the most tangible evidence of its style of collaboration, but they are by no means the only way to measure a team's collaborative effectiveness.

The best teams have a broad collection of tools they can draw on to address different situations. The best tool sets for collaboration have

- **Redundancy:** Tools that do similar things, which allow teams to adapt when one tool fails. For example, having multiple options for video chat in case one service is especially slow that day.

- **Variation:** Slight variation in overlapping tools allows you to choose the right tool for the nuance of the situation. Understanding the slight variation of tools means you can anticipate potential compromises or risks using particular tools in certain situations. For example, I use both Skype and my mobile phone to make phone calls, but I use them in different circumstances.

- **Portability:** Collaboration takes teams to different locations, and the tools must adapt to these circumstances. For example, Dropbox is a service for file sharing, but users can access their files through multiple devices— laptops, smartphones, or tablets.

Software Tools

Your team's toolset should include at least one of each of these types of tools (and I'm going under the assumption that you have email already).

Note: *In addition to this software, I also regularly use a lightweight document camera (the Ipevo Point2View) to share sketches in real time.* ■

- Instant messenger (like Google Talk, Skype, AIM, etc.)

- Voice chat (like Google Chat or Skype)

- Video chat (like Google Hangout, Skype, or GoToMeeting)

- Calendar sharing (like Google Docs)

- Presence indicator (indicating whether you are available or not, present in applications like Skype and instant messenger)

- Screen sharing (like GoToMeeting or Skype)

- File sharing (like Dropbox)

- Document sharing (like Google Docs for spreadsheets and word processing)

- To-do sharing (like Basecamp)

- Assignment sharing (you can use a spreadsheet for this)

- Time tracking (like Harvest)

Yes, a single tool can accomplish more than one of these needs, but I use several tools to be redundant across these needs. For some, like your calendar or to-do or file sharing, you must have only one point of entry, so people know where to find that information. For others, the team can choose the right tool depending on circumstances.

Creative Collaboration Techniques and Methods

There are dozens of books on creative collaboration techniques, describing different ways to engage groups of people in the creative process. This book isn't so much a collection of these techniques as it is a handbook of behaviors and habits for good collaboration. (Those will come in the next few chapters.) As with software tools, however, there are a handful of must-have collaboration techniques and methods:

Note: *For a fantastic collection of brainstorming techniques, see instead* Gamestorming *by Brown, Gray, and Macanufo, or* Thinkertoys *by Michalko.* ■

Structured Brainstorming

Collaboration is much more than brainstorming (see the "Misconceptions about Collaboration" section), but brainstorming is a crucial element. Creative collaboration books are a good source for designing, organizing, and facilitating such a meeting.

For example, my team uses the **design studio technique** to sketch and refine lots of ideas, relying on each other for inspiration and validation. The way the exercise is structured, the team can focus on a single scenario, generate lots of ideas, and zero in on a handful of good directions.

Structured Feedback

Designers thrive on constructive feedback. Vapid nods of assent are like kryptonite for designers. Therefore, good collaborative teams have sessions that provide such feedback, and do so in an organized way.

For example, my team builds **peer reviews** into the project plan, preceding major milestones to ensure the designer has adequate input before finalizing the design.

Performance Reviews

Designers also need ongoing feedback on their overall performance, the value of their contributions, and the quality of their portfolio.

For example, my team couples annual performance review surveys with somewhat more informal **quarterly reviews**. Those sessions allow us to pinpoint any trouble spots while ensuring that their activities align with their goals.

Periodic Work-in-Progress Sharing

Creative all-hands meetings help build connections between project teams, strengthening the relationships across the entire organization. In these conversations, designers prepare short presentations to highlight work in progress.

For example, my team holds a monthly **Share & Care**, where people prepare eight-minute presentations of their recent work. They share work in progress or completed work. Sometimes we see the same project from multiple perspectives, kind of like the *Canterbury Tales* of a design team. We don't use this time to provide extensive critique or feedback: after trying that out, we realized that this isn't the right tool for that job.

Task Planning

Teams working collaboratively to tackle a problem need coordination—who's doing what, what's due when, who's dependent on whom, etc. These task-planning conversations can be formal or informal. They can take place daily or weekly, as often as needed.

For example, my entire team meets on Mondays, and project leads provide a **high-level status** of where things stand with each project. This gives every member of the team an understanding of the "shape" of the week. Individual project teams on large projects also meet weekly to **hash out individual tasks**. Smaller project teams may coordinate somewhat more ad hoc.

Tool-Based Obstacles

Design teams must adopt tools that support the values of collaboration (described in the next chapter). Still, tools are practical things, and they must also do a job. It can be hard enough to find the right tool for the job, much less one that embodies clarity or accountability. Tools can also get in the way of collaboration if they're unreliable, inappropriate, or impractical.

Unreliability

There is perhaps no greater frustration for the designer than a projector that doesn't show colors accurately, or a GoToMeeting where the audio doesn't work. These minor technical hiccups can turn a slight delay in getting started into severe anxiety.

The cure here is redundancy. By giving yourself multiple options for dialing into a conference call or displaying design ideas, you can smoothly circumvent obstacles that arise.

Inappropriateness

Selecting the right tool or technique can be challenging. This may be more relevant for techniques, where you know you need to do, say, brainstorming, but you're not sure which is the right method. What defines "appropriate" in selecting the right technique varies by circumstance. Planning a project where a handful of stakeholders refuse to participate actively might mean scheduling review sessions strategically and foregoing brainstorming. On the contrary, planning a project where stakeholders expect to participate in every design decision requires different tools.

The cure here is knowing the minor nuances of each tool, such that you can fine-tune your selection based on need. You can also anticipate problems because you know that, say, Google Hangout can support only a limited number of participants.

Another cure: Try to build a little room for experimentation into each project, so you can see how different techniques work in different circumstances. Taking an opportunity to expand your understanding of the technique, method, or tool will let you employ or apply it better in the future.

Impracticality

Tools work within a set of constraints imposed by the composition of the team, the nature of the project, or the project's context. Constraints might include

- For team composition: People unfamiliar with the tool; people who don't have access to the tool; people working remotely

- For the project itself: Insufficient budget, time, or resources to implement the tool

- For the project context: No buy-in from the organization to use the tool; geographic limitations of the organization

For example, I may want to conduct a large group brainstorming session, but the team is geographically distributed across several locations and there is insufficient budget to cover that much travel. The team could make some hard decisions about which team members need to be present in person, or they could seek out other technological solutions. In the case of one recent project, the team used a telepresence system, like a room-sized video chat, to conduct the brainstorming session. While it was more cost-effective than flying the team in from four different locations, it did have its limitations—and now we know for next time.

With knowledge of the way constraints impact the use of the tool, teams can anticipate impracticality. They can assess the risk, at worst knowing what challenges they might face and at best attempting to mitigate them. The cure again is an intimacy with the tools.

Mindset

Note: *A disclaimer about introverts: Just because someone needs to be alone to reset and relax doesn't mean he or she is someone without a collaborative mindset. Shy people can derive the same satisfaction from collaboration that others do, but it may happen on different terms.* ■

Tools present an ongoing challenge: collaborative teams constantly demand new and better tools for further improving their efficiency and effectiveness. Their unreliability and inappropriateness and impracticality are facts of life that good teams integrate into their modus operandi.

Furthermore, successful collaboration can be undermined by a single person whose attitude and approach doesn't align with the collaborative way.

This book discusses mindset extensively in Chapter 2, describes the attitudes that make up a collaborative mindset in Chapter 8, and offers behaviors that embody collaboration in Chapter 12. For now, I'll describe the obstacles to collaboration that come from inside a person.

Mindset-Based Obstacles

It may not be easy to swap one tool with another, but you can picture the process. You know what it takes, and what the impact would be. You could probably frame up a project to swap one file-sharing service with another, or introduce a new brainstorming technique into a project. But to swap mindsets? Not so easy. Much of the fear, discomfort, and doubt that hinders a person's ability to collaborate is deep-seated.

To be blunt, each of these issues or insecurities prevents designers from participating in a collaborative process because they prevent them from embracing the values of collaboration (discussed in the next chapter). What's worse,

there's something about the collaborative process that exposes the designer in some way, forcing him or her into a defensive position.

In general, mindset-based obstacles prevent people from exhibiting collaborative behaviors like those described in Chapter 12. Such obstacles manifest themselves in two main ways:

- **Arrested performance:** Not meeting expectations in terms of their assigned tasks

- **Disrupting others:** Preventing other members of the team from performing their tasks

I'm no therapist, so I can't offer any constructive suggestions about how to unseat these anxieties. When confronting my own issues, however, I can tell you that acknowledging and recognizing them goes a long way. Admitting them to colleagues helps you manage the consequences of these fears. Even after acknowledging, recognizing, and admitting, the path to refactoring your mindset is hardly smooth.

Difficult Situations

Most of these mindset-related obstacles are variations on a theme, different ways of singing the same note. You may have observed (or experienced) other ways in which people struggle to immerse themselves in a collaborative process. These attitudes can lead to difficult situations (described in more detail in Chapter 9).

- **Lack of confidence:** Most designers deal with this issue at one point or another in their careers. With a lack of confidence, designers may react by feeling the need to prove themselves or opting out of participation altogether.

- **Too much ego:** Oversized egos disrupt the participation of other people by preventing them from making contributions.

- **Fear of failure:** Fear of failure can manifest itself in many different ways. Designers may approach challenges with apprehension because they are afraid of failure. They might refuse to ask for help, leading to further challenges and additional anxieties.

- **Lack of trust:** Designers may struggle to trust their teammates (perhaps because they also have an oversized ego), making it difficult for them to delegate responsibilities to others.

- **Lack of interest in participating:** Everyone is busy. Some team members and participants may have higher priority projects. Their attitude and

disposition during design activities betray a lack of engagement. Such behaviors may conceal one of the other issues on this list, but the attitude as manifested is, in and of itself, toxic to the project.

- **Inability to take criticism:** Some people respond poorly to criticism, even if offered constructively. Their constant defensiveness makes it difficult to engage in productive conversations.

- **Inability to adhere to role:** Occasionally accompanied by a lack of trust, some people step outside their area of responsibilities. While this blending of responsibilities can be the hallmark of effective teams, it can also backfire when someone prevents other team members from participating.

- **Inability to new try processes:** Some people's insecurities manifest themselves in a fear of trying anything new. They remain stuck in their current approach, unable to adapt to unique situations or changing circumstances.

Perhaps you can think of some examples from your own experience of people exhibiting these and other kinds of fear, discomfort, and doubt. Perhaps you, like me, can see some of these in yourself at various stages of your career.

Culture

Culture is the system of policies, procedures, and incentives built into a team, organization, and workplace. It is the context within which teams operate. The culture may not directly contribute to the project, but it influences the way teams operate and behave. Some consulting companies, for example, have a culture of long hours, allowing their employees to work 10- or 12-hour days without compensating them. Some internal design groups face corporate cultures that are inherently skeptical of the value of design.

Both attributes—long hours, skepticism of design—influence the shape and progress of a design project, and are inherently detrimental to collaboration. (One might argue that the camaraderie built through long shared hours or "us vs. them" helps collaboration, but mutual friendship in adverse circumstances does not an efficient team make.)

Culture-Based Obstacles

Culture is the third leg of the collaboration stool, and the one which individual designers may have the least control over. Attempts to behave against the grain of the organization may have dire consequences. The slightest perception of a poor fit can make things difficult for them. Designers and teams attempting

collaboration may encounter hostile cultural artifacts like physical space, organizational roadblocks, and policies that encourage noncollaborative behavior.

Inappropriate Workspaces

The physical workspace of a creative team must afford different types of activities. A "cube farm" and a totally open workspace are two extremes, neither of which are alone suitable for a creative team. Designers need places for

- Holding large brainstorming sessions
- Holding small design review sessions
- Working quietly in pairs
- Working quietly individually
- Participating in conference calls

Organizational Silos

While organizations require structure to work efficiently, silos can become obstacles to communication: people in one part of the organization are "not allowed" to talk to people in another part. Working together is difficult when crucial contributors are inaccessible.

Emphasizing Competition

Designers like to solve problems. Competing with each other isn't necessarily the best way to encourage problem solving. While it's true that design sometimes means generating lots of ideas and then winnowing those down, that is but a small part of the design process. Stronger and more efficient teams make everyone feel like a valuable contributor, even if the central concept isn't "theirs."

Corporate cultures can emphasize competition, from publicly rewarding "winners" to using competition as the primary vehicle for structuring all creative activities. Such ongoing competitiveness can be exhausting for design teams, who come to believe that winning is more important that solving the design problem.

Obviously, some policies and idiosyncrasies of the organization may indirectly inhibit collaboration. For example, not reimbursing employees for local travel expenses may discourage them from meeting in person when warranted. That said, not every policy can be made in the name of collaboration. Employees must be cautious about overthinking the organization's impact on the team's ability to collaborate.

TL;DR

This chapter defined collaboration in the context of creative projects as

Working together to produce something better that you could not have produced on your own.

It described

1. How multiple perspectives add value to the creative process.

2. How collaboration is different from groupthink.

3. The three main misconceptions people hold about collaboration: how they oversimplify what collaboration is, how they believe it to be ineffective, and how they focus on the wrong aspects.

4. The three aspects of collaboration:

 a. **Tools:** The applications, methods, and techniques teams use to work together.

 b. **Mindset:** The attitudes and preferences individuals have about collaboration.

 c. **Culture:** The system of policies, procedures, incentives, and corporate attitudes that provide a context for collaboration.

5. The obstacles teams face in each of these aspects:

 a. **Tool obstacles:** Tools can be unreliable (they don't work as expected), inappropriate (they don't do what needs to be done), or impractical (they don't suit the constraints of the team, project, or context).

 b. **Mental obstacles:** The variety of mental blocks that people experience may lead to a lack of performance or disruption of other people's work.

 c. **Cultural obstacles:** These include challenges presented by the physical space, by the structure of the organization, and by the institutionalized attitude toward cooperation versus competition.

8

The Four Virtues
of Collaboration

THE PREVIOUS CHAPTER explained that collaboration flows through all aspects of the working environment—the tools used by the team, the mindsets of the people involved, and the culture of the company. Sure, a team can adopt a new collaboration tool to share files, but if sharing isn't in the mindset of the team or encouraged by the organization, what's the point?

When a team has embraced all the virtues of collaboration, its members start to exhibit certain behaviors. Here are just a few:

- They provide candid feedback on design work in a way that offers constructive criticism without putting each other on the defensive.

- They highlight risks to their performance due to unusual or uncomfortable circumstances, like brainstorming remotely.

- They are familiar with a variety of communications mechanisms and comfortably switch between media depending on the need.

- They candidly discuss their roles on a project to ensure they can be mutually supportive without being unnecessarily redundant.

- They immediately set expectations about their ability to deliver on tasks, clarifying the scope or desired output of the assignment.

These behaviors may seem like common sense. Yet the converse isn't so difficult to imagine: feedback that isn't constructive, unwillingness to admit discomfort, stuck using email alone, plowing forward without clarifying roles, and jumping into a task without validating scope or direction.

This chapter describes these virtues, how they make an impact on a project, and the way they manifest in tools, mindset, and culture.

The Virtues

At the center of great collaboration sit four virtues, four guiding principles that pervade tools, mindsets, and culture. Software applications, individual attitudes, and corporate policies all exhibit these same virtues when they support great collaboration.

These virtues are

- **Clarity and Definition:** Expressing and articulating clearly
- **Accountability and Ownership:** Understanding and taking responsibility
- **Awareness and Respect:** Empathizing with your colleagues
- **Openness and Honesty:** Stating and accepting the truth

Clarity and Definition

The virtue of Clarity and Definition requires that

> Team members articulate their ideas clearly and establish a common language for talking about the elements of the project.

Great collaboration depends on participants clearly expressing their ideas, their feedback, and their questions. Any obfuscation prevents people from achieving a shared understanding.

In my work on an internal application for a dental insurance company, for example, I had to learn about all aspects of dental insurance. Being a business owner and someone who has dealt with insurance most of my life, I had some background on things like copays and deductibles and even different plan types. That was a good starting point, but to be effective on the project I had to learn about different types of diagnoses, the classifications of different customers, and how claims were handled.

Every project establishes a unique vocabulary, a set of terms specific to that project that help marry the domain with design. In my work as a Web designer, I use terms like "category" and "navigation" and "header" and even simpler ones like "list" and "item" to refer to different aspects of the Web site design. Web sites rely on underlying structures—those that classify the content, those that establish relationships between the content, and those that frame the domain.

Fundamental project concepts are central to achieving a shared understanding, but the virtue of definition extends well beyond them. The model of conflict laid out in Chapter 5 suggests other parts of a project that require clear definition, including

- Clear definitions for team members' **performance**: tasks, deadlines, expected quantity of output, and expected level of quality

- Clear definitions for the project's **plan**: content of milestones, roles and responsibilities, constraints, and success measurements
- Clear definitions for the project's **purpose**: scope of design work, expected role of design team, intended goal for the project, and role of the product relative to the market

This is but a small sample of project aspects requiring clarity and definition.

Accountability and Ownership

The virtue of Accountability and Ownership requires that

> Every team member has well-defined responsibilities, a good understanding of his intended contribution, and some stake in the project outcome.

For many people, the word *collaboration* implies a sense of shared ownership, consensus building, and the expulsion of lone visionaries. Gosh, I hate that view of collaboration.

Instead, I like to think of collaboration as a well-oiled machine, a sense in which each person has a part to play, knows what part that is, and is held accountable for that part by others. For some, that part is to establish the overall vision, and perhaps even to make most of the design decisions. For others, that part is to flesh out the details, mitigate project risks, or coordinate activities between different team members.

Embracing the virtue of accountability and ownership depends on design teams having three things:

- **The lead:** Teams must have a reliable leader who can make decisions.
- **Roles and responsibilities:** Teams must have well-defined responsibilities.
- **Individual performance:** Teams must support individuals taking responsibility for their actions.

The Lead

Collaboration doesn't work when there is no accountability or ownership. This includes someone who is ultimately accountable for the two dimensions of a project: quality and movement. (Remember those from Chapter 4?) A project lead is ultimately accountable for organizing the project structure and team members so they reach project goals. The lead is also responsible for ensuring

that project stakeholders are getting what they need and that the designed product is good.

These roles may be assigned to different people, such that a project manager drives progress toward milestones and a creative director enforces the vision. My experience shows that separating these responsibilities isn't usually in the best interest of the project: a good lead knows where she wants to go and knows how to get there.

This isn't to say that the rest of the team comprises interchangeable, powerless automatons. A lead relies on team members to bring complementary skill sets and unique perspectives. At the risk of sounding cliché, it takes a village to bring a design project to completion, but the village needs a good leader and everyone in that village needs to know how they contribute to the greater good.

Roles and Responsibilities

Project teams need, therefore, clearly defined roles and responsibilities. If team members aren't mindless automatons, they must know—without a doubt—what they're being held accountable for. Defining a role means clearly stating the expected activities and their corresponding outputs.

Defining activities and outcomes is useful because even among team members with a long-standing rapport, people may have different expectations about what to produce for a given activity. A subtler dimension is the range of quality and formality of an output. Any single activity can yield something rough, informal, and good enough to get to the next step, or something polished and presentable. Different team members may have different expected levels of detail.

In one project, I was working with someone to produce a set of guidelines. We never agreed on the level of detail for those guidelines. Whereas I expected several pages of rich direction for the client, my colleague produced only a one-page sheet with some high-level bullet points. It later became clear that we had different ideas at the outset about what the final output should be.

In my experience it is these variations—quality, formality, detail—that trip up design teams. One person is expecting one thing, and another is expecting something different.

Individual Performance

There is another important component to this virtue: Team members must be accountable for their own performance and behavior. They must own up to their shortcomings to help the team fill the gap. They must honestly communicate progress, even if it isn't meeting expectations. They must acknowledge their inability to deal with certain challenges.

Many new designers I work with struggle to understand that they're not judged on their performance—well, not strictly on their performance.

They're judged on their ability to set expectations with their team leads:

> Not just
>
> "I can have that done by tomorrow."
>
> But
>
> "I can do most of what you asked by tomorrow, but I'm a little unclear on how to handle the navigation. I think what I'll do is present a few options, but I'll let you know in the morning if I'm struggling with it."

Team members are judged on their ability to speak up when they can't meet a deadline or are in over their heads.

> Not just
>
> "I couldn't finish the assignment."
>
> But
>
> "I know you wanted this by the end of the day today, but I'm really struggling with it. Can I show you what I have and then we'll decide what's the best course of action?"

Bringing challenges and obstacles to the attention of managers, team leads, and colleagues allows them to address risks as they arise. While designers may feel uncomfortable admitting their inability to complete an assignment, the team is much better off knowing that with ample time to course correct. For me, the most valuable designers are the ones who help me move the project forward.

By the same token, team members should have a level of self-confidence that allows them to acknowledge the contributions of others:

> Not just
>
> "Veronica was a big help."
>
> But

"Veronica and I brainstormed this stuff when I was struggling with it, and she really helped me formulate some of these ideas."

Accountability, therefore, means giving credit where it is due.

Awareness and Respect

The virtue of Awareness and Respect requires that

> Team members should be respectful of each other's contributions and be aware of how their work affects others.

Intimacy plays a major role in successful collaboration. Team members' intimate knowledge of each other means being aware of each other's strengths and weaknesses. It also means being aware of their shortcomings and limitations.

At the same time, colleagues must respect each other's contributions. Good collaboration comes from colleagues with complementary skill sets—like the architect and the engineer, working together to perfect the design of a building. Great collaboration, in my opinion, comes from colleagues with overlapping skill sets, who don't see that overlap as redundant or unhealthily competitive. In this scenario, the two architects divide and conquer the scope, or assume lead/contributor roles on the project, or just find a way to design together.

A lot of conflict comes from lack of mutual respect. The disrespect of a colleague can lead people to compromise their performance, to ignore input from that colleague, or just to treat them badly.

Embracing the virtue of awareness and respect depends on

- **Boundaries, preferences, and style:** Team members must have a clear understanding of each others' strengths, weaknesses, and approach.

- **Presence:** Team members must clearly communicate their availability.

- **Self-awareness and self-respect:** Team members must be aware of their own strengths and boundaries.

Boundaries, Preferences, and Style

One source of great satisfaction for me as a designer is getting to know the working style of other designers. Through discussions about goals, performance, and just working side-by-side on a project, I get to know how they

prefer to work. I come to understand the challenges that they relish, the parts of the process they dread, and their preferred modes of communication. I get a sense of how many projects they can handle, how much time they need on specific tasks, and their comfort in leading conversations with stakeholders.

Pushing designers into situations where they will struggle or where they cannot thrive is irresponsible and disrespectful. It is one thing to invite a team member into "the deep end" because they want the challenge and quite another to do so without knowing their capabilities.

Every designer likes a challenge, but they also like to be set up to succeed. Respect comes from carefully, responsibly introducing them to uncomfortable situations, assignments, or workloads. It comes from providing a foundation from which they can safely push on their own boundaries, taking risks, without fear of total failure.

Presence

Awareness has a practical side. Colleagues must be aware of each other's availability. This may seem like a simple thing, but in increasingly remote and distributed workplaces, it isn't enough to know if someone's at her desk or not. Some of the various states of presence are

- I'm at my desk, but completely unavailable for disturbance.
- I'm at my desk and would rather not be bothered, but can take an emergency request.
- I'm on the phone, but I can handle a quick instant message.
- I'm on the phone and sharing my screen, so don't IM me.
- I'm available for back-channel chat on this conference call.
- I'm not at my desk, but will be back by 11 a.m. ET.
- I'm not at my desk, but can be reached by SMS.

Remote workers might set the status message on their instant message application to announce their presence. Some teams develop a code to respond to requests to indicate where they are on the availability scale.

Communicating presence has practical value, no doubt, but also contributes to the team's intimacy. Observing a colleague's availability and presence shows respect and builds mutual trust. No one feels comfortable working with the person who barges into offices unannounced. In remote and distributed

workplaces, respecting availability is tantamount to knocking quietly on the door before entering.

Self-Awareness and Self-Respect

Designers must understand their own boundaries, preferences, and style. By understanding their limitations, designers can be honest and open about their capabilities, their ability to contribute to a project, and their level of comfort in asking for help. Starting a series of questions with "Some of these questions may seem ignorant, but I want to make sure I understand…" suggests that a designer is comfortable admitting his or her own limitations.

Designers like this have nothing to prove—at least, they don't act like they do. They don't attempt to conceal their limitations, hoping to appear better than they are. They don't worry about how they look in the eyes of their clients or colleagues. More specifically, they don't see admitting shortcomings as admitting weakness or incapability.

Collaboration fails when the focal point of the team's effort is diverted from the purpose of the project. A colleague's lack of self-awareness can draw attention away from the project. Consequently, other team members need to pick up unanticipated slack, or manage expectations, or wrest responsibilities away from someone incapable of fulfilling them.

Openness and Honesty

The virtue of Openness and Honesty requires that

> Team members should be direct and honest with each other, because design thrives on meaningful, constructive feedback. They should be open to new ideas, to critique, and to opportunities for growth.

Openness and honesty entails more than design feedback, of course. Openness is someone's willingness to listen, regardless of whether they agree with the observation or feedback or critique. It's relevant to the other virtues:

- **Clarity and Definition:** Hearing and accepting project definitions

- **Accountability and Ownership:** Understanding the established roles and responsibilities

- **Awareness and Respect:** Discovering one's boundaries, limitations, and capabilities

Note: *This virtue pervades all the others. It is the most fundamental: the others cannot exist without this one. By the same token, openness and honesty aren't meaningful without the other virtues to temper them. The truth only goes so far if it isn't clear, if it isn't accountable, and if it isn't respectful.* ▪

An open person is willing to admit that he doesn't understand (clarity), he can't live up to expectations (accountability), or he doesn't know what's happening (awareness).

The complement to openness is honesty: direct and truthful communications. Honesty is different from straight-up truthfulness because it comes with a dose of wisdom and moderation.

The truth shouldn't be concealed; it should be packaged to make it actionable, meaningful, practical, and hearable. Honesty isn't saying anything and everything that enters one's mind. Instead, it's conveying feedback, direction, correction, or any other contrary position with respect and with a desire to help colleagues grow.

As with Awareness and Respect, there's a "self" component to honesty. If self-awareness is the knowledge of one's shortcomings, boundaries, and limitations, self-honesty is the ability to admit it. Transparency with one's own ignorance and inability can be challenging, as the psychology of self-preservation (another "self-"!) demands concealing all weakness.

Like other forms of openness and honesty, self-honesty is integral to the other virtues of collaboration:

- **Clarity and Definition:** Admitting whether one truly understands a project's underlying concepts or the assignment given

- **Accountability and Ownership:** Admitting whether one is ready to accept a certain level of responsibility

- **Awareness and Respect:** Admitting one's shortcomings and limitations

Stating the truth and accepting the truth are the two sides to the coin of this virtue. Each other virtue in its own way tempers what "stating" and "accepting" mean:

- Designers must *state* the truth with **clarity**, with **accountability**, and with **respect**.

- By *accepting* the truth, designers must understand the implications, take ownership of the implications, and be aware of what the truth says about them.

Openness and Honesty is the most difficult virtue to embody. Embodying the virtues means, simply, living them, injecting them into projects, and behaving in a way that realizes them.

Every project faces the same risks. The virtues of collaboration attempt to mitigate those risks by introducing principles that drive positive, productive behaviors. As will become clear, the virtues encourage opening communications, taking responsibility, and being respectful of team members.

Embracing collaboration is one way that organizations can mitigate these risks. But embodying the virtues of collaboration comes with potentially uncomfortable risks and behaviors. **Table 8.1** describes some of the additional risks associated with the virtues of collaboration and describes how you might go about mitigating them.

Table 8.1 The Risks That Come with the Virtues of Collaboration

With...	You risk...	Which you can mitigate by...
Clarity and definition	Minutiae: The team gets lost in minor details in an attempt to define every last bit of the project.	Structuring projects to allow sufficient time to spell out the big picture and dig into the details. If that's not feasible, being ruthless about scope.
Accountability and ownership	Toe-stepping: People may not get the responsibilities they want.	Helping designers see opportunities to grow with the responsibilities they're given. Providing designers a path for growth that isn't focused on one single project.
Awareness and respect	Caution: Respecting team members may turn into feeling overly cautious about hurting their feelings.	Informing team members that designers thrive on direct and constructive feedback.
Openness and honesty	Information overload: In the desire to be open, team members flood each other with information.	Teaching people to convey information in an actionable way. Making it easy for people to dispose of information they deem unnecessary.

No project is perfect, but design thrives in environments where people can be direct, where they understand their responsibilities, and where they feel like they're making a contribution. Despite the hurdles that come with these virtues, they are better than the alternatives.

TRANSPARENCY AND ACCOUNTABILITY

Mandy Brown
Cofounder and CEO, Editorially

I've worked in a traditional office in midtown Manhattan, the kinds with walls and doors between every worker; in an open plan startup environment in Brooklyn; and in co-working spaces surrounded by people of all different skills and specialties. I've led remote employees and been one myself. I've been on a team and in the lead; I've worked on books, Web sites, software, and products. But while each of those various collaborations was unique, one thing remained constant—the success of the collaboration depended on two factors: transparency and accountability.

Transparency

Trust is critical to any good collaboration. And one of the ways that trust manifests itself is by making sure the work of everyone involved is transparent: that is, everyone on the team should immediately be able to see who did what and why they did it, as well as recognize how their own work fits into the whole. There are many ways for transparency to be baked into a process, and in general the more methods you adopt the better. Transparency isn't a binary aspect of work so much as a regularly reinforced collection of behaviors.

- Daily standups (whether held in person or over Skype or Google hangout or the like) should allow each person to broadcast what they are working on and ask for whatever help they need. Each standup should make clear the current priorities and how everyone's work addresses them.

- Work in progress should be shared early and often. In the case of software development, this means starting a code review before a feature is working. In the case of design, it means sharing whiteboard sketches. In the case of content, it means sharing outlines and high-level messages before beginning to draft. In each case, that early sharing serves two purposes: informing your colleagues of what it is you're up to in a tangible way and inviting feedback at the stage when it can be most effective.

- Group chat tools (such as 37Signals' Campfire) are ideal for open lines of communication that team members can dip in and out of. Even if your entire team is in the same room all day long, these tools permit an ongoing conversation to take place, without the guilt of missing out. You can step away from the chat room and

focus on a task, knowing that you'll be able to catch up when you return. Just as importantly, the recorded nature means you can always go back to prior discussions and recall how a decision was made, adding to the institutional memory (even when your own memory, inevitably, fails). Real transparency includes not only the present, but also the relevant past.

Accountability

The corollary to transparency is accountability: in addition to making clear what you're doing, you need also to be held accountable for that work. That's not punitive—it's not about whether or not someone made good on their promises; rather, it's the means by which we acknowledge good work and collectively learn how to do it better.

- Assign a note keeper to every gathering. (It can be the same person each time, if your team has someone who's particularly good at this, or you can share the work.) The note keeper should take down any decisions made as well as next steps and the people assigned to each one. Review notes on subsequent gatherings to see how things are coming along. If it hasn't gone as planned, collectively investigate why (remembering that you're interrogating the process and the work, not the person or persons doing it). You've heard this one before, of course, but don't fall into the trap of thinking of notes as mere busywork. They are the tangible reflection of your consensus and deserve attention as such.

- Share the data. Bugs squashed, to-dos completed, features shipped: All demonstrate work that's been done and credit due to the people who made it happen. Create space for regularly acknowledging this.

- Find avenues for reflection. Weekly or biweekly gatherings, in which everyone can talk about what they learned and why it matters, make each person responsible not only for knocking things off the to-do list, but also for continuing to develop their skills. Just as importantly, they make sure critical knowledge moves through the team, rather than getting stuck in the head of one person.

At both Editorially and Typekit, we set aside some time at the end of the week to reflect, share, and ponder our next steps. (One of my colleagues at Typekit refers to these meetings as our "weekly TED conferences.") These gatherings provide an opportunity for each of us to look up from the trees and spot the forest. Because at the end of the day, that's what you're building: an ecosystem, with many small parts each contributing to the whole. The closer your working relationships reflect that system, the better the system will be. ■

Embodying Collaboration

Collaboration's virtues pervade the three aspects of collaboration: tools, mindset, and culture. Good tools, the right mindset, and the right culture all embody these virtues in some way. That is, they support and encourage behaviors that lead to good collaboration.

For example, one way to behave *respectfully* is to keep meetings short and to the point. This respects colleagues by avoiding wasting their time. It respects stakeholders and clients by avoiding wasting their money. It demonstrates respect for colleagues' abilities by implying that they're smart enough to accomplish the meeting's goals as concisely as possible. Short meetings may be embodied in all three aspects of collaboration:

- **Tool:** Shared calendaring software defaults to limiting meeting duration.

- **Mindset:** Meeting organizers structure their agendas to keep meetings as short as possible, arrive prepared, state the agenda, and keep the meeting focused.

- **Culture:** Corporate leaders lead by example; the organization rewards polite meeting behaviors.

Because each aspect of collaboration operates at a different level, there are multilayered ways of embodying the virtues and behaviors.

Choosing the Right Tools

Great collaboration tools are hard to find. No one tool will solve all the problems of a project team. No one tool is going to be perfect for every team. For example, I can't picture working without Dropbox, an Internet-based file storage system. With it, I can access my files from any computer or networked device. Dropbox maintains versions of the files, so I can revert to previous versions of a document. I can share a Dropbox folder with other people, making it easy to work on files together. Dropbox is, in short, essential to my work. (Every word of this book was stored in Dropbox at some point. So there.)

And yet, I wouldn't feel comfortable insisting that every design team needs Dropbox. The good news is that there are now a dozen different products for file storage and sharing, so teams can take their pick.

Instead of presenting a laundry list of great collaboration tools (Chapter 7 comes pretty close to doing this), I'll offer some ideas how various kinds of tools can embody collaboration.

Adjusting Your Mindset

The virtues of collaboration are positioned in an individualistic, psychological way. Openness and respect and clarity and the rest are virtues that put the individual in the middle. Though mindset isn't the most concrete factor (compared to tools) or the most all-encompassing (like culture), good collaboration starts with the individual. As I said in the previous chapter, one bad apple can ruin the collaborative bunch. It is the area over which individual designers have the greatest control—they should be able to control their approach. At the same time, it can be the hardest to change, because a mindset change may require

- Fundamental adjustments of attitude

- Changes in how to perceive situations

- Redirection of knee-jerk reactions to those situations

All of these things may stem from deep-seated psychology, and changing that could require professional intervention.

Here are some examples of a collaborative mindset in action. A collaboration mindset implies certain attitudes:

"I can learn a lot from my colleagues."

"Even if criticism makes me uncomfortable, my work will benefit from another perspective."

"I don't mind admitting when I can't complete a task."

"I'm grateful when others step in to help me finish my work."

"Even if a task isn't mine, I feel strongly that I want to help my colleagues succeed."

"My feedback is valuable. My colleagues thrive when I can offer constructive advice."

"These tasks are uncomfortable, but I'll learn a lot by trying them."

"I'd better keep my colleagues apprised of my progress."

It can be challenging for people to adopt the attitude illustrated by these quotes. They expose weakness and even admit defeat. Most people spend much of their lives concealing their own perceived inadequacies.

On the flip side of attitude, a collaboration mindset implies a certain way of perceiving the world and circumstances:

"I'm stuck, but this is an opportunity to bring in another perspective."

"How can I involve my client more in the process?"

"This person is just trying to help me make this better."

"Attempting to complete all these tasks in the given time frame is unrealistic. I should raise the alarm."

"Failing to complete these tasks will disappoint my manager, but keeping that to myself will cause the rest of the team to fail."

"I understand that they're asking me to do something that's not one of my strengths, but they know I'll be asking for a lot of help."

As with attitude, these quotes about perception imply a way of interpreting circumstances and situations that may run counter to the way a designer might see the world. Interpreting circumstances and projecting the right attitude—the central aspects of mindset—sometimes run against the grain of a designer's personality.

Evaluating Corporate Culture

Presumably, if all the people in a company have individually embraced the virtues of collaboration, surely the corporate culture must be collaborative. Individuals' behaviors, however, do not drive corporate policies. The well-meaning organization may tolerate individuals' collaborative behaviors, but its structure, policies, incentives, and other elements may not support or encourage them. An individual behaving in a collaborative way may be running against the grain of an organization.

There are lots of ways to look at an organization, to find ways in which the organization demonstrates collaboration virtues. By way of example, I'll show how collaboration virtues apply to a project, encompassing the team composition, the process they use, and the deliverables they produce.

For all the talk of software methodologies (agile, lean, waterfall), the real concern for designers is how a project is structured. Well-structured projects embody the virtues of collaboration (**Table 8.2**).

Table 8.2 Collaboration Virtues in Day-to-Day Operations

	Team Composition	Process	Deliverables
Clarity and Definition	Well-defined roles	Less focus on "steps" and more focus on milestones	Well-defined purpose for each output
Accountability and Ownership	Clearly defined lead who owns final design decisions	Established milestones for planning and course correction	Clearly defined owner; clearly defined responsibilities for contributors
Awareness and Respect	Appropriate responsibilities for team members	Ample time for design reviews with stakeholders	Deliverables align with team member abilities

Ultimately, this is a book for individual contributors and not necessarily people who can do something about corporate culture. But for the individual designer, I can offer some ideas on how to evaluate a company to determine the extent to which that organization has embraced the collaboration virtues. Use these questions during a job interview to see how the organization embodies collaboration (**Table 8.3**):

Table 8.3 Evaluating a New Position for Collaboration Virtues

What to Ask	What You Want to Hear
How do people work together on a project?	Projects consist of • Periods of heads-down individual tasks • Frequent formal and informal reviews • Bursts of intense group tasks
Who is in charge of setting professional development goals for designers?	Professional development goals come from • The designers themselves • Collaboration with the designer's manager • Input from relevant project leads
How many annual goals do people set for themselves?	Designers typically have 1–3 professional development goals, with 2–3 metrics apiece.
What are the different ways people share work with each other?	Sharing work happens • Within a project during scheduled peer reviews • Outside a project context through group sharing sessions • During quarterly performance reviews

(continues on next page)

Table 8.5 Evaluating a New Position for Collaboration Virtues (continued)

What to Ask	What You Want to Hear
How do creative directors review design work during the course of a project?	Design leads • Hold formal review sessions to validate the work • Hold informal review sessions to monitor progress and provide feedback • Are available for informal reviews
How do team members stay up to date on what's happening on their project?	Project teams • Meet weekly to discuss status • Meet weekly to assign tasks • Post meeting minutes to a project workspace
Who is in charge of making sure I have a balanced workload?	Workload balance is the responsibility of • Individual designers to make sure they're not overloaded • Project leads to assign tasks based on available time • Management to establish commitments to each assigned project
How does the team deal with failure?	While failure is a term that's become a favorite of the design community, the underlying issues are "how big" and "what now." Large failures should not be celebrated. Projects should be planned to account for at least some iteration (a more structured approach to failing). And performance reviews should give designers direction in how to avoid similar failures in the future.
Who makes decisions on projects?	Designers on projects are empowered to make decisions. Project leads own the ultimate direction for the project.

While lone designers may feel daunted by the task of shifting a corporate culture, they can focus on what's in their control: their own behavior. Modeling ideal collaborative behavior in an environment that is indifferent or even hostile to collaboration is a challenge in and of itself, an opportunity for growth. It may make the designer a bit of an outcast—stopping by offices to share work while everyone else remains tied to their desks—but being an outsider is perhaps what drew us to this field in the first place.

TL;DR

On its surface, collaboration may be nothing more than three things—tools, mindset, and culture. What ties these things together are four virtues that form the foundation of collaboration.

- **Clarity and Definition:** Collaboration requires being explicit about what you say and do and establishing reliable definitions for everything in the project.

- **Accountability and Ownership:** Collaboration depends on people feeling responsible for their behaviors, outputs, and contributions to the project.

- **Awareness and Respect:** Collaboration thrives when team members are mutually empathetic.

- **Openness and Honesty:** Collaboration's key behaviors are stating the truth and accepting the truth.

The previous chapter talked about collaboration in terms of three aspects: tools, mindset, and culture. This chapter extended the virtues to those three aspects, showing how a single virtue could be embodied through them:

- **Tools:** Team members use communicating tools to communicate their current availability.

- **Mindset:** Team members approach situations with the perspective of respecting their colleagues and desiring their input and feedback.

- **Culture:** The organization demonstrates respect for employees by being transparent about new policies that might affect their work.

■

9

Situations: Circumstances and Scenarios Common to Design Projects

THIS CHAPTER DESCRIBES more than 30 different situations you might run into on design projects. I define a "situation" as either a conflict between two or more people, or a circumstance that might lead to a conflict. For example, one situation is called "Distracted by shiny objects." The scene almost writes itself:

Designer: I've assembled some initial ideas for the design of the category page. I'm going to show you three different approaches, which prioritize the main requirements a little differently.

Stakeholder: We really wanted to incorporate social networking functionality.

Designer: You had mentioned that, but for the conference room reservation system on your intranet, I wanted to focus on prioritizing room availability and the appropriate calls to action like "reserve" and "cancel."

Stakeholder: Where are the social networking features? We want people to be able to tweet whenever they've booked a conference room.

How to Use Situations

These situations are pretty specific, and in some cases redundant with small differences between them. They're granular because designers need diagnoses beyond "poor communication" or "he's just grumpy." These situations are specific (but not necessarily exclusive) to creative projects and occur with fair frequency. Not every design project will have all of these situations.

There are a few different ways to use these situations:

1. **During a project:** In the midst of a design project, this catalog of situations can help project participants diagnose the exact obstacles they might be experiencing.

2. **After a project:** When conducting a postmortem of a design project, participants can use these situations to reflect on the project and identify where the process or team dynamics broke down.

3. **Between projects or before a new project:** Teams can use these situations to reflect on past projects and identify situations that were particularly difficult. As they're ramping up a new project, design teams can use this inventory of situations to anticipate potential risks.

About the Situations

Every situation I describe in this chapter includes a sensitizing quote (fictionalized, but familiar) and a description. Every situation also includes

- **See Also:** Other situations that relate to or overlap with the situation at hand. In diagnosing a situation, look at these related situations to see if one better captures it than another.

- **In the Wild:** How to recognize the situation through its expressions or symptoms.

- **Possible Patterns:** Behaviors that may help the situation. The lists provided are by no means comprehensive. There are more than 40 patterns to choose from, and chances are that many will be applicable to each situation.

Recall from Chapter 6 that patterns are the third part of the conflict model. Patterns are behaviors that designers can use to deal with situations.

The Situations

- Design ignorance
- Distracted by internal competition
- Distracted by shiny objects
- Don't know what we need
- Efforts ignored
- Excluded from planning
- False consensus
- Inconsistent expectations
- Insufficient progress
- Irrelevant comparisons
- Lack of clear inputs
- Lack of context
- Lack of decision maker
- Lack of stable strategy
- Late-breaking requirements
- Misinterpretation of tone

- New perspectives
- No plan
- No time to design
- Not a team player
- Overpreparation
- Poorly composed feedback
- Poorly planned presentation or discussion
- Reluctant participation in design activities
- Responses not timely
- Separated from key stakeholders
- Tasks and goals not aligned
- Uncoordinated collaboration
- Unfounded design direction
- Unreasonable constraints
- Wrong scope

Note: *Have you encountered a situation not found here? Drop me a line at suggestions@ designingtogether book.com.* ■

Every one of these situations is a form of healthy conflict. These are good situations to have: They escalate issues that the design team needs to iron out. These situations all represent disparate understanding of key aspects of the project.

Design ignorance

"I don't see why we even need to spend time on this."

Designers sometimes find themselves defending the practice of design itself. While every designer expects to educate stakeholders and other team members about design fundamentals at some point in the design process, the frustration mounts when every conversation entails justifying the value of design. Sometimes this includes demanding that designers justify the techniques they use. Designers will face conflict every step of the way, spending time defending not just their design decisions and their approach but their mere presence, too.

Designers sometimes presume that everyone on the project team has bought into design. They don't take the time at the outset of the project to educate the team about their role, their value, and their contribution.

SEE ALSO

- Reluctant participation in design activities (more skeptical)
- No time to design (more hostile)

IN THE WILD

- Requiring an account of method and technique before every design review
- Questioning inconsequential aspects of the method
- Holding the design team to arbitrary standards

POSSIBLE PATTERNS

Pattern	Example
Reflect the position	"I understand that you think this might be a waste of time. Let me make sure I understand your main reasons for thinking that." (Proceed to list the reasons you heard.)
Anticipate agendas	"I'm pretty sure Joe is going to want to understand how this activity will impact the budget and how it helps the process. Let's include a slide that tells a previous success story."
Communicate implications	"OK, we can eliminate this activity if you think it's not worthwhile. Let me just explain some of the risks we might face downstream. Perhaps we can find another way to mitigate them."
	OR
	"I understand why you think this activity is unnecessary. Let me explain the risks we'll face later in the project and why it's essential."

Distracted by internal competition

"The marketing team is setting up their own Web site."

Members of the project team lose focus on project objectives because they are distracted by a competitor. This competitor may be outside the company, but is often inside the organization—a separate team working toward the same, overlapping, or competing objectives. Project teams can't operate efficiently because resources are diverted to "deal with" the competition.

In design, a better product is the best way to beat the competition, especially when other aspects of the situation are beyond the team's control (for example, office politics). Human behavior, however, prioritizes undermining the competition. It can be difficult to deal with this situation when survival instincts kick in, and team members become transfixed by arguing why the other guy is inferior rather than investing in making their own product better.

SEE ALSO

- Distracted by shiny objects (external distraction)
- Don't know what we need (more broad)
- Lack of stable strategy (more fundamental)

IN THE WILD

- Requests made in the context of an unrelated project
- Design review criteria established in terms of unrelated projects or comparisons

POSSIBLE PATTERNS

Pattern	Example
Help me prioritize	"Introducing this competitor into the mix adds a lot more complexity to the project. Can you help me prioritize these requirements relative to the original ones?"
Frame the conversation	"Let's look at this competitor using the success criteria we established for our project and see what they're doing right and what they're doing wrong. This gives us a better sense of how to address the problem, if at all."
Recount previous conversation	"What are the top three takeaways from this competitor?"

Distracted by shiny objects

"Our site needs social sharing functions."

Team members lose focus of project objectives because they see something novel and wonder how it might fit into their project. "Shiny objects" is one term for ideas or technologies or techniques that have captured the imagination of the public or the industry. The implication is that such ideas are flashy but lack substance. In reality, the shiny object may be worthwhile, but there is no motivation for using it.

Design decisions driven by what's new—not by what's needed—are appealing because they're easy to make. But they're not easy to implement or justify. Project resources become diverted to exploring this great new thing and away from solving the core design problem.

One possible consequence is that some team members may never let go of the shiny object. They raise it in every conversation and design review. Team members may see the project as a failure if it doesn't include the shiny new thing.

SEE ALSO

- Irrelevant comparisons (another kind of misconstrued input)
- Wrong scope (consequence of distraction)

IN THE WILD

- Requirements and requests based on a technology, not a user or business need

POSSIBLE PATTERNS

Pattern	Example
Make it real	"OK, let's take a look at how incorporating those features into the product would work. I'm assuming we're using the same success criteria and goals we started with."
Hold a workshop	"Let's do some brainstorming together so I can see how these new requirements impact the overall product."
Offer alternatives	"Let me do some mock-ups so we can compare and contrast with our original concepts. That way we can see what the marginal improvement is."

Don't know what we need

"What do you think we should do?"

Despite their best efforts, project teams may not be able to articulate a single clear design problem. While a client need not have a fully fledged assignment at the outset, the design team should be able to state the design problem confidently after a couple of discussions. By the time the project is underway, every member of the design team should be able to summarize the objectives and scope of the project.

Without a clear definition of the design problem, the project team may run in different directions. Conflict comes from each member of the team evaluating design directions with a different set of criteria.

Articulating the design problem is perhaps the hardest thing to do in design. Establishing goals and parameters feels very "un-design" to a designer. These efforts, while potentially unpleasant, yield better results because they let the team know what success is.

SEE ALSO

- Lack of stable strategy (shifting parameters vs. absent parameters)
- False consensus (agreeing without understanding)
- Lack of decision maker (possible cause)

IN THE WILD

- Stakeholders shift the goals of the project.
- Stakeholders struggle to prioritize the project needs.
- There is lack of agreement on the project goals.

POSSIBLE PATTERNS

Pattern	Example
Provide starting points	"To frame the design problem, let's start with the end in mind. Here are a few ideas based on the general ideas we've heard. None of these are meant to be final. Tell us what you like about each one."
Set reasonable expectations	"I understand your reluctance to frame the problem, but let me explain what we can and cannot do without a clearly defined problem statement."
Make assumptions	"Since we hadn't defined any success criteria, I made some assumptions about what they could be. Let's start there, talk about the design concepts, and then revisit my assumptions to see if they're correct."

Efforts ignored

"This stuff doesn't really matter because we're working on a separate track."

Stakeholders or other members of the team choose to ignore outputs, recommendations, and solutions provided by people assigned to those activities. The quintessential example here is a disenfranchised design team, where some team members discount the value of their contributions.

Without alignment on activities and outputs, the team will fragment, wasting time and money. Business stakeholders will also waste time trying to reconcile disconnected efforts.

Disenfranchised teams may have no control over their disconnectedness. It may be driven by politics up the ladder, a defensive colleague, or irrelevant interpersonal conflicts.

SEE ALSO

■ Excluded from planning (alternative approach for disenfranchising)

■ Unfounded design direction (complementary situation)

IN THE WILD

■ There is a lack of engagement during review meetings.

■ Stakeholders do not show up for design reviews.

■ Subsequent decisions ignore or contradict recommendations.

POSSIBLE PATTERNS

Pattern	Example
Convert failure to action	"Ugh. Looks like none of the suggestions I made were worthwhile. Can we go through the three main ones and talk about what didn't work about them?"
Help me help you	"Look, there's a lot to get done on this project and I just want to help out where I can. What can I do to help you out?"
Blame a "bad cop"	"Some of these ideas were my boss's. Let's go through them so I know what to tell her about why they're not included in the design concepts."

Excluded from planning

"It's a shame she's not in the meeting. All these action items are for her."

In this situation, the people responsible for delivering and executing are not included in the planning process. They may be excluded on purpose—I once worked with someone who was a constant frustration in meetings—or because of logistics.

Here the conflict is that contributors will not have an opportunity to shape their own destiny. They will be unable to perform, thus creating more frustration and perhaps generating more of the behavior that got them excluded from planning in the first place.

A pattern of exclusion generally implies something political or personal beneath the surface. People aren't excluded because they're agreeable and will do anything asked of them. They're excluded because one party finds the other difficult to work with, or because the other party represents a threat or loss of control.

SEE ALSO

- Tasks and goals not aligned (consequence of poor planning)
- Responses not timely (more of the same)
- Not a team player (broader issue)

IN THE WILD

- Planning meetings do not include all the people performing tasks.
- Specific people are excluded for fear of the plan being disrupted.

POSSIBLE PATTERNS

Pattern	Example
Acknowledge achievements	"Looks like you guys have made a lot of progress in developing these plans. I'd like to take a look and make sure you covered everything we'll need."
Communicate implications	"Your plans make sense, but I'm worried that you haven't accommodated some of our needs in the project. Let me explain what we need."
Reduce the assignment	"I definitely want to help out, but since I wasn't part of the planning, I'm not sure what I can do. What if I focus on just X, which is reasonable given the amount of time."

False consensus

"I think we all agree here."

In this situation the team comes to some agreement (on direction or approach, for example) but doesn't really understand the underlying assumptions or the downstream implications. If they understood those, they might not agree.

While a false consensus seems to move the project forward, it likely leads to more challenging conflicts later when the underlying assumptions come to light.

Since everyone appears to agree, it may be difficult to detect that this is a problem.

SEE ALSO

■ Lack of decision maker (reason why team relies on consensus building)

■ Poorly composed feedback (inputs that might lead the team astray)

IN THE WILD

■ No one asks any questions.

■ No one challenges underlying assumptions.

■ No one raises implications of the design decisions in the consensus.

POSSIBLE PATTERNS

Pattern	Example
Ask for a story	"OK, since we all agree, can someone tell me a story about how this decision will impact their target audience?"
Communicate implications	"Before we all agree, let's spell out the implications of this decision."
Help me make this better	"Everyone agreeing on this doesn't make it better. Can you help me by challenging some of my assumptions?"

Inconsistent expectations

"That's not what I said!"

From one conversation to the next, team members change their expectations. They might have expected the team to work on certain parts of the design, incorporate certain improvements, or reach a certain goal. The team works diligently on the tasks they think they should, only to find that, in the eyes of their colleagues, they focused on the wrong stuff.

But this is more than just wrong scope. It's the situation where even agreed-upon and understood expectations change from conversation to conversation.

While this situation can be addressed through documentation, even a careful inventory may not prevent these conflicts before they start.

SEE ALSO

- Lack of a stable strategy (With no guiding star, the team can't be consistent.)

- Late-breaking requirements (another way expectations shift)

- New perspectives (With new perspectives come new expectations.)

IN THE WILD

- The conversation reveals a disconnect between different members of the team.

- There are accusations of poor performance.

POSSIBLE PATTERNS

Pattern	Example
Blame a "bad cop"	"My project manager had a different set of expectations based on our last conversation."
Make it real	"OK. Let me take notes that we can all see so we are all agreed on our next steps."
Set reasonable expectations	"This wasn't my understanding of the assignment. Let's talk about what I can and cannot do to get back on track given our constraints."

Insufficient progress

"You've done how much?"

The designer hasn't advanced the project forward: assigned tasks remain incomplete, design problems remain unsolved, or feedback isn't fully incorporated. Colleagues will call into question the designer's ability to perform, and lack of progress has a downstream effect on the project budget and schedule.

Insufficient progress rarely has anything to do with laziness. In most cases, lack of progress comes from

- Inability to manage time effectively
- Having too many assignments to juggle
- Inability to ask for help
- Inability to solve the design challenge at hand

Be aware that confronting an underperforming designer can make him or her defensive, undermining confidence and potentially further disrupting progress.

SEE ALSO

- No plan (Insufficient progress may result from not having a plan.)
- Not a team player (By not engaging with the team, no progress is made.)
- Wrong scope (Insufficient progress may result from not focusing on the right thing.)

IN THE WILD

- Missing design review meetings
- Showing up to a design review unprepared
- Getting defensive when confronted with basic questions about design

POSSIBLE PATTERNS

Pattern	Example
Go back to basics	"Let's schedule daily check-ins so we can make sure we stay on the same page."
Reduce the assignment	"Let's start with something smaller to make sure we're on the same page."
Set reasonable expectations	"Can you help me understand what would have been a more reasonable assignment?"

Irrelevant comparisons

"Have you seen this Web site?"

Here, someone contributes comparative examples with little or no practical relevance to the design problem. Bringing content-heavy Web sites to a brainstorming meeting about a transactional application, for example, distracts the team from the core problem.

Every design process is, no doubt, well served by examples and inspiration from outside the immediate problem. While incorporating examples into the design process is useful, the team must use caution when employing examples that don't relate directly to the design problem.

SEE ALSO

- Lack of clear inputs (The comparison contributes only one input.)
- Unreasonable constraints (The design team is forced to work within other irrelevant constraints.)
- Don't know what we need (Without clear goals, the team looks for other factors to set direction.)

IN THE WILD

- Deriving requirements and success criteria solely from other products
- Drawing unsubstantiated desires from comparative products without acknowledging the discrepancies in objectives, audience, or business
- Dismissing more relevant comparisons that may not be as cool

POSSIBLE PATTERNS

Pattern	Example
Consider micro/macro perspectives	"From a strategic perspective, this competitor is trying to X, Y, and Z. You can see this clearly in how they designed their product, which includes A, B, and C."
Help me prioritize	"If this comparison is introducing new requirements, can you help me prioritize them relative to the existing requirements and goals?"
Communicate implications	"OK, if we incorporate this stuff into our work, it will have an impact on our schedule. It may impact our work, too."

Lack of clear inputs

"Mmm... yeah... we're not going to have the budget to do user research."

Designers don't have detailed inputs (requirements, starting points, etc.) to frame the problem and inform the solution. In response to this lack of clear inputs, designers might spin, flounder, or churn on outputs without arriving at their destination; stall altogether; or make rash assumptions.

Experienced designers know what they need, can anticipate risks for moving forward without inputs, and can determine whether they should bother. If they don't recognize this situation, designers face performance issues: they won't meet expectations in the specified deadlines, or they will prepare work without the right inputs.

SEE ALSO

■ Separated from key stakeholders (don't have the right information from the right people)

■ Lack of stable strategy (no mechanism for making decisions)

■ Don't know what we need (no objective or goal specified)

IN THE WILD

■ Inability to produce meaningful outputs for assignment

■ Inability to answer basic questions for designers

■ Inability to explain why designs don't work (need more constraints, but can't define what those are)

POSSIBLE PATTERNS

Pattern	Example
Make a plan	"Since we're missing some crucial information, I'd like us to take a deliberate approach with the design. Here are the steps we should take to prepare the design and potentially fill in the gaps in our knowledge."
Make it real	"Let me show you some of the questions we'll face during the design process and how the lack of inputs will prevent us from answering them."
Make assumptions	"We'll move forward filling in the gaps, but we're going to be making educated guesses. We'll let you know every time we do it."

Lack of context

"There's a lot going on behind the scenes here…"

Teams do not have insight into the organizational, business, or operational context surrounding a project. Late in the design process, they learn about additional stakeholders, approval processes, or arbitrary business rules. Context is crucial to the success of a design project because it allows designers to gauge what approach, process, and solution will be the best fit. Context establishes constraints, not only for the project, but also for the design itself.

In this situation, the project team runs into unanticipated risks, obstacles, or delays in the design project due to their ignorance of context. Stakeholders may see "insulating" the design team as an important responsibility, reluctantly relinquishing that role. They believe that they offer protection from the chaos of the organization. In reality, that chaos offers useful insights to the design process.

SEE ALSO

- Wrong scope (Without context, the team might prioritize the wrong thing.)
- Separated from key stakeholders (The team is missing context because they're not talking to the right people.)
- Lack of stable strategy (Without context, the team might not have insight into the shifting strategic foundation.)

IN THE WILD

- Introduction of additional reviewers
- Introduction of new requirements or constraints after those have been defined

POSSIBLE PATTERNS

Pattern	Example
Pick one thing	"I understand that there's a lot going on behind the scenes. Our design work can be more productive if we just understand X."
Help me help you	"Besides creating a great product, my job is to help you succeed. What do you need from me to manage the behind-the-scenes stuff?"
List assumptions	"Without knowing context, I'm going to have to make some assumptions. Can you correct me on each of these?"

Lack of decision maker

"So, what does the group think?"

Design decisions drag out because no authority is capable of rendering executive decisions when necessary. There are several variations of this situation:

■ Authority is diffuse among several stakeholders, and approval requires consensus.

■ Authority is centralized on one person, but that person is incapable of making decisions.

■ No one has been granted authority to make decisions.

■ The sole decision maker is dissociated from the team.

Even a sound strategy cannot automatically validate every design decision. Some design choices require deliberation and a final decision rendered by an authority.

SEE ALSO

■ Separated from key stakeholders (There may be a decision maker, but one that's not engaged.)

■ Responses not timely (Without centralized decision making, responses won't come quickly.)

■ Tasks and goals not aligned (Without strong oversight, no one is ensuring that the activities yield meaningful outcomes.)

IN THE WILD

■ The team frequently defers decisions.

■ The team turns to voting to make decisions.

■ At the climax of a meeting, there is awkward silence.

POSSIBLE PATTERNS

Pattern	Example
Anticipate agendas	"Since we need buy-in from everyone, let's make sure the work addresses everyone's concerns. That said, the goals and criteria we laid out at the beginning of the project will be our primary guiding principles."
Hold a workshop	"We need to reach some crucial decisions so we've organized a workshop with hands-on activities. These are designed to make our decisions as tangible as possible."
Communicate implications	"Without centralized decision making, we will struggle to move quickly. Let's talk about how this impacts the schedule."

Lack of stable strategy

"So, things have changed since we last spoke..."

By "stable strategy" I mean the underlying foundation for the project:

- The **business** that will support the product—the organization, the business process, the way the product adds value, or any number of ways the product fits into the business of the organization.

- The **project parameters** that frame the design effort—objectives, constraints, and requirements

Here, the project's objectives, parameters, or constraints change regularly. The cause may lie well outside the design team, but sometimes the design process itself instigates such a change.

One variation of this situation is that an underlying foundation never existed. Designers find themselves floundering not because things are constantly changing, but because they were never defined in the first place.

SEE ALSO

- Separated from key stakeholders (With no opportunity to corral key stakeholders, the team has no opportunity to extract and define a strategy.)

- Unfounded design direction (making design decisions without a strong foundation)

- Distracted by internal competition (With no strategy, it's easy to succumb to distractions.)

IN THE WILD

- Kicking off a meeting with, "Before we start, I should tell you about this conversation we just had with the executive team."

- Sudden about-face on previously agreed-upon decisions

POSSIBLE PATTERNS

Pattern	Example
Make assumptions	"We need a set of principles from which to design."
Blame a "bad cop"	"In order to hit our deadlines, we need to stop making changes to the design based on shifts in direction. February 1 will be our deadline for any final changes to the strategy."
Treat it like a project	"Since we need a stable strategy to drive the design, let's set aside some of our budget and time to establish that strategy. Here's a plan for the next four weeks to build a basic foundation."

Late-breaking requirements

"Now that I think about it, we're also going to need…"

Most design processes spend at least a little time establishing requirements up front. Through this process, design teams can identify most requirements. More importantly, they can quash any late-breaking requirements.

Still, late-breaking requirements occur: the stakeholder who didn't have time to participate in the process; the one thing that one guy forgot; a change to the business that has a ripple effect throughout all the company's systems.

Ultimately, the design team must acknowledge whether a new requirement changes the design challenge altogether. Even the subtlest shift in priority can have a dramatic effect on the design solution.

SEE ALSO

■ New perspectives (New people on the project introduce new requirements.)

■ Reluctant participation in design activities (Play now or pay later.)

■ Responses not timely (new requirements, or just poorly timed feedback)

IN THE WILD

■ Any statement that starts with, "Guys, I just thought of something…"

■ Failing to find a way to incorporate new requirements into an existing design framework: "Maybe we can squeeze it in here?"

POSSIBLE PATTERNS

Pattern	Example
Help me prioritize	"Given these new requirements, we're going to have to revisit the design. Can you help me prioritize which are most important?"
Make it real	"Let's sketch out how these new requirements impact the design. I don't think we can find a way to make it work given our other constraints."
Make a plan	"OK, these new requirements impact our plan. Here's how we can revise the plan to accommodate the new requirements."

Misinterpretation of tone

"Your email was really snippy."

Another participant in the conversation, whether in-person or electronic, real-time or asynchronous, breeds hostility or disrespect in the communications. Their responses are positioned relative to the perceived tone, not to the actual content of your message. Unfortunately, some people are wired to read the worst into even the simplest of messages.

When this happens, communication on a project comes to a halt because the recipient can't get past the perceived tone of the message. In this case, the recipient may be as much to blame as the sender.

SEE ALSO

- Not a team player (doesn't like interacting with other people in general)
- Poorly composed feedback (unable to express themselves smoothly)
- Reluctant participation in design activities (reluctance = insecurity = easily misinterprets tone)

IN THE WILD

- Long diatribes in response to simple requests
- Emotional responses to otherwise innocuous statements
- Expressions of fear about job security or performance for otherwise innocuous statements

POSSIBLE PATTERNS

Pattern	Example
Change the channel	"Sorry to call. I felt like I wasn't expressing myself well in email."
Reflect the position	"Sounds like you were pretty upset. Can I summarize what I think upset you to make sure I got it right?"
Come back later	"When I first read your email, I thought you were pretty annoyed with me. Now that I've had a chance to digest it, though, I'd like to talk about your feedback."

New perspectives

"I know I'm coming in with this late, but…"

Sometimes, the hardest thing about stakeholders is their timing. The project team faces two challenges when stakeholders show up late:

■ Managing expectations with a new stakeholder, who may not understand, appreciate, or care about the project plan.

■ Managing incoming feedback that is actually valuable.

Regardless of the input, stakeholders offering new perspectives may not welcome their positions being hastily dismissed.

SEE ALSO

■ Late-breaking requirements (Like new perspectives, new requirements can unhorse a project's momentum.)

■ No plan (A plan may have helped integrate the stakeholders at the right moment.)

■ Unreasonable constraints (New perspectives yield constraints that conflict with existing requirements.)

IN THE WILD

■ Meeting a new stakeholder after 25 percent of the budget or schedule is expired

■ Finding that someone on the project team showed the work to someone outside the project team, only to discover that person is a crucial stakeholder on the project

■ Experiencing organizational shifts in the midst, such that reporting structures and budgets may be different from when the project began

POSSIBLE PATTERNS

Pattern	Example
Assert your process	"Given the project parameters, we can't incorporate this new feedback and still hope to meet our deadlines. Can we talk about what it would take to address this new perspective?"
Frame the conversation	"I know this is the first time you're seeing this. You probably have lots of different ideas. Let me start by asking you some specific questions so I can get validation."
Offer alternatives	"With this new information, we have a few choices. Option A is to ignore it and plow forward. Option B is to prioritize what we got and see how it impacts the schedule. Option C is to revisit the schedule entirely."

No plan

"OK, so what do we do next?"

In this situation, the project lacks a plan that defines desired outcomes, activities, schedule, and assignments. As such, no one knows what they're doing week to week. They may understand one aspect of a plan, like the project's goals, but not others, like how they're getting there. At worst, plans don't exist at all, and all team members must fly by the seat of their pants. Even the simplest plan can get everyone on the same page, trigger a conversation about coordination, and hold people accountable for their work.

When people don't know what they're doing from day to day or even week to week, they become stressed. They wonder whether they're doing the right thing and whether their work is meaningful. Operational conflict emerges, where people bump into each other or fail to coordinate their activities.

SEE ALSO

- Don't know what we need (There's no plan because there's no defined objective.)

- Tasks and goals not aligned (People are working on stuff that doesn't move the project forward.)

- Overpreparation (Without a plan, the team may start designing before they're ready.)

IN THE WILD

- Inability to articulate specific tasks and objectives in the coming days or weeks

- Inability to articulate important milestones in the project

- Discovering duplicate work

- Discovering missing dependencies

POSSIBLE PATTERNS

Pattern	Example
Blame a "bad cop"	"Look we can keep going around and around on the design, but my boss needs an account of my time. It would be helpful if we could frame up some basic milestones."
Draw pictures	"I'm going to draw a calendar of the next three months on the board. Let's figure out where we want to be at the end of those three months and what we need to do each week to get there."
Offer alternatives	"There are two possible approaches. We can deliver a little bit at a time, or we can deliver everything at once. Let me show you how those two plans work and you let me know which you like better."

No time to design

"Just get some rough ideas down by tomorrow, OK?"

Forces outside the design team establish an unreasonable schedule for producing design ideas. They don't account for the time to develop ideas, vet the ideas, and put them into a format suitable for explaining to other people.

Designers confronted with this situation will resent the project team if forced to prepare outputs without sufficient time. If they comply with the unreasonable request, they may find themselves committed to a design concept that doesn't effectively solve the problem. Even if they pull it off, they set an unreasonable precedent for future work.

The design team may be eager to dive into the problem or to prove their value, ignoring the risks that come with shortchanging their process. They may be reluctant to push back on the request because they don't want to disappoint the requestor or undermine their own authority.

SEE ALSO

- No plan (There's no time because there's no schedule.)
- Untimely responses (Design time is compressed because feedback is late.)
- Design ignorance (Planners don't know what it takes to do design.)

IN THE WILD

- Unreasonable comparisons: "But you did it fast for me before."
- Oversimplification of design process: "But I don't need it perfect, I just need some ideas."
- Threats: "If you don't do it, I'll find someone who will."

POSSIBLE PATTERNS

Pattern	Example
Assert your process	"This schedule affords us no time to solve the design problem adequately. Our process calls for frequent collaboration and iteration. With this timeframe, we cannot be successful on this project."
Help me help you	"I want to help you be successful, but the schedule specified doesn't give us the time we need. Can you help me understand how this time frame was set?"
Set reasonable expectations	"This schedule is unrealistic. Let's go through the scope, and I'll let you know what we can and cannot do."

Not a team player

"I can take care of this."

Someone on the team refuses to engage with other members. If in a position of authority, this person might refuse to delegate or complain endlessly about others' shoddy work. If a contributor, he or she might ignore other people's contributions, refuse to ask for help, or take on tasks outside his or her responsibility.

With one person on the project who refuses to collaborate, other team members cannot contribute effectively. They're met with resistance and dismissal, threatening their performance.

Sometimes this situation is more than a simple lack of cooperation. In the extreme, this situation is about one person constantly positioning people to fail—and not the good kind of failure. In this version of the situation, the only guarantee of success appears to be removing this person. In such untenable situations, other team members may feel like they need to route around the challenging person or reduce the assignment, meeting only minimum requirements.

SEE ALSO

■ Overpreparation (Lone rangers tend to show up to meetings with everything figured out already.)

■ Reluctant participation in design activities (not overbearing, but "underbearing")

■ Separated from key stakeholders (using one's position to block transparent communications)

IN THE WILD

■ Regularly responds defensively when asked to share responsibilities

■ Prefers heads-down tasks to group participation tasks

POSSIBLE PATTERNS

Pattern	Example
Ask for help	"Can you help me organize this project so that everyone can make a meaningful contribution to it?"
Go back to basics	"Let's schedule regular check-ins so that I can make sure your progress aligns with the rest of the team."
Communicate implications	"With the team so disconnected, we are having trouble keeping our stakeholders up-to-speed on what's happening on the project."

Overpreparation

"I think we've got the solution already."

Product teams may create early mock-ups to frame the problem, which locks them into a particular way of thinking about the problem. While getting ideas on paper is a good way of framing the design challenge, vetting initial ideas and validating a common understanding of the problem, it can also stifle further exploration.

Good design strategy—the beginning of a design project where the team defines the problem and sets direction—takes the design just far enough to validate the objectives and constraints, and establish an overall vision. When a design concept lingers too long, becoming entrenched, it can cause conflict because some team members may be unwilling to depart from the initial idea.

Overcoming this situation is hard because people tend to prefer familiarity. They may feel a sense of ownership of the design concept and be reluctant to let it go.

SEE ALSO

- Unfounded design direction (basing a design concept on a flimsy strategic foundation)
- Distracted by internal competition (basing a design concept on reaction to the work of another team)
- Irrelevant comparisons (basing a design concept on a single input)

IN THE WILD

- Relying on design *decisions* (not design *principles*) from early in the project to justify or eliminate subsequent decisions.

POSSIBLE PATTERNS

Pattern	Example
Hold a workshop	"The best design happens iteratively. Let's give everyone a chance to throw out some ideas. We'll see what else is out there and we can extract use cases to validate this design."
Ask questions	"Great start. Let me ask you some questions about your design decisions and priorities."
Ask for a story	"Explain how someone will use this to accomplish the top three tasks of our target audience."

Poorly composed feedback

"That just doesn't look right to me."

The team receives feedback that doesn't clearly articulate the next steps, the desired improvements, or the issues with the current version. Extracting this information from colleagues is part of the designer's responsibility, but incompatibility among team members makes this process unnecessarily cumbersome.

With poorly composed feedback, the design team will be at a loss for how to move forward. They may be unable to provide direction to other members of the team. Ultimately, they are unable to triangulate their position relative to success, leading to frustrations around performance (Are we adding value?) or operations (Are we communicating right?).

What can make this situation especially difficult is that people may not be aware or willing to admit that they're incapable of providing meaningful feedback. Moreover, designers may not be equipped to ask the right questions. If the project has a history of poor communications, participants may not be able to see past prior failures to capture good feedback.

SEE ALSO

- Misinterpretation of tone (mistaking frustration at inability to provide feedback with personal attack)

- Distracted by shiny objects (unable to give meaningful feedback because this thing keeps shining in my eye)

- Don't know what we need (not enough project context to provide meaningful feedback)

IN THE WILD

- No clear action items from the conversation

POSSIBLE PATTERNS

Pattern	Example
Frame the conversation	"Thanks for your initial comments. I had some specific questions that I wanted feedback on."
Take baby steps	"That's great high-level feedback, but can we go through the design point by point so I can get your input on each of the decisions we made?"
Change the metaphor	"OK. Now pretend you're a user of the system and walk me through how you would accomplish the most important tasks."

Poorly planned presentation or discussion

"I hate to put you on the spot, but…"

Project stakeholders do not understand the design work because the design team hasn't assembled a meaningful narrative. Designers may have been asked to present concepts without sufficient notice, or the design team may have neglected to anticipate questions from the stakeholders. Perhaps they expected one set of participants and a different set showed up. ("The CEO is coming, too. Is that OK?" "Um, it was supposed to be an internal meeting.")

Progress on the design work may be held back until stakeholders buy into the design concept. High-quality work may be undermined by a poor presentation.

Design processes balance spontaneity with deliberation. Presenting a design at a moment's notice is not necessarily unreasonable, but the project team must understand the potential risks to the project.

SEE ALSO

- Late-breaking requirements (another kind of curveball in the process)
- New perspectives (still another curveball, often coming with surprise presentations)
- No time for design (insufficient planning time for other activities)

IN THE WILD

- Less than one day's notice for presentations
- Additional people arriving for presentation
- Lack of meeting agenda
- Unknown participants on meeting invitation

POSSIBLE PATTERNS

Pattern	Example
Set reasonable expectations	"I'm happy to participate, but I don't know that I'll be able to add a lot of value without additional preparation. Here's what I think I can cover…"
Assert your process	"Sorry, I can't participate without more preparation. I'm happy to sit in and listen to get guidance on what you're interested in."
Ask questions	"Can you help me understand what this presentation is for?"

Reluctant participation in design activities

"I'll leave the drawing to my colleagues."

Some members of the team may not actively participate in creative games and brainstorming activities. Collaborative sessions to generate lots of ideas or validate an approach are a staple of the design process. Since designing products (Web sites or otherwise) touches so many people in the organization, these sessions typically involve lots of different kinds of people. Some of them may regard these activities as soft or superfluous.

In this situation, "One bad apple can spoil the bunch." One person's reluctance may be contagious, causing other members of the team to disengage. This may turn into methodological conflict, where the rest of the team questions the approach of the designer.

The designer may not see his or her role as getting someone to love the design process, but instead as creating a great product. Solving this situation will be difficult if no one takes the responsibility to actively engage otherwise reluctant team members.

SEE ALSO

- Not a team player (preference for doing things separately from team)

- Design ignorance (no interest in participating or understanding)

- Late-breaking requirements (no participation now means new information later)

IN THE WILD

- Leaving the meeting when things start to get interesting

- Declining meeting invitations for design meetings

- Switching to another activity (checking laptop or phone)

POSSIBLE PATTERNS

Pattern	Example
Provide starting points	"Actually, you don't have to do too much. I've got some starting points to get us going."
Assert your process	"I know this feels uncomfortable, but give the exercise a try. It really works best with everyone participating."
Communicate implications	"OK. I understand you don't want to participate now, but if you've got crucial input, we may not be able to account for it later."

Responses not timely

"[This quote intentionally left blank.]"

You're not receiving responses to your inquiries about feedback, next steps, required inputs, or other dependencies for forward progress. This could lead to operational issues if you fail to make progress because you aren't getting the responses you need. And it could impact your performance.

Unfortunately, patterns of unresponsiveness shift the conversation from the design itself to the communication channels. Instead of spending precious hours discussing and debating the merits of different design concepts, you are wondering about the best way to keep so-and-so involved. You're wondering how much more work you can do without his or her input. You're wondering whether you can nag such a person.

SEE ALSO

- Late-breaking requirements (With late responses may come additional requirements.)
- Poorly composed feedback (Late responses or useless responses—it's hard to know which is worse.)
- Uncoordinated collaboration (Without coordination, teams can't get feedback when they need it.)

IN THE WILD

- Regularly missing meetings
- Regularly ignoring emails
- Even when cornered, finding excuses not to respond to the request at hand

POSSIBLE PATTERNS

Pattern	Example
Assert your process	"I need feedback before I can continue. Do you have 15 minutes today to walk through the design quickly to see if there's any reason not to move forward?"
Communicate implications	"Without this feedback, I won't be able to finish the design by our deadline. I'll need at least a week between getting your comments and handing in the next draft, depending on the scope of your feedback."
Provide starting points	"I still haven't heard from you on the feedback I need. What I really need more than anything is input on two questions."

Separated from key stakeholders

"Let me take this to the VP, and I'll let you know what she says."

Designers find themselves separated from the true client or customer through layers of bureaucracy. This separation may be an artifact of the organization or may be actively encouraged by some team members.

The "telephone effect" hampers the designer's ability to communicate ideas, solicit input, and understand feedback. Members of the team (especially those who are part of the bureaucratic layers separating the designer from the client) may perceive performance issues.

While the bureaucratic layers may be part of the corporate culture, prior conflicts between the designer and the team will make it difficult for the designer to circumvent these obstacles. By demanding to work directly with stakeholders, the designer may be seen as a "troublemaker," and bureaucratic layers will try to preserve their importance by acting as communications channels. The first step to closing the separation is building trust.

SEE ALSO

- Uncoordinated collaboration (It's difficult to coordinate activities when crucial participants are inaccessible.)

- New perspectives (Stakeholder perspectives may invalidate the project direction if not integrated effectively.)

- Unreasonable constraints (The team is forced to design without access to key information.)

IN THE WILD

- Offering to take design concepts to important stakeholders without involving the design team

- Limiting the exposure to stakeholders or customers, making meetings few and far between

POSSIBLE PATTERNS

Pattern	Example
Hold a workshop	"Since you have limited availability, we wanted to make the most of your time. To that end, we need just a couple of hours one morning next week to do some design brainstorming."
Assert your process	"These people hold information crucial to the success of the project. Without their participation, we cannot execute our commitment to you."
Take baby steps	"I'll organize this part of the project assuming limited access to them, but let's make it a goal to get them more involved in the next phase.

Tasks and goals not aligned

"Everyone says we need to hold a daylong brainstorming session."

Designers sometimes engage in design activities with no real rationale. Such activities yield outcomes that likely don't move the project forward, or do so inefficiently.

If a designer is doing an activity related to the project, how can it not be productive? Assume that the design team prepares a specification document the way they've always prepared a specification document. But because the project is new, and it has unique needs, requiring different behaviors and commitments from everyone involved. Relying on old methods may be the right choice, but only after the project team collectively determines that it will support their new behaviors.

A design team may have a repeatable process, but good teams recognize that every process must adapt to unique circumstances.

SEE ALSO

- Don't know what we need (can't assign tasks if we don't know the goals)
- Wrong scope (variation on a theme—right activities, wrong focus)
- Distracted by shiny objects (A symptom of misalignment is getting easily distracted.)

IN THE WILD

- Not validating the need for each and every activity or output
- Not being able to explain how the activity moves the project closer to its goal

POSSIBLE PATTERNS

Pattern	Example
Set expectations	"Even though our project plan calls for these activities, I don't think they're the best way to get to our goals. Let me set your expectations about the outcome I predict."
Ask for the first step	"Now that we know where we're going, what's the first thing we need to do?"
Make a plan	"Let's take a step back, articulate the goals, and work backward from there to make sure we're working on the right things."

Uncoordinated collaboration

"So, which one of us is doing this?"

Some project teams have no plan, no overall direction of where they're going long-term and the activities required to get there. Other teams may understand the project's objectives and have a general sense of the activities and outputs, but have no structure for how people will work together.

When people don't know how they're working together, they don't know whether they should be making decisions individually or as a group.

This situation may stem less from poor planning and more from an anticollaboration culture or mindset. Deep-rooted reluctance to collaborate, either in the corporate culture or in the individuals, will be difficult to change.

SEE ALSO

- Tasks and goals not aligned (People working toward different objectives.)
- Not a team player (One person marches to a different beat.)
- Lack of decision maker (Without a central authority, no one can coordinate collaboration.)

IN THE WILD

- Lack of planning meetings
- Poorly understood schedule
- Lack of agendas for meetings
- Poorly understood next steps

POSSIBLE PATTERNS

Pattern	Example
Take responsibility	"I should have been more on top of how we were all working together. Let's take a step back and look at all the dependencies."
Provide starting points	"Each person is working on a different piece, but let's all start with [some part of the design problem], so we can start on common ground."
Enumerate issues	"Let's make a list of all the different dependencies we have to make sure we've accounted for them in timing. Since the prototype is the ultimate goal, let's start there."

Unfounded design direction

"Hey, I did some mock-ups!"

Someone outside the design team prepares screen designs, concepts, or other artifacts attempting to establish a creative direction. When a non-designer shows up with design artifacts, the team may feel tension because it implies lack of performance from the designers. Designers may regard the non-designer with renewed anxiety as a "troublemaker" who is going to short-circuit or stall the design process. Perhaps most significantly, designers start to divide the world into designers and non-designers (see Introduction). Ahem.

Often, the intent isn't to intrude or be disruptive. Instead, the non-designer is merely finding a way to get involved. The conflict arises when

■ This isn't the case, and the non-designer has an inherent mistrust of the design team.

■ Or, the design team reacts negatively to an otherwise innocent expression of ideas and enthusiasm. The team subsequently chooses to exclude the team member.

SEE ALSO

■ Lack of stable strategy (The direction has no foundation because there is no foundation.)

■ Design ignorance (People don't incorporate basic tenets of design.)

■ Distracted by shiny objects (People use the wrong things to drive design.)

IN THE WILD

■ Showing up to a design kickoff with rendered concepts

■ Assuming any design concepts are a done deal, without accepting critique

POSSIBLE PATTERNS

Pattern	Example
Ask questions	"This is great. I have a bunch of questions about it. Let's start at the top..."
Take responsibility	"I appreciate your work, but I have a commitment to our stakeholders to create a prototype and detailed specifications. I'd like to use this as a starting point, but I need to demonstrate that the design team has added value."
Acknowledge achievements	"This is nice. I can tell you worked hard on it. Can you walk us through the decisions you made and why you made them? It's likely we'll want to revisit some of them or elaborate on the details as part of this project."

Unreasonable constraints

"I want the design to look the same on every Web browser."

Designers thrive on constraints: boundaries help designers understand what constitutes a good solution for the challenge. Some projects, however, are bounded by constraints that are arbitrary.

The conflict arises when designers seek to push against these boundaries and are denied the opportunity to relax the constraints. On the flip side, they may devise a solution that works within the boundaries, but the other members of the team find the design unacceptable.

SEE ALSO

- Irrelevant comparisons (one form of unreasonable constraint—make it look like [insert Apple product name here])
- Lack of clear inputs (another deficiency in the design foundation)
- Not a team player (a different kind of constraint—someone doesn't want to contribute)

IN THE WILD

- Justifying a requirement with "That's just the way it has to be"
- Competing requirements are given equal priority.

POSSIBLE PATTERNS

Pattern	Example
Consider micro/macro perspectives	"Can you help me understand this constraint by first describing the big picture—why it exists—then zoom into how it manifests? I'd like to see if we can find other ways to adhere to the rule without negatively impacting the product."
Help me prioritize	"Some of these constraints conflict and interfere with the product requirements. Can you help me prioritize the constraints relative to the other inputs?"
Make it real	"OK. Let's start drawing stuff that adheres to these constraints and we can see if they impede our ability to solve the design problem."

Wrong scope

"What do you mean I wasn't supposed to work on that?"

A designer works on the wrong thing. This manifests itself in different ways. Perhaps the designer misunderstood the assignment, or might have done work on the wrong part of the project. Perhaps the designer prioritized his or her tasks incorrectly. And, having just sunk lots of time into something that's potentially unusable, the designer potentially impacted budget and schedule.

This may be the most humiliating situation for designers. It's one thing to design something that doesn't work, but quite another to design the wrong thing entirely. Besides having to get the project back on track, the design team will now question the designer's ability to understand assignments. Such a situation undermines the designer's confidence. With the wrong mindset, that designer may shut down rather than embrace the challenge.

SEE ALSO

- Lack of stable strategy (working on the right thing, which slipped out from under you)

- No plan (difficult to know what to work on when there's no plan)

- Uncoordinated collaboration (overlapping efforts)

IN THE WILD

- Kicking off a meeting saying, "Not exactly sure this is what you were looking for"

- Floundering presentations without a focus on desired outputs

POSSIBLE PATTERNS

Pattern	Example
Take responsibility	"I clearly misunderstood the assignment. Let's discuss it to make sure I know what I should be working on. I'll get back to you about how quickly I can make up the delay."
Acknowledge achievements	"I appreciate your putting effort into this portion of the design. I was expecting something different because I thought I'd assigned a different portion. Let's talk through this quickly, talk about the assignment I need, and then try to figure out where the communications broke down."
Go back to basics	"I've written down the assignment so we're both on the same page about what's needed. Let's also schedule some intermediate milestones and check-ins to keep each other apprised of progress."

10

Traits:
Evaluating Yourself
and Your Colleagues

THIS CHAPTER DESCRIBES more than 15 different traits you might run into when working with designers. A trait is a characteristic of a designer. The traits that help designers understand the dynamic of a team rarely have to do with talent, but instead affect how they react to circumstances, how they interact with others, and how they perceive the world.

If my team knows, for example, that I work best at a high **level of abstraction**, they may grant me more time during the detailed design phase to deal with the tangible aspects of the design. If I'm aware that someone on my team usually has a quick **knee-jerk reaction**, I may set up a separate review session to give them some time to digest my work before soliciting more constructive feedback.

The Traits

- Adaptability
- Adherence to style
- Assumption threshold
- Creative triggers
- Defining the challenge
- Desired cadence
- Dogmatism
- Format for feedback
- Giving and getting recognition
- Knee-jerk reaction
- Level of abstraction
- Perception of control
- Preferred environment
- Preferred perspective
- Project load
- Structure of design reviews
- Transparency

Some traits are inherently positive or negative. For example, with transparency, designers either exhibit behaviors that are more open or they don't.

Designers should set negative traits to zero and turn positive traits up to 11. That is, they should strive to cultivate the positive traits (like transparency) within themselves and quash the negative traits (like dogmatism).

Most traits are bipolar, with different extremes. For example, with "Defining the Challenge" designers at one extreme jump to conclusions about the nature of the design problem. At the other extreme, they struggle to characterize the

design problem based on the project inputs. With traits like these, the designer should avoid the extremes: both ends of the spectrum yield anxiety. For other bipolar traits, there isn't a better setting on the scale: Just knowing where the designer sits on the scale is helpful.

Why Not Myers-Briggs?

Fans of Myers-Briggs and other personality assessment tools may wonder why the model of conflict in this book doesn't rely on that kind of established tool for assessing designers. Many of the traits described in this chapter may, in fact, be addressed by those other personality assessment tools.

I'm not dogmatic about how to assess designers (see "Dogmatism," later in this chapter), but I do believe that members of the team should understand each other's characteristics. This understanding leads to better project planning, better resource assignments, and smoother interactions and collaboration. As such, designers need a language for describing their preferences, style, and approach, and those of their colleagues. The advantages of the model in this book include

- **Granularity:** This model highlights very specific traits rather than very broad categories of personality. Given the range of situations designers face, it's more practical and useful to talk about characteristics at a more concrete level.

- **Distinctness:** Another consequence of granularity, this model dissociates traits, such that possessing one trait doesn't automatically imply possessing another trait. It diminishes the likelihood that anyone would make unfair assessments based on limited knowledge.

- **Range:** This model acknowledges that polarity (extravert versus introvert, feeling versus judging) may not always be meaningful, and that some traits are inherently positive or negative, desirable or undesirable for designers.

- **Specificity:** This model is targeted specifically at designers and creative professionals.

How to Use These Traits

The granularity of these traits means that designers can use them to reflect on individual behaviors and perspectives that have a direct impact on the design process. When I mentor designers, I encourage them to first understand where they sit with each of these traits. Through our conversations, we identify those traits that have the most direct negative impact on their performance.

Looking through these traits, reflect on where you might sit with each one. Try to identify the traits that

- **Distinguish you from others on your team:** What makes you a uniquely valuable contributor to the design team?

- **Hold you back:** What prevents you from becoming the designer you want to be?

In addition to aiding self-reflection, these traits can help enhance understanding of colleagues. In reviewing these traits, think about an especially difficult coworker and whether these traits might

- Motivate otherwise inexplicable behavior

- Make it difficult to work with him or her

- Cause anxiety in members of the team

- Run counter to the corporate or team culture

No one-size-fits-all fix exists for correcting behaviors that inhibit work. On the flip side, zeroing in on a particularly challenging trait can trigger a productive and specific discussion.

Each trait description includes a fictionalized quote from someone who exhibits one of the extremes of the characteristic. It provides a description of the trait itself and then details the way people might exhibit the trait. In some cases, this is an account of the two extremes. In other cases, this is a discussion of the different ways people embody the trait.

Adaptability

"I can deal with new situations, but struggle when we experiment with the design process."

Some people are great at dealing with new situations and some struggle. But designers also have to contend with scale: designers may face larger changes in process, methodology, or project structure.

The Web design business contends with its own methodological trends. Back when I started in this business, for example, design teams touted their elaborate and extensive user research techniques. The pendulum has since swung the other way, such that the buyers of design services may expect less user research.

Design teams themselves may generally remain true to a particular methodology or process. Others may relish experimentation with new techniques. Designers must understand how well they cope in each of these circumstances.

THE EXTREMES

- **Not adaptable:** The designer becomes anxious or defensive when confronted with changes in circumstances or when challenged to change her process.

- **Craving change:** The designer becomes anxious when performing the same process, dealing with the same project, or experiencing the same circumstances over and over again.

Adherence to style

"My style is to include textures that complement the purpose of the product."

Designers sometimes strive to have a signature style, elements of design that bear their fingerprints. For example, my wife and I like to look at houses for sale, and as we entered one that had been recently renovated we immediately knew who the architect was—his style was that distinctive.

Should workaday designers even have a hallmark? One might argue both sides of that debate. More relevant for this discussion is the designer's willingness to let go of these elements. Some designers invariably insert those style elements, reluctantly withdrawing them from the design solution as the process progresses. Others drop them in to give the design a starting point, with the understanding that they are placeholders.

My design style for Web sites tends to incorporate dense information displays. I like stuffing a lot onto a Web page, an approach that went out in the 90s, but one that I haven't yet abandoned. In my process I start there, but iterate on the first draft to design something more concise and lightweight.

THE TWO DIMENSIONS OF ADHERENCE

There are two dimensions to this trait—whether the designer has a strong style and whether the designer injects it into every design. Leaving aside the idea of whether designers have a distinct style or not, the key attribute is how much they inject and then adhere to the style.

Assumption threshold

"I didn't have a lot to go on, so I filled in some of the blanks myself."

Designers almost always work with an incomplete set of inputs. They find themselves making assumptions to fill in the holes in their knowledge. Every designer has a threshold, a level of input he needs in order to produce anything of value. Designers must understand their thresholds: How much input do they need on a design challenge in order to attack the problem meaningfully?

This isn't to say that when presented with only an objective, great designers can produce great designs. Great designers understand what level of input is required for a particular problem. They understand when filling in assumptions crosses the line from responsible progress to irresponsible.

THE EXTREMES

- **The go-getter:** At this end of the spectrum, designers eagerly fill in details to avoid losing momentum, potentially at the risk of getting things very, very wrong.

- **The patience of a saint:** At the other end, designers won't pursue a task unless they have all the inputs they think they need, making them thorough but slow.

Creative triggers

"Once I get my arms around the motivation of the target audience, I can design anything."

Most designers I've encountered need a trigger, something to get them engaged and excited about the design challenge. This isn't so much about finding the hook that makes the product interesting to them personally. Instead, it's about getting them to a comfort level such that they can start generating ideas.

Designers may have several triggers. Here are a couple of mine:

- Becoming engaged on an obscure software product occurred when we were challenged to boil down information for executive-level people.

- Conducting research on a new business model for health care became engaging after two user interviews in which we discovered that our target audience was filled with interesting and insightful people.

Understanding a designer's triggers means

- Knowing what it takes to get her fully engaged in a project

- Explaining why she might not be inspired or enthusiastic

- Knowing how to assign different designers to different projects

No doubt good designers can be productive and engaged on any project. Great designers find something to make them enthused on any project.

SAMPLE TRIGGERS

This trait doesn't have extremes or dimensions, but here are a few triggers designers typically have:

- Insights about the target audience

- Definition of the big underlying concepts

- Clarification of the business model

- Working with a favorite colleague

- Working on a certain type of product

Defining the challenge

"I can summarize the project in three points…"

Even with limited or distracting information, some designers are great at seeing the design challenge. They can understand the project's objectives and see the steps required to devise a solution. Stakeholders rarely express exactly what they need (nor should they be expected to). Requests are muddied by misinformation, lack of information, the wrong kind of information, or simply ignorance—not knowing what's needed. Some designers can see through the mud to zero in on the design challenge.

THE EXTREMES

- **Unable to define:** At one extreme, designers struggle to characterize or summarize the design challenge based on limited inputs. This compromises their ability to generate a solution—either a process for approaching the challenge or design concepts that address the requirements.

- **Jumping to conclusions:** At the other extreme, designers make irresponsible and rampant assumptions to fill in holes, ultimately misunderstanding the challenge.

Desired cadence

"A weekly check-in would be great."

Cadence refers to the rhythm of producing design work, things worthy of discussion among the larger team. I've worked with designers who like to check in every day, having made sufficient progress that they like getting at least some intermediate feedback. Other designers prefer a weekly cadence, desiring perhaps to give themselves enough time to develop and polish some ideas before showing them again.

Cadence isn't always a function of the designer, instead being defined by

- **Workload:** With multiple simultaneous projects, a designer may struggle to progress rapidly on any one project without sacrificing the others.

- **Client culture:** The rest of the project team or other project stakeholders may not be able to meet the designer's rhythm. The organization's culture may move faster or slower, or may expect alignment among many, many stakeholders.

Generally speaking, however, designers should be empowered to set the rhythm of deliverables, reconciling these external factors with their own preferences.

THE EXTREMES

- **A week or less often:** Designers at this end prefer regular interactions that happen every week or less often. These interactions may be more formal or more polished. They can still be productive and useful, but are not appropriate for every project.

- **Daily:** Designers at this end of the spectrum like to interact every day or several times a week. They're confident they can make sufficient progress between meetings to have something meaningful to discuss.

Dogmatism

"Proper methodology calls for…"

Some designers demand strict adherence to methodology. They insist that people follow the letter of the method exactly. They stall projects that deviate from the textbook methodology. They confront designers who have employed the methodology in a different way.

What's perhaps more dangerous about methodological dogmatism is the belief that a particular methodology is one-size-fits-all. Dogmatic designers don't compromise their process, but they also don't acknowledge that their process isn't appropriate for every project.

My characterization here implies that I prefer a middle-of-the-road approach. My experience with dogmatic designers suggests that they more often than not introduce roadblocks to the design process. Successful collaborators defend their process and don't compromise lightly, but must acknowledge the need for a flexible approach. Different projects have different needs, and a good design process accommodates the nuances of a project.

Methodology seems to be the most typical victim of dogmatism, but there are countless religious wars in design. Besides methodology, designers can be dogmatic about

- **Tools:** Some designers swear by a certain tool for rendering design concepts. Their conviction runs so deep that they see other tools as vastly inferior or even incorrect.

- **Techniques:** Narrower than methodology, a technique is a way to solve a specific problem or accomplish a specific task. As with methods, designers may have strong opinions about where and how certain techniques are applied.

- **Project management:** Some project participants (even designers) feel strongly about how the project is structured, organized, and managed.

THE EXTREMES

- **Dogmatic:** At one extreme, designers feel very strongly about specific topics, and they constantly seek opportunities to educate people about the right way of doing things.

- **Complaisant:** At the other extreme, designers have no opinion about method, tool, technique, or any other part of the design process.

Format for feedback

"What will help me most is if you ask me a lot of questions."

Providing effective feedback is perhaps the central soft skill of design. Great designers don't just produce meaningful, useful, viable work—they also help others do so with a series of well-balanced nudges and critiques.

Not every colleague, however, will be great at feedback. Designers should be great not only at giving feedback, but also at soliciting it. Soliciting productive feedback means

- **Asking questions to trigger useful responses.** Designers usually need more than "yes" or "no" to help them refine their designs.

- **Identifying specific topics or aspects** of their ideas that they want feedback on.

- **Providing sufficient background** for participants to understand the context of design decisions.

On one hand, designers must facilitate feedback conversations so as to maximize the input from colleagues. On the other hand, designers must request feedback in a way that's going to be most effective for them.

THE DIMENSIONS OF DESIRED FEEDBACK

There are lots of ways to classify feedback. Here are a few that seem to resonate most:

- **Structured vs. unstructured:** Is the feedback delivered in a way that follows a particular structure, or is it a more free-flowing conversation?

- **Broad vs. detailed:** Is the feedback rendered broadly ("I don't like the layout"), or is it directed at specific issues ("There's too much white space in this part of the page")?

- **Conceptual vs. execution:** Does the feedback dig into the underlying concept, or does it call out specific aspects of the design?

- **Suggestions vs. issues:** Does the feedback offer specific suggestions, or does it merely highlight the key issues?

Giving and getting recognition

"I notice when my colleagues don't give me credit for my contributions."

Creative work, one might argue, thrives on recognition. Designers get paid, sure, but what keeps them going is the ability to point at a product, a building, a Web site, or something and say, "I did that." In projects involving many designers, each likes to feel the glow of recognition.

Like the other traits in this list, recognition isn't so black and white. Some designers thrive on every acknowledgement, and others need the occasional nod. I've rarely encountered the designer who doesn't need his contributions recognized at all. Given the nature of the work, it's always safer to provide the recognition than not.

I've conflated giving recognition with getting recognition because they're similar processes, not because they necessarily go hand in hand. Experience shows that people who crave recognition are no better or worse at giving it.

THE EXTREMES

This trait is binary: designers are either good at recognition or bad at it. Generally speaking, great designers acknowledge the contributions of others, publicly and transparently.

TRAITS

Knee-jerk reaction

"That's awesome!"

As unfair as it is to see the world in binary, experience shows that upon seeing someone's work, people react with either encouragement or critique. "Encouragement people" immediately sing the praises of the work, show enthusiasm, and appreciate the effort put in. They may have some constructive feedback, but it takes time for them to see past their own enthusiasm before it surfaces.

By contrast, there are people who immediately see everything wrong with the work. Their knee-jerk reaction is to challenge, to poke holes, and to throw it away and start again. These people, too, may come round to the other side, eventually surfacing support for at least some part of the idea.

There's something almost primal about this reaction, as if people can't stop themselves from being either enthusiastic or critical. Every time. The more rational part of their brains eventually cuts through the fog of the primal reaction, providing a more balanced and useful critique.

THE EXTREMES

- **The cheerleader:** People at one extreme immediately greet someone's work with positive enthusiasm.

- **The critic:** At the other extreme, people immediately identify all the problems with someone's work.

Level of abstraction

"I like working with the frameworks and the concepts."

One way of looking at design is as a process of increasing the focus on a set of concepts. By the end of the process, the design is a product fully in focus, but initially it's a blurred mess. At the blurry end, designers work with very abstract ideas, very broad concepts. Like working with the more abstract concepts of mathematics, design at this end of the spectrum can be difficult to grasp. At the focused end, designers work with very concrete decisions. At this end of the spectrum, the ideas are easy to picture because they're concrete, but there are many of them.

Every designer has a comfort zone. Some like playing at the more abstract end, manipulating concepts to establish an underlying structure or framework for the product. They can anticipate how the abstractions will work into definitive interactions or spaces or features, but they prefer operating with concepts. Others are more comfortable mired in the concrete. This isn't a distinction of big picture versus details, though it might correspond with that. Abstractions can have endless details, too. It is instead a question of material. Is this a designer who prefers pushing specific design elements around the page or pushing boxes representing concepts around the page?

Designers end up working at all levels of abstraction. Rarely can a designer work at only one end and outsource the rest of the work. Great designers understand where they need help to work out the abstract or the concrete.

THE EXTREMES

- **Abstraction maven:** At this end of the spectrum, designers are more comfortable thinking about the underlying concepts of the project. They prefer thinking through structures and concepts that are elegant and serve to unify the project's requirements.

- **Reality wizard:** At the other extreme, designers prefer to deal with the concrete aspects of the product itself. They prefer making decisions about the reality of the product, even if those decisions aren't elegant and require compromise.

Perception of control

"If I can't move the pieces on the board, I'm not interested in the game"

Designers have a complicated relationship with control. Painting with a broad brush, they want to feel utterly autonomous in making design decisions that address the central challenge. They want to avoid arbitrary constraints and prevent non-designers from wielding any influence over the product. But designers also acknowledge that they are not in complete control over the final product, that they need to accommodate a range of requirements and adhere to project parameters.

This trait reflects how much control the designer perceives himself or herself to have—whether the designer is making a meaningful contribution or just following orders. No doubt the perception of control has to do with the project configuration itself. The control a designer has over his or her own destiny varies by project: the circumstances and other participants influence this.

The reality of control is almost immaterial to the perception. Generally, experience shows that the amount of control one wields is derived from the amount of control one perceives. Ultimately, designers must realistically assess what parts of a project they can influence and what parts are legitimately beyond their control. Typically, however, designers come to projects with preconceived notions about their influence and control.

THE EXTREMES

- **I'm a pawn:** Regardless of circumstance, designers at this extreme believe themselves to never have any control. For them, the autonomous project is always over the next hill.

- **This project would fail without me:** At this extreme, designers believe that they are the solitary drivers of decisions.

Preferred environment

"Gimme an easy chair and a set of headphones, and I can design anything."

Different designers thrive in different ecosystems. Some prefer quiet solitude, and others prefer the chaos of the war room. For some, frequent interaction with other people, even if not in the context of a project, is necessary for their mental health. Others prefer structured and predictable interactions with people.

The reality of design today is that within the space of a single design project (or activity or task) designers find themselves working in many different environments. They'll go from the small meeting room to the multisite conference call to a table in a coffee shop to the boardroom. And that's just to run a round of usability testing.

THE DIMENSIONS

Instead of extremes, designers can characterize their environment by different dimensions, or variables:

- **Noise level:** How much ambient noise is there?
- **Exposure:** How much can people at their desks see office traffic?
- **Closure:** Can people close off their personal space for total privacy and no interruption?
- **Huddling:** Can people easily huddle?
- **Diversity:** Can people easily change their surroundings?
- **Amenities:** Can people easily access diversions, distractions, and nourishment?
- **Anonymity:** Can people be unrecognizable?

Preferred perspective

"I'm a details guy."

Unlike level of abstraction, perspective is less about the building blocks designers prefer to use and more about the way they see a project. By "seeing a project" I mean the designer's ability to understand some fundamentals to overcome their anxiety about starting something new. Designers can best understand their preferred perspective by reflecting on when the project clicks for them.

For me a project clicks when I understand the business context: who needs to talk to whom; who derives value from the product or process; what are the nuances that make this product or process especially challenging. Once I have this basic understanding, I can confidently move forward with the rest of the design process.

For other designers, the project makes the most sense when they take a ground-up approach, seeing all the details of the project. In the case of software, this might be a total set of requirements. In the case of a Web site, this would be a list of all the content to be incorporated into the site. Some designers find comfort in this detail. (By way of contrast, for me this detail is useful but immaterial to my anxiety level if I understand how all the big moving parts interact.)

CHARACTERIZING PERSPECTIVE

This perspective doesn't have a single scale, but there are a few different ways of characterizing a designer's preferred perspective:

■ **Project plan:** For some designers, their understanding of the project clicks only when they see things in terms of budget, timeline, and resourcing.

■ **Design process:** Some designers like looking at things from one particular area of design, like research or production or modeling.

■ **Business challenge:** Understanding clicks when the designer has a clear sense of how the product will fit into the marketplace.

■ **Underlying structure:** For some designers, the abstract concepts that comprise the foundation of the product must be understood before they can be productive.

■ **Building blocks:** Some designers will be anxious until they have a complete inventory of all project inputs.

Project load

"Anything above four projects and I start to flail."

With some exceptions, every designer must balance more than one project. Even those working for one organization or one client have several different streams of work happening at once. These vary in scale, scope, and duration. Designers may play different roles on different projects, and have different levels of commitment. They may work with different teams, for different stakeholders. Or, they're working with the same people in different capacities. Even for two projects, it's a lot to keep in one's head.

Designers have project load thresholds. The more designers know and understand the nuance of their thresholds, the better. So, knowing that I become less effective when I have more than three projects on my plate is good. Knowing that my ideal mix of projects is one large and two medium is better.

THE EXTREMES

- **Dedicated:** At one end of the spectrum, a designer thrives when she has one and only one project to focus on.

- **Diversified:** At the other end of the spectrum, a designer thrives when she has many things going on.

Structure of design reviews

"Just interrupt me as I'm talking. I like hearing your ideas and feedback as they come to you."

The design review is a crucial tool for design teams, giving designers unbiased input from stakeholders and other team members. Design reviews generally occur throughout the project. They may be formal or informal, ad hoc or built into the project plan. Design reviews can offer a fresh perspective, and they allow design teams to enforce quality standards that may come from outside the project itself.

The design review is, in a sense, a design tool. And designers should have an opinion of how they like to use it. Some designers prefer informal conversations about the current state of their work, while others prefer to get feedback on specific items.

With an awareness of their preference, designers can confidently drive the conversation to get the feedback they need.

THE DIMENSIONS

The structure of design reviews may be measured along multiple dimensions.

- **Formality:** A formal presentation versus an ad hoc get-together
- **Interactivity:** Lots of conversation versus presentation followed by questions
- **Participants:** Large heterogeneous group versus one-on-one
- **Timing:** Several times a week versus once a week or less

Transparency

"I don't like to tip my hand too much."

Being open and honest is a virtue of collaboration (see Chapter 8). Yet many designers can find it difficult to be honest with their colleagues and to be open to honest input from them.

Designers should consider how confidently they can be honest with their colleagues and how open they are to critique, feedback, and input.

THE EXTREMES

- **Open book:** Some designers struggle to moderate their thought processes.
- **Closed book:** Some designers struggle to communicate their thoughts and feelings.

■

11

Conflict Patterns:
Behaviors for
Reaching Resolutions

A PATTERN IS a behavior, a way of dealing with a difficult situation. These patterns suggest

- A way to treat a situation (like converting failure to action)

- A way to look at a situation (consider micro/macro perspectives)

- A way to frame a conversation (blame a "bad cop")

- A technique to inject into the conversation (draw pictures)

Patterns are intentionally high-level starting points. No book can give you a perfect recipe for dealing with every situation.

Recall that there are four types of patterns:

- **Empathize:** Build understanding between people.

- **Involve:** Engage people more directly in the project.

- **Redirect:** Get people to focus on the right things.

- **Reframe:** Use a different language to talk about the situation.

Recall, also, the principles of using the patterns:

- **No right answer:** There isn't one "right answer" for a given situation. That is, the pattern that works in that particular situation is the right answer, but it may not work in similar circumstances next time.

- **Diversity corollary:** Because there's no one right answer, any of the patterns may introduce a new approach for dealing with a particular situation.

- **No perfect fit:** Not every pattern works in every situation. It can be a valuable exercise to imagine applying a nonobvious pattern to a situation, but that could be disastrous in practice.

- **Convergence:** Several patterns for a given situation may yield the same outcome or even the same approach. This doesn't make the diversity of patterns useless. Instead, it just means that there may not be a lot of different ways to think about that particular situation.

- **Comfort zone:** Designers will find that some patterns are more comfortable for them and may retreat to these patterns frequently. Sometimes the best way to untangle a situation is to try something new, especially since it might surprise participants.

The pattern descriptions in this chapter each provide

- **An example:** Usually a fictitious but familiar quote showing how someone might use the pattern

- **A description:** A short explanation of how to use the pattern

- **A type or types:** One or more of the types identified in "The Patterns" (see the next page)

- **Use when:** A description of the types of circumstances when the pattern will come in handy

One final note on patterns: Many of them will feel similar to each other, as the patterns draw on the same themes appearing throughout this book. Techniques for dealing with conflict involve restating what people say, breaking things down into manageable chunks, positioning people as owners, and simplifying communications. These and other themes will pop up time and again, but each pattern offers a different perspective on them, and some patterns combine them in different ways.

How to Use the Patterns

There's no one right way to use patterns. One simple way is to flip through and see what jumps out as a possible solution to a current problem.

Another approach: Identify a few different ways of dealing with a situation, and play out the dialog mentally to see how each fits with the conflict.

The patterns can help designers understand their own tendencies and behaviors. Look through the patterns and determine which feel the most comfortable and which feel the most uncomfortable, regardless of the situation. Reflect on what the comfortable patterns have in common, and what makes them different from the uncomfortable patterns. The themes that emerge from that self-reflection may reveal essential aspects about perspective or attitude that shed light on overall mindset.

Finally, pick a new pattern to try when facing the next conflict. Keep it in your back pocket. Use such a conflict as an opportunity to challenge your mindset.

The Patterns

- Acknowledge achievements
- Anticipate agendas
- Ask for a story
- Ask for help
- Ask for the first step
- Ask questions
- Assert your process
- Blame a "bad cop"
- Call their bluff
- Capture lessons learned
- Change the channel
- Change the metaphor
- Channel your colleagues' best qualities
- Come back later
- Communicate implications
- Consider micro/macro perspectives
- Consider your work/ their work
- Convert failure to action
- Draw pictures
- Enumerate issues
- Frame the conversation
- Go back to basics

- Help me help you (The Jerry Maguire)
- Help me make this better
- Help me prioritize
- Hold a workshop
- List assumptions
- Make a plan (Logistics specifics)
- Make assumptions
- Make it real
- Offer alternatives
- Offer a sneak peek
- Pick one thing
- Pick your battles
- Prioritize the portfolio
- Provide starting points
- Recount previous conversation
- Reduce the assignment
- Reflect the position
- Seek small victories
- Set reasonable expectations
- Show the goal
- Show your work
- Take baby steps
- Take responsibility
- Treat it like a project

Acknowledge achievements

"Wow, you guys did a great job on this. I can see the effort you put in. Can you walk me through to make sure I understand everything?"

Don't discount the work, effort, or ideas that someone has contributed. Highlight them as a starting point for more detailed conversations, and give people a way to start from a strong position.

Type Involve

Use When Engaging with someone about his or her work, and potentially balancing achievements with opportunities for improvement.

Anticipate agendas

"I know there are a few things that are especially important to you, so I wanted to address them right away."

Imagine what's important to other members of the team or project stakeholders before engaging in a discussion with them.

Type Empathize

Use When Entering a conversation with people expected to be competitive or confrontational, to demonstrate that you have their best interest in mind.

Ask for a story

"I think I understand what you're trying to say, but can you walk me through the scenario as if someone from our target audience were trying to use the product?"

Ask someone to describe their ideas or thoughts or needs in the form of a story.

Type Reframe

Use When Someone struggles to articulate their needs in the abstract, and you want to help them make it more concrete.

Ask for help

"I'm really struggling with this design problem and before I sink too much time into it, I was wondering if you could help me get on the right path."

Directly ask someone to help you with your task.

Type Involve

Use When You need help. You're preoccupied with proving yourself instead of solving the design problem. You need to involve someone in the task and need to ask them for their participation.

Ask for the first step

"You're supposed to create a governance plan. Honestly, I have no idea how you're going to get there. Can you tell me what your first step will be?"

Ask someone what their first step will be in attempting to achieve an objective.

Type Reframe

Use When Someone struggles to articulate their process for performing a task, by getting them to focus only on a small slice.

Ask questions

"OK. You've got a good start here. Let me ask you a bunch of questions to see if I understand what you're getting at."

Instead of jumping to conclusions, ask questions to make sure both you and the other people understand what's going on.

Types Reframe, Involve

Use When All. The. Time. No other skill is as essential to designers as being able to ask good questions. Except, perhaps, listening to the answers.

Assert your process

"We can't just dive into design without a better understanding of requirements, constraints, and other project parameters. I know you're eager to get started, but let's be deliberate about defining the problem before we start to solve it."

Remind participants of the schedule and the process on which it is based, providing lots of detail about activities, outcomes, and goals.

Type Redirect

Use When Someone introduces factors that may compromise or derail the process, like late-breaking requirements.

Blame a "bad cop"

"I understand the constraints we're facing but I need to give my project managers some good news. Let's talk about what we will and will not deliver at our first milestone, so I can clearly set expectations."

"I need to check with my partner before I commit us to anything."

Use another team member (not present) as a scapegoat. By putting a human face on the situation, people might work harder to find a compromise, or might forgive ignorance.

Type Reframe

Use When Facing unreasonable constraints or being put on the spot for a question you can't answer immediately.

Call their bluff

"I understand that the stakeholders are expecting the design work to be finished by the end of the week. They've had the drafts since last Monday, but we haven't heard from them. Will they be able to provide feedback in time for us to incorporate it?"

Take a challenge to its inevitable conclusion and hold everyone involved accountable for meeting the challenge. Help other team members understand the impact of their request.

Type Reframe

Use When Presented with unreasonable requests that aim to put pressure on the design team without any meaningful outcome.

Capture lessons learned

"The last time we tried a project like this, we ran into some issues. Before we get too far into this project, let's make a list of everything we learned on the previous project and any other projects like it."

Make a list of issues, obstacles, and difficulties that came out of a prior project or situation or challenge.

Types Involve, Redirect

Use When The project team hasn't taken a moment to reflect on their previous work and how they could have done it better.

Change the channel

"Hey, sorry to call unexpectedly. I thought we might be getting our wires crossed on email."

Find a different "channel" in which to communicate. Sometimes this means moving from email to voice, or in person to email, or instant messenger to video chat. Sometimes this means taking a conversation out of a public venue.

Type Reframe

Use When The medium of communications is impacting participants' ability to express themselves clearly.

Change the metaphor

"We're looking at the activities as a series of parallel tracks, but I think we should be looking at the project as a set of milestones. Let's agree on everything we will know at each milestone."

Use a different concept to explore or explain a complex idea.

Type Reframe

Use When Participants become fixated on the metaphor and not the problem being solved, or when participants need a new way of looking at the same old problem.

Channel your colleagues' best qualities

"What would Nathan do in this situation?"

When struggling to cope with a situation that isn't in your "sweet spot," think about a person who would deal with it well. Consider how they would behave and attempt to incorporate it into the situation.

Type Redirect

Use When Confronting a situation that is causing you particular anxiety or frustration. Sometimes, pretending to be a different person allows us to tap into not only their capabilities, but also their strength.

Come back later

"We're going round and round on this problem. I need a break to think about things, and I'd like some time to review some of the materials. Can we reconvene on Wednesday? I'd rather make the right decision than a hasty decision."

Postpone taking action until participants can consider the situation more deliberately.

Types Empathize, Redirect

Use When The situation has gotten out of hand, such that the participants aren't providing reasonable and appropriate contributions.

Communicate implications

"If we don't get feedback until next week, we'll have to shift our delivery milestones. Without feedback, I'm worried that we'll have more work later in the project dealing with late-breaking requirements."

State, in the simplest terms possible, the consequences of a decision.

Type Reframe

Use When Participants make decisions without realizing the negative consequences for the process or project outcome.

Consider micro/macro perspectives

"On the one hand, by not finishing the task, you've given your colleagues more work to do. On the other hand, though, at the client relationship level, you've cost us some credibility and trust."

"OK, we've been talking at a high level. Let's zoom into the details of the project and see how our big decisions will affect our day-to-day work."

Look at the situation from two different angles, broad versus narrow or high versus low. Adopting a new perspective can help expose new issues and solutions.

Type Redirect

Use When Participants become so focused on one perspective that they lose sight of the project or task objectives.

Consider your work/their work

"Their job is to make sure our ideas can be implemented and work within their current systems. Your job is to understand their constraints and offer refined solutions."

Offer encouragement and deflate the anxiety of critique by reminding colleagues that stakeholders and other team members are just doing their jobs. (Restated from Carol Dweck's Mindset, page 224.)

Type Reframe

Use When Confrontations have escalated to the extent that participants are having trouble hearing each other's concerns.

Convert failure to action

"Based on your feedback, I see this isn't working for you. Let's make a list of what's wrong and prioritize. We can dissect the communications breakdown later. For now, let's focus on what we need to do to get back on track."

Take outcomes that seem to be dead ends and use those as starting points for subsequent tasks.

Type Redirect

Use When Confronted by people who approach failure with a gloom and doom attitude, thinking that nothing is recoverable from such outcomes.

Draw pictures

"I'm having a really hard time understanding what you're talking about. Mind if I draw it out? Let me know what I get wrong."

Use visual aids, spontaneous sketches, whiteboards, diagrams, or other visualizations to organize thoughts. Encourage participants to draw or embellish others' drawings.

Type Reframe

Use When Participants are having trouble making sense of each other's statements.

Enumerate issues

"There's a lot going on here. Let me make sure I have everything correct. I'm going to make a list of everything I heard."

As people are talking, or to summarize what was said, make a list of the chief complaints or concerns.

Type Redirect

Use When You need to break down a seemingly elaborate situation involving competing priorities or differing perspectives.

Frame the conversation

"There's a lot to discuss. Here are the two big topics we need to cover: feedback on the design from the engineering team and next steps for preparing the design specifications. The goals for this meeting are to capture feedback items from the engineering teams, then get their input on the specifications. Let's avoid going down any rabbit holes until we have a list of all issues."

Establish a structure for conversations, with clearly articulated topics and goals. To the extent feasible, identify items outside the scope of the discussion to avoid getting off track.

Types Involve, Redirect

Use When Participants struggle to keep conversations focused or the agenda becomes dominated by a few players that distract from objectives.

Go back to basics

"With so many moving parts, I'm worried that we're going to lose track of something. Let's use shared to-do lists on the intranet to keep track of tasks."

Rely on tried-and-true project management tools and techniques to keep project teams aligned and on track.

Types Redirect, Involve

Use When Project teams begin to spin out of control because they take project management basics for granted.

Help me help you (The Jerry Maguire)

"I know how important this design project is to your work here. I'd like to make sure you can be successful and meet the milestones of the larger project. What I can I do to help you meet those goals?"

Position the team's work and the team's role relative to another's goals. Show how the team's goals align with the individual's goals.

Type Empathize

Use When A stakeholder or participant signals that they see themselves as competitive with or opposed to the rest of the team.

Help me make this better

"I just took a first stab at this, and I know it's not a great fit for the design challenge. Can you help me make this better? What can I do to make sure it's meeting the project goals?"

Position work as a first draft, requiring input and feedback. Position participants as crucial experts with knowledge that can help improve the design.

Type Involve

Use When Participants are unwilling or unable to provide constructive feedback.

Help me prioritize

"You've given me a lot to think about. Can we look at this list and prioritize what's most important? If we get to 'it's all important,' then there's probably something else going on, so let's try to be ruthless about prioritizing."

Ask participants to prioritize issues, requirements, feedback, or whatever else may be driving subsequent activities.

Type Redirect

Use When Presented with a list of issues that will impact the team's ability to execute their plan or to complete tasks within the project's constraints.

Hold a workshop

"We've been going round and round on design feedback, so the team has organized a series of activities that will help us zero in on the key issues with the design."

Structure a meeting as a collection of participatory activities combined with presentations, as if team members were attending a training workshop. By making the activity more participatory, teams can engage all stakeholders.

Type Involve

Use When Working with a team of people who need structure to actively contribute to a project.

List assumptions

"To make progress on this work, I had to make some assumptions. Let me tell you what my assumptions were, so you can see what drove some of my decisions."

List the educated guesses the team made to allow them to move forward with the project. Assumptions may be related to any context: product, performance, plan, or purpose.

Type Reframe

Use When Many of the team's decisions rely on information that the rest of the participants may not know. The team may be entering into a conversation where participants have disparate expectations about the underlying assumptions. The list of assumptions may be used to justify decisions or as a tool to validate assumptions.

Make a plan (logistics specifics)

"Based on all this feedback, we need to revisit our milestones. Can we draw out what the next few weeks will look like so we can align on activities and expectations?"

Identify a goal, a set of activities to reach that goal, and a set of milestones leading up to the goal. With multiple goals, be sure to prioritize.

Type Reframe

Use When Confronted with an overwhelming amount of work and no clear next step on how to make progress.

Make assumptions

"I'm missing a lot of data about the target audience. I'll just create a rough profile of the target audience based on some of my assumptions about the product."

Don't let unknown information stand in the way of reaching project goals. Make educated guesses about missing information. Be sure to share those assumptions with the project team to provide a rationale for design decisions.

Type Redirect

Use When You are ready to start the design process but unable to close additional gaps in understanding.

Make it real

"The only way we'll see if these ideas work is if we try them out. Let's take some time right now to draw out how the screens would look with these requirements added in."

Take steps to embody abstract ideas so people can react to something more concrete.

Type Redirect

Use When Participants are throwing out ideas and feedback without regard to feasibility.

Offer alternatives

"I think I understand what you want, but let me spell out three different approaches so we can clarify our constraints."

Present two or three ideas, concepts, solutions, or approaches. Present them such that it is easy for participants to compare and contrast.

Type　　Involve

Use When　Presented with an ambiguous problem that will not have clear criteria for evaluating a solution. Offering a set of alternatives allows participants to compare and contrast instead of determining whether one approach or solution is "correct." I sometimes use this pattern when selling a new project to help people understand the different ways to approach it.

Offer a sneak peek

"We'll be running through three different concepts tomorrow. Let me give you a heads-up about what you're going to see."

Show or describe upcoming work in brief to set expectations about what will be seen or what participants will need to comment on. Involving people before the established milestones creates a sense of ownership.

Type　　Involve

Use When　Presenting ideas or approaches that will challenge some underlying assumptions, as a way to build the right mindset in key participants.

Pick one thing

"You've laid out a lot of different critiques of this work, and it's all great feedback. Let's focus on the first thing you said for now, that you worry about the relative priorities of the features. Can we go through each feature and define its priority?"

Select one item from a list to focus on.

Type　　Redirect

Use When　The team or participants feel overwhelmed by the range of issues confronting them. Selecting a single item is a good way to begin addressing the list.

Pick your battles

"I agree that some of the client's feedback isn't going to improve the design, but we've got some bigger issues coming up. I'd rather avoid a confrontation now so that we'll be in a better position to deal with whatever comes up later."

Choose the right time to engage in active conflict.

Type Empathize

Use When Facing a potentially major conflict that, compared to confrontations likely to emerge later, will have little impact on the final outcome.

Prioritize the portfolio

"I'm not entirely happy with the direction this project took. I don't know that we'll achieve the project objectives, but I can use the project to improve my own professional goals."

Find a way to meet a personal set of objectives through work on the project. This could include something as concrete as "Produce a nice piece for the portfolio," or "Get better at resolving conflicts."

Type Redirect

Use When The thread of a project or task has become so compromised that it's difficult to find personal meaning or satisfaction in it.

Provide starting points

"When preparing the documentation, make sure your writing focuses strictly on functionality. I've put together a page of examples for you."

Give people examples that set the bar for the level of work expected. Starting points model the desired outcomes.

Type Empathize

Use When Delegating a task to someone new to the project, to the task, or to the team, to establish direction and expectations.

Recount previous conversation

"Before we dig into this new round, let me hit the high points from our last conversation. Last time we talked..."

Summarize an earlier conversation to set the stage for the current conversation.

Type Reframe

Use When Working with people with poor short-term memories, to ensure that everyone agrees on the key points from previous discussions. This is especially useful when some stakeholders habitually change their minds in between meetings.

Reduce the assignment

"For our next meeting, we need to complete parts A, B, and C. Let's schedule an internal check-in tomorrow, though, and for that just focus on A."

"I have a good idea of what we need to cover before our next client meeting, but it would help me if we could break it down further. Can we schedule a check-in for Wednesday, and I'll have ready some ideas for part A?"

Bite off a smaller chunk of the task at hand to control scope.

Type Redirect

Use When Dealing with a large project assignment with ambiguous direction or potentially misaligned expectations. A smaller piece of the assignment allows people to focus on a manageable design problem and align their expectations.

Reflect the position

"Let me just make sure I understood what you said..."

Repeat another person's assertion to assure comprehension and alignment. When people repeat statements made by someone else, they show that they are listening to what's being said.

Type Empathize

Use When Participants should repeat each other when they feel they may not understand each other's positions. They should repeat each other when they sense that other participants may be increasingly frustrated or anxious about being left out.

Seek small victories

"There are a lot of different ways we can go with this project. Let's focus on one way, and try to get that right."

"I know we've struggled to align on these different aspects of the design, but I have some ideas that might address one of them. Let's start there."

Drive toward a win, no matter how small, to demonstrate success or establish a foundation of success.

Type Redirect

Use When The team faces myriad challenges and is enthusiastic about pursuing all of them, but perhaps within a hostile environment. Use small victories to win over everyone else.

Set reasonable expectations

"I know there's a lot you want me to accomplish in the next week or so. Let me tell you what I think I can accomplish in that time, what I could accomplish sooner, and how long the whole list will take me."

Provide a clear account of how long tasks will take. Avoid compromising timelines for the sake of arbitrary deadlines. Be honest about scope within predefined timelines, and be honest about time for a predetermined scope. Rarely does a project team demand the unreasonable.

Type Redirect

Use When Facing a request with a predefined scope or predefined timeline, and being put on the spot to commit to a particular delivery.

Show the goal

"We have a pretty elaborate project plan laid out, but I'd like to have a better sense of our objective. Can you paint a picture of what you expect to have in hand when the project concludes?"

Ask stakeholders to describe as vividly as possible the desired outcome of a project or task. This isn't so much to describe the final design as it is to make sure they know what they're getting.

Types Empathize, Involve, Redirect

Use When The team has placed too much emphasis on activities and doesn't have a collective understanding of the desired outcome.

Show your work

"Now that you've seen the final design, let me show you the steps I took to get here."

"We have a long way to go before we arrive at final designs, but let me share where things are at. If you've got some feedback now, I'd love to hear it. Keep in mind that you're looking at working artifacts that are interim steps to our final objective."

Reveal the key decision points in the process. This validates the level of effort, provides a foundation and rationale for design decisions, and involves participants in the design process.

Type Involve

Use When Presenting design ideas to stakeholders not involved with the day-to-day design process.

Take baby steps

"Introducing a whole new design process is going to be daunting. Instead of changing the entire process, let's just add a new activity at the beginning of the process to solicit requirements."

Introduce small changes into a project, a culture, or an organization to effect large charges.

Types Redirect, Involve

Use When The habits of the team or organization are so entrenched that new ways of thinking or approaching a problem seem scary or unattainable.

Take responsibility

"I wasn't able to complete the assignment. I should have raised a warning earlier in the week. I know this leaves the team in the lurch. What can I do to help close the gap?"

Be honest and forthright with errors. Offer to help clean up the mess.

Type Empathize

Use When Facing an error that has an impact on other team members or the success of the project.

Treat it like a project

"We're having trouble coming to an agreement on how to deal with all the feedback we got from our testing cycle. Let's create a plan that will help us prioritize and act on it."

Establish a goal, activities, dependencies, roles, and other structure to drive toward a solution for a conflict.

Type Reframe

Use When Facing a conflict with so many moving parts that resolution requires careful planning.

▪

12

Collaboration Behaviors: Embodying the Virtues

BEHAVIORS FOR COLLABORATION aren't so much starting points as they are habits. The conflict patterns of the previous chapters are like medication: something to try when things are going wrong. Collaboration behaviors, on the other hand, are extensions of the virtues described in Chapter 8, and as such, extensions of the mindsets described in Chapter 2. They are habits to be cultivated and adopted into day-to-day work. By incorporating these habits into day-to-day behaviors, project teams will become more collaborative and more efficient, and will produce better work.

Note: *There is of course some overlap between these behaviors and the conflict patterns. Some of those starting points make great habits.* ◼

This chapter begins by describing these behaviors and includes a list of the most common behaviors. Each entry in this chapter then includes a description of the behavior, some simple ways to adopt the behavior, and an explanation of why the behavior is important to collaboration.

How to Use These Behaviors

Unlike the conflict patterns, these collaboration behaviors aren't tools to whip out when needed. Instead, these behaviors must be cultivated. Consequently, they represent a longer period of investment.

Some behaviors will come naturally to some people, and others will feel against the grain of their personality. Comfort (or discomfort) with different behaviors depends in part on mindset. That said, changing behaviors isn't a matter of changing mindset. These two things feed off each other. By forcing some of these behaviors—even if they feel uncomfortable—individuals will start to shift their mindsets. Likewise, by forcing themselves to see situations differently, individuals will feel more comfortable with these collaboration patterns.

Effecting Change in the Team

Getting a team or organization to adopt a change in its behavior is challenging. Expectations around how people communicate and work together are ingrained and inscribed in the corporate culture. Starting small and making incremental changes is the best way to proceed with groups that are generally unwilling to change. **Table 12.1** describes how some example behaviors might start with a baby step.

Table 12.1 Changing Behaviors in Small Steps

Behavior	Current Culture	Desired Change	Small Change
Centralize decision making	Projects rely on consensus building to make important decisions.	At the start of every project, every team establishes a lead , the person responsible for making final decisions.	Ask for some decision-making criteria around a specific aspect of a new project. Refer to those goals or criteria throughout the project.
Employ tools that yield meaningful outcomes	Use the same tools and techniques over and over on every project, irrespective of their value.	Project leads decide on tools and techniques for each project, drawing on past experience.	For one particular activity or deliverable, ask to present the same information in a different way to contrast with the existing practice.
Know when you're "spinning"	Team leads don't care how something gets done.	Team members recognize when they're not making progress and can expect team leads to check in with them.	Upon receiving a new assignment, ask for one check-in.

Effecting Change in Yourself

One exercise I've done with workshops is to use the list of behaviors to reflect on individual performance and preference. I ask individuals to review the list of behaviors and honestly assess which behaviors play to their strengths and which are most uncomfortable.

For example, these behaviors play to my strengths:

■ Ask questions that yield specific answers. (I love asking questions.)

■ Embrace constructive criticism. (I love hearing new ideas.)

■ Keep meetings focused and short. (I love leaving early.)

While these behaviors are uncomfortable for me, personally:

■ Communicate progress. (I hate admitting things took me longer than anticipated.)

■ Employ tools that yield meaningful outcomes. (I hate trying new tools.)

■ Engage in dialogue. (I'm more of an asynchronous communications man, myself.)

Having identified these strengths and weaknesses, workshop participants then make commitments or resolutions that will help improve their weaknesses. These resolutions should be actionable and measurable. For example, with "Engage in dialogue," I might

- Allow myself to stray from the agenda.

- Ask probing questions to encourage colleagues to elaborate on their thoughts.

- Suggest more informal venues for meetings.

- Have in-person coffee with one colleague each week.

In the workshop, people pair up and make these commitments to each other, establishing a sort of social contract. You could do the same with a trusted colleague or your manager.

The Behaviors

- Ask questions that yield specific answers
- Centralize decision making
- Clarify expectations regarding ability and delivery
- Communicate progress
- Don't hog opportunities
- Embrace constructive criticism
- Embrace risk
- Employ tools that yield meaningful outcomes
- Encourage disruptive communications
- Engage in dialogue
- Engage multiple senses to communicate
- Establish role definitions
- Give others room to learn from mistakes
- Have a communications plan
- Have a project plan
- Have decision-making mechanisms
- Have objectives for every discussion
- Keep meetings focused and short
- Know when you're "spinning"
- Offer direct critiques
- Play to strengths
- Provide a rationale for decisions
- Recognize contributions
- Reduce competition
- Reflect on your performance
- Respect the calendar
- Set availability expectations
- Set performance expectations

Ask questions that yield specific answers

Structure questions to encourage increasingly direct and detailed responses. Yes/no questions are OK, so long as they validate a specific decision or direction.

Virtue Clarity and Definition

How Avoid asking broad questions like "So what do you think?"

Point to specific aspects of a design or plan: "We created a structure based on the user research. That includes prioritizing three key functions. Take a look at where we put them in the interface and how we labeled them. Do those make sense to you?"

Communicate implications of different decisions: "By structuring the interface in this way, users have direct access to three key functions, but have to scroll to get to the other ones. Any concerns about that?"

Why Clarity requires specificity. Broad acknowledgment or validation can be misleading, getting people to agree to things they may not really understand.

Centralize decision making

The project's ultimate decision making comes down to one person. Obviously, there are different kinds of decisions, and each one (budget, creative, timing) may be owned by a different person.

Virtue Accountability and Ownership

How At the beginning of the project, ask who owns final decisions about design.

Lean on the decision maker to validate direction and approach.

Why Collaboration depends on everyone working toward a common goal, and on everyone being aligned in how they do it. Without a central decision maker, the execution of activities can become muddled, and teams may spin off in arbitrary directions.

Clarify expectations regarding ability and delivery

At every opportunity, project participants should be clear about what they can deliver and when. They should indicate risks to their ability to deliver on assigned tasks, and present an alternative delivery schedule.

Virtue Accountability and Ownership

How After receiving an assignment, make sure you are aligned with the project lead in terms of what you are delivering and when you are to deliver it.

Ask for help in estimating time for assignments.

Why Collaboration relies on every participant doing his or her part successfully. A mutual understanding of each person's part is what allows participants to rely on each other.

Communicate progress

Project participants should keep each other up to date honestly and openly about where they are in their assignments.

Virtue Accountability and Ownership

How Establish a rhythm for communicating updates to project leads.

Use a simple template for email or other electronic messages to communicate updates.

Why Collaboration is more than coordination among team members, but coordination is a necessary component. Coordination depends on everyone knowing where everyone else is in their assigned tasks.

Don't hog opportunities

Allow every project participant to make a contribution. Don't make the project a competitive sport.

Virtue Awareness and Respect

How Acknowledge tendencies to be the first to jump in, and set a goal for yourself to wait 15 minutes before saying anything in a group setting.

Recognize that saying "yes" to every assignment can undermine your credibility.

Remind yourself that you have nothing to prove beyond doing good work.

Why Collaboration values more information over less, as well as a variety of perspectives.

Embrace constructive criticism

It can be easy to take criticism personally. When that happens, people become defensive, shutting down their ability to listen.

Virtue Accountability and Ownership

How Use the "Consider your work/their work" pattern to separate the person from the task of providing feedback.

Anticipate critiques before they happen to soften the blow.

Critique is about listening. Make sure you listen to the feedback when people are reflecting on your work, not just the judgment.

Why Great design depends on iteration, validation, and refinement. Critique is an essential part of that cycle.

Embrace risk

Be prepared to take some chances throughout the process. Be prepared to take responsibility for failures.

Virtue Accountability and Ownership

How Before leaping, articulate the possible negative outcomes of taking this risk.

Be a willing participant in other people's risks, but be their conscience, too.

Why Design projects are never a dot-to-dot affair, with one step simply and uneventfully leading to the next. Great design depends on designers taking risks. It can be scary. Risk-taking done responsibly, however, can be rewarding.

Employ tools that yield meaningful outcomes

Use tools, techniques, applications, and artifacts that make a real contribution to the project. Tools that become rote should be under greatest scrutiny.

Virtue Clarity and Definition

How Question the value of every activity or deliverable, and seek to understand how it will move the project forward and how it will lead to the next step.

Why Having a rationale for using specific tools for specific outcomes helps to enforce the process and to get support from the entire team.

Encourage disruptive communications

Allow participants to be interrupted from their work for spontaneous or ad hoc reviews and conversations. People can stop by each other's offices, use the phone, or contact each other through other collaboration technologies.

Virtue Clarity and Definition

How Make use of calendars to indicate availability.

Adopt a variety of communications channels to give team members a variety of ways to engage with each other.

Why Creativity and team chemistry thrive on spontaneity. Modern workplaces should not erect obstacles to communications. Sometimes the creative process needs feedback immediately.

Engage in dialogue

Use conversation and questions/answers to elaborate on concepts, design requirements, or other aspects of the project. Don't conduct all business asynchronously, but instead encourage team members to converse with each other.

Virtue Clarity and Definition

How Show up to meetings with lots of questions prepared, whether you're responsible for presenting concepts or not.

Don't be a total slave to the calendar: pick up the phone or IM colleagues whenever you feel the need for some conversation.

Honestly state that you need to talk through some ideas and that you could use some help.

Why The occasional meandering conversation is essential for generating and validating ideas. Talking through a concept or approach is a valuable vetting process.

Engage multiple senses to communicate

Specifically, engage sight and sound. Use both speaking and pictures to engage team members.

Virtue Clarity and Definition

How Plan meetings around not just what will be said, but what will be shown.

Have a document camera ready to display quick sketches on-screen or to project them on the wall.

Pay attention to the rhythm of the pictures shown, especially which pictures people will spend the most time looking at.

Why People pay attention more when they have something to look at. They can offer more considered opinions when fully engaged in the conversation.

Establish role definitions

Make sure everyone on the team knows what his or her responsibilities are. Take the time to ensure they understand whether they own particular activities, or are just contributors. Identify who is responsible for coordinating the creation of particular artifacts, and their associated responsibilities during client meetings.

Virtue Clarity and Definition

How If you're not in charge of defining roles, ask for each participant's responsibilities.

Quash apparent overlaps and competitive responsibilities early.

Happily give up responsibility: It's highly unlikely you'll be excluded entirely from the project if you carve out a specific role.

Why Collaboration means each person doing his or her part, and essential to that is each person knowing his or her part.

Give others room to learn from mistakes

Don't go cleaning up after everyone. Team members are entitled to make mistakes and correct their own courses.

Virtue Awareness and Respect

How Value team growth equivalently with project completion and quality.

Offer to help colleagues reflect on their failures. (It doesn't have to be as condescending as I make it sound.)

Identify potential risks and ask for the opportunity to take them.

Why People become better contributors when given opportunities to take risks and learn from their mistakes. Teams build trust when they see each other recover from failure.

Have a communications plan

Create standards for communication between team members.

Virtue Clarity and Definition

How Use templates for common email formats.

Establish rules for using different communications channels.

Identify who can respond to inquiries from different stakeholders.

Define parameters for communicating with stakeholders.

Why While such granularity may strike some as micromanagement, an entire team working from the same guidelines appears aligned and focused. Team members don't get distracted with dilemmas about who should say what and how.

Have a project plan

Create a project schedule with milestones and resource assignments. Clearly state how much time each team member should spend on each activity.

Virtue Clarity and Definition

How At a minimum, ensure you can answer who, what, where, when, why, and how questions about the project.

If you're not responsible for creating the plan, ask these questions of the project lead. Make sure you know what you need to do and by when.

Why Project plans establish expectations around performance and allow teams to coordinate their activities.

Have decision-making mechanisms

Design, project planning, resource usage, and other big items need a way for the team to arrive at decisions. The mechanism can be a set of criteria or a person, or anything else that helps people make decisions.

Virtue Clarity and Definition

How Establish goals or principles for the design or project plan to guide decisions.

Designate specific people responsible and accountable for specific decisions.

Why Consensus building is the death of collaboration. Collaboration doesn't depend on everyone agreeing; it depends on the ability of teams to make quick and valid decisions, and understand how those decisions are made.

Have objectives for every discussion

When you walk into a conversation, know beforehand what you expect to come out of it.

Virtue Clarity and Definition

How If you're organizing the meeting, send an agenda, a list of topics, or even a one-sentence objective beforehand.

If you're not organizing the meeting, ask the organizer for the agenda or objectives.

If it's an ad hoc meeting, take a moment to validate expectations with other participants.

Why Spiraling discussions of doom are the undoing of projects. Meetings or conversations without a goal can waste time and do not contribute to moving the project forward.

Keep meetings focused and short

The business equivalent of the Golden Rule: Assume other people's time is as valuable as yours. The purpose of a meeting isn't "Talk until 60 minutes are up."

Virtue Awareness and Respect

How Conclude a meeting when it's over, not when the clock says it's over.

Show up with an agenda and objectives so you know when it's over.

Why So you don't waste any more time than you have to.

Know when you're "spinning"

Be aware of when your effort is not productive. Spinning is the act of turning a problem over and over without making any real progress in solving it. Some people insist on gnawing at a problem, draining time and money, because they need to prove something to themselves.

Virtue Accountability and Ownership

How Spend a small amount of time (maybe 10–20 percent of the time allocated) on a task or assignment, then assess progress. If comfortable with the start, keep at it. If there's no solid direction, solicit help from colleagues.

Why Draining time and money from the project is irresponsible. Engaging a colleague is far more productive, and can "unstick" creative blocks.

Offer direct critiques

When providing criticism to a colleague, be specific about what needs work. Offer solutions only when asked, and focus on what isn't working and why. Avoid generalizations like "This isn't working for me," or "I just don't like it."

Virtue Awareness and Respect

How Avoid generalizations like "It's not good."

As someone is presenting a design, make a list of your first impressions as you have them.

Practice critiquing your own work.

Ask the presenter what they would like feedback on.

Point out specific things that work well, to lend authority to critiques.

Why Critique is the central mechanism for iterating and evolving design concepts. Solid critique depends on specificity and directness. Attempting to spare a designer's feelings is disrespectful and doesn't help them grow. By the same token, broad generalizations and unspecific feedback show a lack of awareness of what they need.

Play to strengths

Make sure roles and responsibilities on projects align with team members' individual strengths in terms of skill set and personality.

Virtue Accountability and Ownership

How Reflect on abilities and skills to identify strengths.

Talk to project leads about ensuring assignments align with those strengths.

Be honest about assignments that fall outside your sweet spot.

Why While people like to be challenged, they also like to be set up to succeed. They will feel unable to take ownership of their portion of the project if they aren't positioned to succeed.

Provide a rationale for decisions

Make sure all decisions—about the product, about the plan, about the project—have a reasonable rationale.

Virtue Accountability and Ownership

How Enumerate key decisions and identify the primary rationale for driving them.

Establish an overall framework, a story, or principles that drive the design process.

At the outset of a project, identify different criteria or objectives that will drive design decisions, and refer to them frequently throughout the project.

At the outset of a project, establish boundaries and parameters for the activities, deliverables, and milestones. Clearly articulate the boundaries to all participants, such that they become mantras for the project. As the project changes, ensure the parameters are bent or broken only for good reason.

Why People will be more accountable for their decisions if they have a solid reason for making them.

Recognize contributions

Give credit where credit is due. While there is no need to highlight every contribution by every team member, if someone inspired a particular direction or lent an insight, give them a shout-out.

Virtue Accountability and Ownership

How "One of the things we did was suggested by Nathan…"

"When Latesha and I were brainstorming, she suggested…"

"The team really worked hard to develop this concept, but Akil really drove the direction."

"Thanks for giving me your feedback yesterday. It really helped solidify the direction."

Why Acknowledging people's contributions gives them a sense of ownership in the project. It rewards good behavior with positive reinforcement, encouraging everyone on the team to work together. It demonstrates that "collaboration" doesn't necessarily mean "Everyone gets credit, so no one gets credit."

Reduce competition

Eliminate activities from the design process that pit designers against each other. Encourage people to work together, not race for the top.

Virtue Accountability and Ownership

How If multiple design directions or concepts are needed, make sure team members work together to generate them.

If individuals prepare separate design directions, have them work side by side so they can provide constant feedback and get inspiration from each other.

Assign ownership of a deliverable, such that even if people are competing on their contributions, one of them is ultimately responsible for the content.

Why In competitions, there is always a loser. Losers no longer feel as invested in the project. When people feel like they will make a meaningful contribution, regardless of their role, they will do better work and support each other in the pursuit of the project's goals.

Reflect on your performance

Take time to think about your performance on a project or task. Identify areas where you could have performed better, and where you played to your strengths. Identify things you would do differently next time and lessons learned that you would apply next time.

Virtue Awareness and Respect

How Engage someone outside the project to interview about your performance. Talking through it can help you see things more clearly.

Review the Traits (Chapter 10), using them to zero in on specific aspects of your personality that may have contributed to your performance.

Revisit a situation and identify the points that caused the greatest anxiety.

Why The best contributors have a keen understanding of what they can contribute, their boundaries, and their potential areas of growth. Such awareness allows them to set realistic expectations about their performance.

Respect the calendar

Use a shared calendar to stay aware of teammates' availability. Use your calendar to schedule time to perform tasks and activities. Do not schedule meetings during times colleagues have set aside for other activities.

Virtue Awareness and Respect

How Make the calendar the central place for your availability.

Schedule time to perform tasks and assignments, ensuring you have the time to work as needed.

Check calendars before scheduling people into conversations.

Do not assume your meeting is more important than anything else already on people's calendars.

Push back on people who attempt to cut into your work time.

Why Good collaborators respect each other's time and conscientiously set expectations about availability.

Set availability expectations

Use a variety of tools to communicate availability and commitments to effectively set availability expectations.

Virtue Awareness and Respect

How Shared calendars let teams see where and how people have allocated their time.

Be sure to block off time for travel.

Use instant messenger status messages to indicate availability: Available, In a Meeting, Do Not Disturb.

Use email to indicate to the team major outages (personal time, off-site work) and long-term unavailability.

Communicate outages to the team with as much notice as possible.

When interrupted and unavailable, indicate your next opportunity for collaboration.

Why Project coordination depends on understanding the comings and goings of team members. Collaboration depends on spontaneous and potentially disruptive communications, so colleagues should be informed about whether they can interrupt or not.

Set performance expectations

Clearly communicate ability to complete tasks and assignments. Highlight potential risks, and call attention to milestones and deadlines as appropriate.

Virtue Awareness and Respect

How Honestly indicate the amount of time the assignment will take.

Request intermediate milestones.

Ask for help in estimating the amount of time needed for the assignment.

Seek to understand the consequences if the assignment is incomplete.

Ask for clarity on scope and other assignment parameters to ensure valid estimates.

Honestly and openly explain any performance concerns like capability, capacity, or competing priorities.

Why Collaboration depends on careful planning, which in turn requires a clear understanding of the level of effort for assignments.

■

Author Bio

 Dan Brown is a Web designer, entering the business in 1995, when it was just barely a job title. In 2006, he and Nathan Curtis founded EightShapes, LLC, a user experience design firm based in Washington, DC. EightShapes' clients include Marriott International, Cisco Systems, and Yahoo!

In 2011, Dan released the second edition of his book *Communicating Design*, a manual on effective design documentation like wireframes and flowcharts. It is widely considered part of the essential canon of design books.

In 2012, Dan designed and published *Surviving Design Projects*, a card game for creative teams to exercise their conflict management skills.

Dan has facilitated dozens of workshops on Web design, design documentation, and conflict management. He regularly speaks at the IA Summit and has led workshops at the School of Visual Arts. Dan has written articles on information architecture, Web design, and design documentation for several online publications including UXMatters.com and BoxesandArrows.com.

Outside the office, Dan likes spending time with his family exploring the Washington, DC metro area, designing and playing board games, and cooking.

∎

Contributor Bios

David Belman

David Belman is a founding partner of Threespot, a digital agency headquartered in Washington, DC. He and his teams have developed and deployed brand, communications, and digital experience strategies for clients that range from U2 to Harvard Business School, from the National Football League to Planned Parenthood. He has developed and executed enterprise digital and brand strategies for American Greetings, McDonald's, Peace Corps, and The World Bank.

Prior to opening Threespot, David served as Vice President and Creative Director for Magnet Interactive (now AKQA), where he shepherded the online experiences for Kellogg's, Nissan USA, and Crayola, among others. His online work has won widespread recognition, including One Show pencils, Webby awards, and recognition in *Communication Arts*, *ID Magazine*, and AIGA annual design reviews.

David has taught graduate studies in Digital and Brand Strategy at Johns Hopkins University. He received a master of fine arts in creative writing from the University of Montana, Missoula and a bachelor of arts from Wesleyan University in Middletown, Connecticut. He lives in Washington, DC, with his wife and two children.

Mandy Brown

Mandy Brown is cofounder and CEO of Editorially, a new platform for collaborative writing. She is also cofounder of A Book Apart and a former contributing editor for *A List Apart*. She served for two years as communications director and product lead at Typekit, doing her part to contribute to better typography on the web. She lives in Brooklyn.

Erika Hall

Erika Hall is the cofounder and director of strategy of Mule Design Studio, an interactive design consultancy based in San Francisco. She champions clear communication and evidence-based decision making. Erika is the author of *Just Enough Research*, a concise handbook of design research and the creator of Unsuck-It.com, a punitive lexicon of business jargon.

Denise Jacobs

Denise Jacobs is a speaker, author, and creativity evangelist who evangelizes techniques to make the creative process more fluid, methods for making work environments more conducive to creative productivity, and practices for sparking innovation. Denise is also a respected expert in Web design, and the author of *The CSS Detective Guide*, the premier guide to troubleshooting CSS code. She is a coauthor of *The Smashing Book #3: Redesign the Web* and *InterAct with Web Standards: A Holistic Guide to Web Design*. Denise has presented at conferences and organizations worldwide, such as SXSW Interactive, the BBC, Future of Web Design, Paris Web, and FITC: Future, Innovation, Technology, Creativity.

Jonathan Knoll

Jonathan "Yoni" Knoll is a researcher, strategist, and designer who has spent more than a decade engaged in nearly every facet of software design and implementation. He brings UX deliverables to life through his extensive knowledge of prototyping, and his skills have been brought to bear for Standard & Poor's, The Gilt Groupe, Refinery29, Happy Cog, and more. He's rocked the UX casbah on projects for Standard & Poor's, Mozilla, Time, Purex, Keds, Gilt, and ADP, and his solutions have a penchant for seeing the light of day.

An active member of the UX community, Yoni is ever engaged in at least half a dozen UX community sites, initiatives, conferences, and activities. He is also a strategic advisor for Rosenfeld Media and recently served on the advisory board for the IA Institute.

Yoni has led workshops on collaborative sketching and prototyping at IDEA, Interaction, IA Summit, and Big Design conferences. He is currently focused on product strategy and design for startups and businesses with new ideas.

He occasionally rants at http://sketchingincode.com/ and tweets often as @yoni.

Marc Rettig

Marc Rettig is founding principal of Fit Associates LLC. His career spans more than 30 years in business, design, education, and technology. His work as designer, researcher, and educator has put him on the frontier of applying design methods to social and strategic questions. He currently serves on the advisory boards of Rosenfeld Media and the IxDA Interaction Awards. He is a founding faculty member of the Masters in Design for Social Innovation program at the School of Visual Arts in New York, and previously taught at the Carnegie Mellon University Graduate School of Design, and at the Institute of Design, IIT. Marc's interests include cultural immersion, language, and photography.

Jeanine Warisse Turner, PhD

Jeanine Turner is an associate professor at Georgetown University, where she teaches in the Communication, Culture, and Technology program as well as the McDonough School of Business. Her research explores the human factors and management issues involved in the introduction of new communication technologies within organizations and the development of virtual organizations. Specific examples of this research include the study of instant messaging and multicommunicating, computer-mediated bulletin boards as a form of social support, use of videoconferencing technology and the Internet for distance education, and the implementation of telemedicine technology as a means of augmenting the delivery of health care services. Turner teaches courses in business communication, executive presentations, and the impact of communication technologies on organizations to graduate students, executives, and undergraduates.

Bibliography

The Business of Design

Monteiro, Mike. *Design Is a Job*. New York: A Book Apart, 2012.

Sherwin, David. *Success by Design: The Essential Business Reference for Designers*. Blue Ash, Ohio: HOW Books, 2012.

Conflict

Cloke, Kenneth, and Joan Goldsmith. *Resolving Conflicts at Work: Ten Strategies for Everyone on the Job*. San Francisco: Jossey-Bass, 2011.

Stone, Douglas, Bruce Patton, and Sheila Heen. *Difficult Conversations: How to Discuss What Matters Most*. New York: Penguin Books, 1999.

Collaboration and Project Management

Coleman, David. *42 Rules for Successful Collaboration: A Practical Approach to Working with People, Processes, and Technology*. Cupertino, CA: Super Star Press, 2009.

Harvard Business Review. *Harvard Business Review on Collaborating Effectively*. Boston: Harvard Business School Publishing, 2011.

Lyons, Nancy and Meghan Wilker. *Interactive Project Management: Pixels, People, and Process*. Berkeley, CA: New Riders, 2012.

Sanker, Dan. *Collaborate: The Art of We*. San Francisco: Jossey-Bass, 2012.

Sibbet, David. *Visual Teams: Graphic Tools for Commitment, Innovation, and High Performance*. Hoboken, NJ: Wiley, 2011.

Tamm, James W., and Ronald J. Luyet. *Radical Collaboration: Five Essential Skills to Overcome Defensiveness and Build Successful Relationships*. New York: Collins, 2005.

Facilitation and Brainstorming

Gray, Dave, Sunni Brown, and James Macanufo. *Gamestorming: A Playbook for Innovators, Rulebreakers, and Changemakers*. Sebastopol, CA: O'Reilly, 2010.

Sibbet, David. *Visual Meetings: How Graphics, Sticky Notes, and Idea Mapping Can Transform Group Productivity.* Hoboken, NJ: Wiley, 2010.

Unger, Russ, Brad Nunnally, and Dan Willis. *Designing the Conversation: Techniques for Successful Facilitation.* Berkeley, CA: New Riders, 2013.

Mindset

Dweck, Carol. *Mindset: The New Psychology of Success.* New York: Ballantine, 2007.

■

Index

WATCH READ CREATE